Manufactured pleasures

STUDIES IN
DESIGN
AND
MATERIAL CULTURE

general editor
Paul Greenhalgh

Manufactured pleasures
Psychological responses to design

Ray Crozier

MANCHESTER UNIVERSITY PRESS
Manchester and New York

distributed exclusively in the USA and Canada by St Martin's Press

Copyright © W. Ray Crozier 1994

Published by Manchester University Press
Oxford Road, Manchester M13 9PL, UK
and Room 400, 175 Fifth Avenue, New York, NY 10010, USA

Distributed exclusively in the USA and Canada
by St. Martin's Press, Inc., 175 Fifth Avenue, New York,
NY 10010, USA

British Library Cataloguing-in-Publication Data
A catalogue record for this book is available from the British
Library

Library of Congress Cataloging-in-Publication Data

Crozier, Ray,

 Manufactured pleasures : psychological responses to design / Ray
Crozier.
 p. cm. — (Studies in design and material culture)
 Includes bibliographical references and index.
 ISBN 0–7190–3841–3 (hardback), — ISBN 0–7190–3842–1 (paperback)
 1. Design—Psychological aspects. I. Title. II. Series.
NK1520. C76 1993
745.4′01′9—dc20 93–26016
 CIP

ISBN 0 7190 3841 3 *hardback*
 0 7190 3842 1 *paperback*

Typeset in Times
by Graphicraft Typesetters Ltd., Hong Kong
Printed in Great Britain
by Redwood Books, Trowbridge

To Sandra, John, and Beth

Contents

Contents

Figures

Acknowledgements

Friends and colleagues have helped me in numerous ways with this book. I owe special thanks to Paul Greenhalgh for his advice and encouragement over many years, and I very much appreciate his invitation to contribute to the series, Studies in Design and Material Culture. I am grateful too to my editor at Manchester University Press, Katharine Reeve, for her constructive advice at all stages in the development of the book. Many others have contributed to the project, and in particular I should like to thank Wynford Bellin, Joe Campbell, Tom Dawkes, Don Jackson, Paul Locher, Rob Ranyard, Gerda Smets, and Peter Walker. My research has been assisted by facilities and services provided by the School of Education and the Library of the University of Wales College of Cardiff. Finally, I owe much to Sandra, John, and Beth Crozier – I could not have undertaken this project without their support.

Acknowledgements for figures

1 The landscape by Richard Wilson, *Landscape with Banditti round a tent* (1752) is reproduced with the permission of the National Museum of Wales, Cardiff.
2,3 These photographs were provided by Don Jackson, Cardiff Institute of Higher Education, and are reproduced with his permission.
4 This example of Gestalt figure-ground differences was originally drawn in 1915 for *Puck* magazine by the cartoonist W. E. Hill, and was introduced to psychologists by E. G. Boring in *American Journal of Psychology*, vol. 42, 1930. This figure is reproduced with the permission of Professor R. L. Gregory, University of Bristol.
5 Printed earthenware mug, 'puzzle of portraits', attributed to Swansea, *c.* 1794, is reproduced with the permission of the National Museum of Wales, Cardiff.
6 Source: Le Corbusier (1954), *The Modulor*, Translated by P. De Francia and A. Bostock, London: Faber and Faber, p. 143. This figure is reproduced with the permission of Faber and Faber Ltd, London.
7 Source: Kanizsa, G. (1979), *Organization in Vision*, New York, Praeger, p. 193. This figure is reproduced with the permission of Praeger Press, New York.
8 This computer-generated figure was provided by Dann E. Passoja, New York, and Akhlesh Lakhtakia, Pennsylvania State University and is reproduced with their permission and with the permission of Pergamon Press. For additional

information, see Passoja, D. E. and Lakhtakia, A. (1992), Carpets and rugs: an exercise in numbers, *Leonardo*, 25, pp. 69–71.

9 Photograph of the Alhambra is reproduced with permission from The Hulton Picture Company.

10 These photographs were provided by Don Jackson, Cardiff Institute of Higher Education, and are reproduced with his permission.

11 These photographs were provided by Paul Locher, Montclair State College and Gerda Smets, Kees Overbeeke, Delft University of Technology, and are reproduced with their permission.

12 These drawings were by my daughter, Beth, and are reproduced with her permission.

13 The data points that form this inverted-U curve are based on simulated preference data.

14 Photograph of Madonna is reproduced with permission of Universal Pictorial Press & Agency Ltd.

15 High-backed chair for the Ingram Street Tea Rooms, Glasgow, designed by Charles Rennie Mackintosh, 1900 is reproduced with the permission of the Taffner Curator, Mackintosh Collection, Glasgow School of Art.

16 These computer-generated variations of the Mackintosh high-backed chair were provided by Joc Campbell, University of Wales, Cardiff, and are reproduced with his permission.

17 Photograph of Freud's study in Maresfield Gardens, London, is reproduced with permission of Mary Evans Picture Library.

18 Derby porcelain centrepiece of dessert service, 1787, made for Thomas Jones and painted with a view of the house recently built upon his estate at Hafod, Cardiganshire. Reproduction with the permission of the National Museum of Wales, Cardiff.

19 This illustration is based upon information provided by Csikszentmihalyi, M. & Rochberg-Halton, E. (1981), *The Meaning of Things: Domestic Symbols and the Self*, Cambridge: Cambridge University Press. Computer graphics by Wyn Bellin.

20 Both these advertisements appeared in Cosmopolitan, July 1993.

21 The photograph is reproduced with the permission of The Hulton Picture Company. The quotation is from Melly, G., *Revolt into Style*, Harmondsworth, Penguin, 1972, p. 34.

22 Source: Baber, C. & Wankling, J. (1992), 'An experimental comparison of text and symbols for in-car reconfigurable displays', *Applied Ergonomics*, 23, pp. 255–262. I am grateful to C. Baber, University of Birmingham, and to Butterworth-Heinemann Ltd for permission to reproduce it.

23 Source: Lee, K., Swanson, N., Sauter, S., Wickstrom, R., Waikar, A., & Mangum, N. (1992), 'A review of physical exercises recommended for VDT operators', *Applied Ergonomics*, 23, pp. 387–408. I am grateful to Naomi Swanson, NIOSH, Taft Laboratories, Cincinnati, and to Butterworth-Heinemann Ltd for permission to reproduce it.

24 This photograph was provided by Dr Urs Guggenbuhl, Swiss Federal Institute of Technology, Zurich, and is reproduced with permission.

25 Source: Judd, D. B. & Wyszecki, G. (1975), *Color in Business, Science and Industry*, 3rd edition, New York, Wiley, p. 256. This figure is reproduced with the permission of John Wiley & Sons, New York.

Acknowledgements

26 See Kohler, W. (1947), *Gestalt Psychology*, New York, Liveright Publishing Corporation, pp. 133–134. This computer-drawn version was provided by Joe Campbell, University of Wales, Cardiff, and is reproduced with his permission.

27 The typeface Norway Alphabet Normal was created by DesignCo for the Norwegian Royal Ministry of Foreign Affairs, as part of Prosjekt Norgesprofil. This example is reproduced with the permission of the Royal Norwegian Embassy, London. I am also grateful to Leif Frimann Anisdahl for sending me material on the typeface and for his permission to reproduce it.

General editor's foreword

This series of books is principally about the history of objects. When put so bluntly, there seems to be a certain absurdity in the suggestion that there might be a need for such an enterprise. After all, is that not what various other disciplines are already providing us with? The answer to this question, I fear, is no. The History of Design, Material Culture, or Decorative Arts, as it is variously understood, usually begins where others end. Many disciplines have objects of one kind or another at their centre, but the history of design stands alone in its analysis of the wide range of genres which fill people's lives. The furnishings, utensils, adornments, decorations, clothing, graphic materials, vessels, electrical and mechanical products which give form and meaning to the cultures they reside in.

The range of texts in this series has not been limited either by the social status of the objects concerned or by their production methods. There are volumes on mass-produced commodities designed as low-value disposables, as well as exclusive products designed for a very rarefied usage. This range means that the series is not particularly united by its taxonomy, but rather by the aims of the contributing authors. They seek to expose the meanings of the objects within the cultural context they were produced in. In order to do this they will adopt approaches from other disciplines; from archaeology, art history, anthropology, literary studies, the history of science and sociology. By the very nature of its subject matter, design history is, and always must be, interdisciplinary.

Introduction

Psychological responses to design

More and more the world we inhabit is designed by ourselves. We have become preoccupied with design, and objects are regarded as having status and value to the extent that they are identified as having been designed. Increasing numbers of people earn their living as professional designers. These trends are one of the consequences of economic and social trends that are transforming the world. The wild places of the world are being irretrievably altered by exploration and exploitation. The human population is rapidly growing and is becoming more and more an urban population. In 1850, two per cent of the world's population lived in cities; in the 1980s that percentage had risen to twenty-five, and to seventy in the USA. The dominance of international monopoly capital has required mass production and mass consumption of commodities and has raised advertising and marketing to crucial cultural practices. The survival of national economies has become identified with their growth, and this growth requires increasing levels of consumption of material goods, levels that can only be attained by persuading consumers that they need different, better, or just new possessions. The luxury services and commodities that are now regarded as essential for many in the world and remain the dreams of so many more – hairstyles and body shape, clothes and cosmetics; kitchen utensils and furniture; pens, calculators and computers; televisions, videos, and compact discs; the pictures on the walls, the programmes on the screens, the music on the tapes; the car in the garage; the garage, the house, the street, the school, the supermarket – are all thought out, analysed, synthesised, are *designed.*

The term 'design' now has a variety of different meanings, many of which are remote from its senses of a preliminary sketch for a picture, a plan for a building or machine, or the specification for the

1

arrangement of the parts of an object or building. It has connotations of a certain lifestyle, of aesthetic appeal, of fashion. Many of its uses share an implication that a *choice* has been made, that an object will take on one appearance or arrangement of its parts rather than another. In Western capitalist society such choices are made to enhance the appeal of objects to consumers, and the search for the best choice requires a considerable investment of money, time and talent. Even in a communist society where there may be a state monopoly of design, one design still has to be chosen over the possible alternatives to go into production. Any choice is made within constraints, and the design of artefacts is constrained by technical and economic factors and also of course by public taste. Thus the history of the design of objects is revealing of the society in which the objects were produced; even the rubbish left behind may be informative.

The concept of taste is closely allied to that of design, particularly when it is used to describe good or bad taste. Like the concept of design, it has many connotations. It describes preferences and values at different levels. First, one may talk of the taste of an era, the prevalent or most typical styles over a period of time. Much of design history, at least of a certain kind of design history, is concerned with the description of taste in this sense. The existence of taste is often more apparent in the past than in the contemporary world – the objects displayed in the Great Exhibition in London of 1851 seem heavy and over-elaborate to contemporary eyes, yet presumably looked just right at the time. Tastes change of course. One has only to contrast illustrations from that exhibition with, say, a current IKEA catalogue. Shifts in taste are also evident in alterations of old buildings such as churches, where medieval features were removed in, say, the nineteenth century to be replaced by what were thought to be improvements, changes that are subsequently themselves deplored and regarded as acts of vandalism. The ubiquity of change implies that good taste is a relative concept, and at any one time it may merely refer to the preferences of a particular elite group in society.

There have been many attempts to promote good taste. The Second World War in Britain was a period of shortages of basic materials and state regulation of production and pricing was extended to civilian products such as furniture and clothing. The Government

supported the Utility scheme, launched in 1942 with the aim of controlling the specifications and designs for furniture and domestic goods that were to be provided for priority groups, such as those whose furniture had been destroyed by bombing. The group of designers who advised the Board of Trade were concerned to promote 'good design'. Gordon Russell, a furniture designer and member of the group wrote in 1946: 'I felt that to raise the whole standard of furniture for the mass of people was not a bad war job. And it has always seemed sound to me, when in doubt as to people's requirements, to aim at giving them something better than they might be expected to demand' (Sword, 1974). The standards of design proposed by Russell included 'a respect for natural methods and honest construction', values that reflected the aspirations of groups like the Arts and Crafts movement which themselves were reactions to earlier standards of taste. Bodies like the Design and Industries Association and, later, the Design Council were intended to encourage and set standards for good design. It would nevertheless be misleading to imagine that at any particular period there is consensus on what constitutes good design or taste. For example the collection of essays on modernism edited by Greenhalgh (1990) provides ample evidence of the controversies that can exist. Differences in taste at any period of time are not haphazard but are related to social differences in the population in broadly predictable ways. Marketing organisations are aware of this as they use census data to draw up maps of the distribution of different kinds of consumers or categorise the population into socio-economic groupings which can be targeted by specific advertising campaigns. 'Geocoding' or 'cluster demographic systems' in America link zip (or postal) codes to a range of measures of 'lifestyle' and then define groupings of people who are similar in income and taste: 'Bunker's Neighbors', 'Young Influentials' and 'Shotguns and Pickups' (Aaker & Day, 1990). And of course 'Yuppies'.

Gender is another source of differences in taste. Forty (1986) provides several examples from the period 1895 to 1980, comparing designs of everyday items for men and women like watches, hairbrushes, pocket knives and electric razors. The appearance of these objects reflects stereotypes of men as plain, strong, and assertive and women as 'decorative', weak, delicate and sensitive. As Forty points out (p. 63) 'The study of design not only confirms the existence of

certain social distinctions, but also shows what the differences between the categories were thought to be.' Despite the attention given to gender differences in public debate in recent years and in particular the rise of the feminist movement, inspection of any catalogue or shop-window still reveals gender differentiation, and this is evident too when new kinds of products become widely available, as can be seen in the differences in the frequency of use and the imagery and types of games associated with the recent proliferation of home computers and games consoles. The issues here are complex. On the one hand people are free, within financial constraints, to make their own choices among the designs available. On the other hand images of what is appropriate for particular groups are directed at those groups with great repetitiveness and much ingenuity.

At a further level, taste is related to individual personality. One of the most widely shared views among psychologists is that taste is associated with a person's sense of self. Taste reflects upon oneself as it is revealing to others of the kind of person one is. There are differences among social groups in what constitutes taste but nobody wishes to be seen to lack it. Abelson (1986) has suggested that a person's beliefs are like their possessions, and our tastes too are part of us and help to define us: a criticism of our taste is not to be taken lightly. This can result in conformity to the standards of particular groups, and this phenomenon is an important reminder that the self is a complex concept, being both private and public. It is what makes a person distinctive and, at the same time, it reminds us of the social nature of the self, in that the meaning of our identity arises out of our interactions with others and our social groupings.

Why are things designed the way they are? Why do they take on one appearance rather than another? Why do they give pleasure? Why do designs change? Why is the desirable object of one generation neglected or scorned by the next? These are all simple questions to pose but difficult to answer. We quickly reach the conclusion that a host of factors – cultural, historical, economic and technological – interact to contribute to the look of objects and places. Many people would immediately assign an important role to psychological factors. Objects and places arouse emotions, carry messages, reflect and convey information about the kinds of people we are, the groups to which we belong or aspire, the ideals and standards that are endorsed in a particular time and place. Any discourse on design soon

encompasses psychological needs, choices, and the ways in which people behave.

Psychological explanations

Mention of psychological factors brings to mind for many design professionals and lay persons alike the names of Freud and Jung. These major psychologists and others influenced by them have had much of interest to say on the questions we have introduced. However, during this century there has developed an alternative approach to psychology that is characterised by a vigorous attempt to apply scientific methods to the study of all aspects of human life. This endeavour has dominated psychological thinking in the universities, the health and education professions, and increasingly in the worlds of business and commerce. It is probably less well known among the population at large, including those branches of the population professionally concerned with the theory and practice of design. It is the goal of this short volume to introduce this discipline of psychology and its attempts to provide answers to the questions we have raised about the psychological impact of designed objects and places.

My attempt to realise this goal has the following structure. The second chapter of the book introduces one of the major debates within psychology, the relative importance of biological and social factors in determining our responses to design. Do objects and places make their impact because of some innate human responsiveness to shape, colour, texture and so on, or are these reactions acquired through socialisation experiences? I explore this issue largely in the field of environmental design, and then suggest three kinds of approaches to these debates. The first proposes that we respond to the formal qualities of design, that there is a systematic relationship between the pleasure and interest to be derived from objects and their objective qualities of size, shape and colour. The implication of this view is that there are some constants in human reactions that transcend time and place. The second view is that we respond to the meanings of designs, with the implication that these meanings are variable and are acquired in particular cultural settings. We next consider the notion that the source of affective reactions to objects and the constructed world resides in their use and the extent to

which they fulfil their functions. Clearly any particular designed object has uses, meanings and objective qualities. It is produced under constraints of efficiency and safety, and is marketed with emphasis on its effectiveness, meanings, and pleasingness. Nevertheless it is hoped that teasing out these different attributes allows some insights into the applications of psychology to design. Finally we explore through the topic of colour the notion that all three of these features contribute to our understanding of the psychology of design, ending with a discussion of some of the shortcomings of current approaches.

We must address one problematic issue at the outset, the notion of psychology as a science. Can psychology *be* a science? There are many controversies here, to do with different conceptions of the nature of science. There is, I think, a stereotype of the scientist as one who deals largely with *facts* and who can provide detailed answers to questions of the kind we raised earlier by referring to an extensive and agreed body of knowledge and to general laws that have been arrived at through lengthy processes of investigation. It often seems that psychology fails to meet this criterion for a science in that there appears to be frequent disagreement as to the facts and their interpretation. Thus, for example, some psychologists may argue that a particular combination of colours is appealing because of innate properties of the human nervous system, and they would regard the scientist's role as seeking to provide a detailed account of this relationship. Others may point out that extensive recording of preferences among different cultures has documented significant variation in responses to that combination of colours. The apparent inconclusive or contradictory nature of much psychological research can be frustrating to many. Others are reluctant to accept that a scientific approach has any role at all to play in discussions of design, believing that this is a matter of human creativity and diversity that cannot be reduced to a body of knowledge or a set of general principles. Yet others will be disappointed (or even relieved) to read the scientific literature and discover that it rarely addresses their interests as students of design, that there is little robust knowledge and few generalisations, or that the knowledge that does exist is tangential to the really interesting questions.

In response to these criticisms it can be argued that these questions should not be prejudged. The scientific approach has illuminated much of human experience and there is no intrinsic reason

why it cannot be applied successfully to matters of design. There is no reason to believe that psychological questions will have simple answers or that science cannot accommodate uncertainties or a diversity of interpretations. There are dangers in having a closed mind, in assuming that our common sense is sufficient to interpret experience, and, in so doing, missing the opportunity to discover facts about ourselves and the impact upon us of objects and places that are not apparent to common sense. As the career and changing reputation of Freud has revealed, the outrageous claims of one historical period can become the common sense of another. Furthermore, Freud's generalisations about psychology have heightened many people's experience of the arts and have had a major impact upon art criticism in our time.

Mention of Freud raises a further problem, to do with the nature of science. We shall see that very different approaches to psychology believe that they are alone in following correct scientific procedures. Freud was trained in medicine and practised as a researcher, and he was quite explicit that his psychological theories were scientific – they were based on careful observations of his patients as recorded in his case studies, and the assertions that he made about infantile sexuality that so shocked his contemporaries were claimed to be empirical discoveries and not the researcher's own preconceptions. Freud's initial observations were complemented by his own self-analysis which in turn gave rise to his generalisations about the hitherto unrecognised psychological significance of mundane phenomena, and, as we shall see later, his formulation of psychological symbolism that has greatly influenced discussion of the pleasure inherent in objects. These observations and generalisations were then integrated into the general theory of psychoanalysis in ways that Freud argued were essentially scientific.

However, contemporary mainstream psychology has rejected most if not all of psychoanalysis on the grounds that it is unscientific! Some of these criticisms are that psychoanalysis is poorly applied science, that it goes beyond the available evidence, that the original samples of observations are small and unrepresentative of humanity as a whole, that the observations cannot be replicated by objective observers, and that the chain of reasoning is often obscure. Thus it is argued by these critics that science ought to be a public activity where problems that are raised can be resolved by recourse to agreed

procedures. Psychoanalysis has failed to develop these procedures and consequently its problems tend to be resolved by appeals to the authority of the scientist. It is this failure of the discipline, it is proposed, that has given rise to the schisms that have characterised its history. A further criticism of the approach is that psychoanalysis does not make predictions about behaviour, but merely provides an explanation of behaviour that has already occurred. It allows the analyst to interpret the effect of a sculpture upon its viewer, but it does not predict which features of the sculpture will have particular effects. The argument that an interpretation after the event is insufficient and the important role that is ascribed to prediction are of course revealing of the critic's stance towards the nature of science, and we will briefly consider this issue by examining trends in psychological research in this century.

In an influential textbook first published in 1962 George Miller defined psychology as the 'science of mental life', and this definition would be broadly accepted today. Two elements of this definition need consideration: 'science' and 'mental life'. The notion of science that has dominated psychological thinking has been based on the natural sciences such as physics. At the turn of the century a number of thinkers became dissatisfied with speculative approaches to psychology, and were impressed with the success of scientific techniques in elucidating the natural world. They believed that these methods could be applied with equal success to psychological questions. These techniques included the careful observation of phenomena, preferably under laboratory or controlled conditions. It was also crucial to introduce measurement, as without the capacity to apply numbers to things it would not be possible to formulate laws.

Perhaps the most valuable technique of natural science is the experiment. By carefully controlling the possible influences upon some event and by manipulating one or more of these in systematic ways one can examine the susceptibility of that event to those manipulations and ultimately make causal statements linking events to their causes. Which features of a sculpture produce a psychological response? If one could take a measure of that response then one could expose the spectator to variations in the features and examine the consequent changes in the response. Indeed among the earliest essays in the application of these techniques to psychological questions the pioneering scientist Gustav Fechner attempted in 1876

to examine through the use of experiments questions about the beauty of objects that had been the subject of philosophical speculation for centuries. The key influence upon this 'new' science was Charles Darwin. After his seminal work on the theory of evolution, Darwin wrote on psychological issues, for example his discussion of the facial expression of emotion in *The Expression of the Emotions in Man and Animals*, first published in 1872. But his profound influence was on considering man as a species and locating the human within the natural world. In the next chapter we will consider the influence of this upon enquiries into the psychology of design; here we make the point that this conception of human nature provided a justification for applying scientific techniques to the study of psychological phenomena.

The concern of the first experimental psychologists to apply these techniques led quickly to the problem of inner psychological experience. This is, after all, private and I can know nothing of another person's mental life except through observation of her or his behaviour and interpretation of that behaviour in the light of my own inner life, including what I have learnt through experience and have been taught about why people behave as they do. This is of course a problem that has been familiar to thinkers for centuries, and one that troubled the first experimentalists in Germany. They had developed controlled introspective techniques to examine thinking processes but had been unable to deal with processes that turned out to be central to thought but were not amenable to consciousness. The reaction to these problems was to deny the importance of inner mental life for psychological explanation, and for the first half of this century the discipline was dominated by the school of thought known as behaviourism. This held that laws could be formulated by relating observed behaviour to environmental manipulations without recourse to mental phenomena. As a research strategy the study of animals was encouraged – their psychological processes were arguably 'simpler' than those of humans and their environments could be rigorously controlled and manipulated in ways that were unthinkable for humans (and perhaps now would be regarded as unthinkable for animals). The influence of Darwin encouraged the belief in a continuity of processes across different species.

Whatever the scientific merits of this strategy it had the unfortunate effect of reducing public interest in psychology and, in the eyes

9

of many, psychology has remained the study of animals. This is unfortunate for two reasons. Much of the theory that has been developed within this paradigm is of interest, as one cannot deny the importance of learning in our reactions to the world. To take one example, much of the research was concerned with the emotional impact that could be instigated by an object or event (a 'stimulus') that had previously been innocuous but that had acquired its impact through its conjunction with another stimulus that had inherently such an affective quality. Such associations could be quickly set up and could be very resistant to change. One could argue plausibly that much of the designed world has acquired its affective significance in this way. Certainly much of advertising and marketing, and these are key ingredients in any account of contemporary design, relies very heavily upon providing objects with meaning through association and repetition. The very success of these techniques has probably rendered them invisible. These techniques can be blunt or subtle, and can be applied to particular objects and products or to the image of multinational corporations. The associations may be pictorial or may make use of words and sounds. The reader probably has a large mental repertoire of images, slogans, and theme tunes that call to mind, or are elicited by, particular products, and products have 'images' or connotative meaning that can be investigated by the market researcher and targeted by promotional campaigns. Indeed the extreme behaviourist would maintain that all of the designed world has acquired its psychological significance through association.

The second unfortunate side-effect of this stereotype of the psychologist as engrossed in the study of animals is that it maintains in its adherent's mind an outmoded view of the discipline. We return to Miller's definition of a science of *mental* life. Since the Second World War psychology has been characterised by a revival of interest in the mind and a rejection of the behaviourist position that satisfactory explanations can be provided without recourse to consideration of mental events. There have been several influences upon this trend, but a crucial one has been technological – the development and refinement of computers. To take another phrase of Miller's, 'the mind came in in the back of the machine' (Miller, 1983, p. 26). The war itself had an impact both upon these technological developments and upon the role and self-perceptions of psychologists.

Development of the first working computers was for military

purposes. The prospect of the computer and early models can be traced to Charles Babbage's work in the early nineteenth century, but its design was effectively progressed by a group of British mathematicians and engineers including Turing, Good and Michie working at Bletchley to decode German intelligence messages, and by a team of Americans including Mauchly, Eckert and von Neumann who developed the Electronic Numerical Integrator and Calculator (ENIAC) to compile the enormous number of calculations needed for ballistics.

The influences upon psychologists were manifold. Their involvement in the war came from the need to solve problems in training people in the use of radar systems and different kinds of machines. This entailed the analysis of errors that were made, for example, in reading aircraft instruments, and resulted in suggested improvements in the design of instrument displays. If the theories these researchers brought with them were not relevant to these problems their ability to design experiments and to measure behaviour was, and these applications of psychology led after the war to the growth of the study of (hu)man–machine interaction and the discipline of ergonomics. We shall discuss these in a later chapter.

Psychological theory was also not immune to the influence of technology. Any misgivings about the value of explanations in terms of hidden mental processes seemed weak in the face of machines that could have memories, could solve problems, and that seemed to have goals. If engineers could construct machines with memory it hardly seemed appropriate to disparage talk of memory as 'unscientific'. The computer provided a valuable metaphor for thinking about the mind, and this gave rise to the 'information processing' school of psychology that took as its subject-matter mental processes such as attention, perception, memory, thinking, and decision-making. Despite the rehabilitation of mental life psychologists were still wedded to experimental methods; there was no return to introspection. As the valves of the original computers were replaced by transistors and then successive generations of microchips, computers became capable of increasingly 'intelligent' behaviour. In parallel with these developments in information technology, the information-processing paradigm has evolved into cognitive psychology and allied fields such as artificial intelligence and cognitive science, and has penetrated more and more psychological phenomena.

Manufactured pleasures

The hegemony of behaviourism has gone. Nevertheless, cognitive psychology has retained much of the behaviourist methodology, and mainstream psychology is increasingly being challenged by alternative schools of thought with varied conceptions of the nature of scientific method. Humanistic psychologists offer challenges on both moral and scientific grounds, arguing that the computer metaphor is dehumanising and that analytical methods fail to do justice to the complexity of human behaviour. They argue that psychology needs to pay greater attention to the concept of human agency, to people's control over, and sense of responsibility for their actions. This concept of agency is, it is asserted, incompatible with the language of cause and effect and with experimental methods that manipulate human responses.

A further line of attack is that psychology is unduly individualistic. Its explanations are framed in terms of the individual's behaviour or understanding of events as if reality is constructed by the person, whereas, according to this view, the concepts through which we understand reality have a long social history. A child does not learn all of the uses of objects like a bat and ball by exploring or manipulating them. These objects have evolved over a long period of time and the child is born into a society that knows how they are to be used. Through playing with adults and older children the child comes to *appropriate* at least some of this knowledge. More generally, understanding of objects and their meanings and functions is shared in a particular culture and precedes any particular user. The wheel is not endlessly reinvented. To take a further example, one might imagine the scientist observing people playing a game like cricket or lacrosse, categorising the different kinds of activities and counting the frequency of acts of different kinds. The scientist would attempt to identify regularities in behaviour and suggest causal connections between behaviours. Critics of this approach argue that this will never result in an understanding of the activity: the meaning of the game is in its rules and conventions and these are known to the participants. Indeed they can only be players if they have an understanding of the nature of the activity, even if their own role is only part of the action. This suggests that the appropriate scientific method is to examine the accounts that players and others involved provide of the activity.

This approach emphasises the social construction of knowledge.

It regards psychologists' search for general or universal laws of behaviour as scientism rather than science – psychologists ape the methods of natural science while failing to recognise that both human behaviour and explanations of it are shaped by historical circumstances. According to this view it is impossible to formulate generalisations with the status of natural laws. People's awareness of such generalisations would in itself have the potential for changing their behaviour. I shall return to a discussion of these trends, but at this point I shall summarise the arguments so far and introduce a tension between two types of explanatory framework that have characterised psychology and its application to design: the biological and the social.

Summary

This century has seen the evolution of psychology as a scientific discipline that has examined a range of phenomena including questions concerning the impact upon people of objects and places. However, it is argued that psychology should not be seen as a monolithic discipline gradually accumulating facts about these questions. There is no consensus about the nature of psychology or indeed about scientific methodology. A combination of technological developments, intellectual influences and exposure to practical problems has elevated cognitive psychology to a predominant position, but one that exists alongside earlier approaches, including psychoanalysis and behaviourism, and also a number of more recent alternative formulations that I shall address later.

1 Nature or culture?

Why is the attempt to connect the higher and ideal things of experience with basic vital roots so often regarded as betrayal of their nature and denial of their value? Why is there repulsion when the achievements of fine art are brought into connection with common life, the life that we share with all living creatures? (John Dewey)

Biological explanations

The recognition that the discipline of psychology may be regarded as a set of competing schools of thought poses the question: what distinguishes these schools? We have already alluded to one source of difference, the contrasting perspectives that are taken on the nature of scientific activity. A second dimension distinguishes those perspectives that stress humankind's biological inheritance and those that emphasise the social context of behaviour. The first perspective looks for continuity in behaviour between humans and other species whereas the second stresses people's social and cultural context and looks for behaviour that is distinctively human and that varies from society to society across time and location. No one since Darwin doubts that human behaviour has both biological and social aspects, but theorists differ considerably on the relative weight that they attach to these. Both positions can be traced to Darwin's influence. Many psychologists on observing some behaviour will ask what is its adaptive significance and whether similar behaviours or behaviours sharing apparently similar functions can be observed in other species. Such questions are often triggered by the assertion that some behaviour is a universal in the human species. For example, Berlyne has proposed a highly influential theory of aesthetics that takes as its premise that 'the psychologist cannot feel that he has completed his work and explained a form of behavior until he has placed it in a biological perspective, which means relating it to natural selection

and to learning.' (1971, p. 8) According to Berlyne a psychological theory of the determinants of responses to works of art must seek out its biological origins. His own theory emphasises the origins of aesthetic reactions in the adaptive significance of the animal's exploration of the environment. Given these assumptions Berlyne derives consequences and attempts to test for these. This approach has given rise to a considerable body of research, probably the most sustained psychological investigation of aesthetic reactions, and I examine this in chapter 2.

In response to this it could be argued that whereas works of art are conspicuous in all known cultures it is their diversity that is striking. Furthermore it can be argued that the term 'art' is being used here in a very loose way. Many if not most of these artefacts served particular cultural purposes in rituals of various kinds, such as military parades, religious ceremonies, initiation or marriage rites or other celebrations of transitions in human life, marking significant seasons or times of the year. Our notion of 'art' is only a local one in terms of history or culture and perhaps only members of our culture would look at these artefacts in this objective or disembodied way. These issues suggest a different kind of research exercise where one should try to understand artefacts by considering them in their context rather than searching for some universal principles relating qualities of the objects to affective response. An emphasis on the social dimension is associated in many cases, although, as we shall see, not in all cases, with a concern with the *meanings* of objects. However, no one would be satisfied with our understanding of a phenomenon if we could not offer *explanations*, if we did not have some theory about these meanings. This raises questions as to what this theory is to be and what methods will be appropriate for its investigation. I return to these questions in chapter 3.

I have suggested that different theories may be described along dimensions such as the biological–social dimension because I did not wish to convey the impression that we are forced to choose between either a biological *or* a social explanation. These represent opposite poles and each may prove to be more or less useful in enabling us to grasp particular phenomena. As philosophers of science have frequently pointed out, the value of a theory is in its usefulness: does it lead us to ask novel and fruitful questions? Does it illuminate some phenomenon by drawing our attention to neglected aspects?

Manufactured pleasures

Does it stimulate useful research? I will address these questions by considering in some detail two approaches to environmental design that have drawn upon the biological metaphor: Jay Appleton's theory of responses to landscape, and Oscar Newman's theory of urban environmental determinants of crime.

Preferences for landscape

The environment is more than the backdrop to the dramas of our everyday life, it can be a source of affective responses ranging from interest and enjoyment to rapture, alienation or horror. The growth of mass tourism is indicative of the pleasure that can be obtained from exploring different places, and the extreme reactions that can be elicited by proposed changes such as the demolition of a traditional building and its replacement by a contemporary one, or plans to route a motorway through a 'beauty spot' are expressive of the strong feelings that we have concerning our environment. One particular source of pleasure is landscape. Clearly there are many different responses to landscape. One can imagine conditions of life in, say, the Dorset described by Thomas Hardy, where the intense relationship of the farm worker or the reddleman to the countryside would be trivialised if described in terms of 'enjoyment'. What has been found to be pleasurable in landscape has changed over time. Here one might think of the 'discovery' of the wilderness as a source of pleasure as opposed to the 'picturesque'. There are close links between art and landscape. Nature and the countryside are celebrated in the art of many cultures. The experience communicated by artists modifies the perceptions of others, as is evident, for example, in the influence upon eighteenth-century English taste in landscape design of the paintings of Claude Lorrain (1600–82) encountered by estate owners making the Grand Tour. Our contemporary Romantic taste owes much to the 'Lake Poets', William and Dorothy Wordsworth, Coleridge and Southey, and their writings about the Lake District in Cumbria.

What gives rise to our feelings for landscape? Should our account emphasise these differences in style and taste or are there more universal principles at work? This last position is stressed by the geographer Jay Appleton in his book *The Experience of Landscape*, where he attempts to explain preferences in terms of physical and

symbolic qualities of the environment. The starting-point for his approach is the recognition that animal survival depends on successful adaptation to the environment. The search for food, competition with other animals and other species, sexual selection and courtship, and finding places for breeding and raising the young all entail an interaction between the animal and its habitat. Successful adaptation requires behaviours such as exploring the environment and seeking shelter and escape routes. Appleton proposes that there is a degree of continuity between humans and other animals in these behaviours: 'If we share with animals a desire to eat, to drink, to sleep, to mate, to seek shelter and to escape from danger, is it reasonable to believe that we have inherited all these inborn desires but that, for some reason, the spontaneous awareness of the perceived environment which is such a conspicuous feature of all the higher animals, has "dropped out"?' (1975, p. 67). He answers this question in the negative and suggests that the principal problem facing the researcher is to analyse the properties of the environment that give rise to this spontaneous awareness. His solution to this problem is termed Prospect–refuge theory.

Prospect–refuge theory

This theory rests on the assumption that environments have significance in terms of the opportunities that they afford to 'see without being seen' (Appleton, 1975, p. 70). That is, the opportunities to satisfy needs are heightened where the animal can obtain a clear view of its environment, as when hunting or having sight of potential threat in advance, and where the animal itself reduces the possibility of being seen, as when stalking a prey or hiding from an adversary. Similarly a shelter or safe place for sleeping, resting, feeding or rearing the young is more successful to the extent that it is hidden and that it provides the opportunity for surveillance. Accordingly it is imperative for the animal to seek out such refuges and to interact with the environment in such a way as to maximise opportunities for observation and minimise opportunities for being observed. It would follow from the assumption that there is continuity in behaviour between human and other animals that the human environment might have similar significance, and that the landscape might have meaning to the human in respect of its affordability for seeing (prospect) and hiding (refuge). Appleton (1975, p. 73) summarises the relationship

between these qualities of the environment and the individual's aesthetic reaction:

> Habitat theory postulates that aesthetic pleasure in landscape derives from the observer experiencing an environment favourable to the satisfaction of his biological needs. Prospect–refuge theory postulates that, because the ability to see without being seen is an intermediate step in the satisfaction of many of those needs, the capacity of an environment to ensure the satisfaction of *this* becomes a more immediate source of aesthetic satisfaction.

However, the theory also recognises discontinuity between the human and other species. Among many cultures the human's interaction to the environment is such that many of the threats to survival are no longer salient. Also, humans have the capacity for language and can represent the environment in symbolic terms. Nevertheless, Appleton argues that recognition of these differences does not undermine the basic proposition of his theory. The environment can offer direct evidence of prospects, refuges and hazards, but it can also symbolise these at different levels. A landscape painting is not in itself a landscape and in a sense all the information that it conveys about place is symbolic. It may present a vista or prospect as in depicting, say, an extended view from high ground; alternatively it may depict a distant mountain topped with a tower, and this too would be symbolic, hinting at a further prospect not itself included in the picture. Similarly cottages in a valley or overhanging trees might stand for refuge. Of course we learn to understand symbols as we learn to interpret pictures, but this in itself should not be seen as invalidating the theory; the theory does propose an innate response to landscape, but this concept should not be interpreted too narrowly. The theory is about perception of the environment (Appleton, 1988, p. 35). All perception involves categorisation, and it can be argued that prospect and refuge are innate categories that are brought to bear on perception of the environment. It will be a question of learning which objects and environmental features will represent members of these categories.

Appleton then proceeds to derive a scheme for analysing landscape in terms of the key concepts of prospect and refuge, and of hazard, or the dangers against which the organism seeks to protect itself. I shall set out some brief definitions and selections from the analytical scheme in order to illustrate the approach taken. Landscape

can be described in terms of many qualities, its scale, its light and shade, its shapes and substances. We concentrate here on Appleton's scheme for the categorisation of shape or form, and on the concepts of prospect and refuge. Limitations of space (on the page rather than in the landscape!) preclude consideration of categories of hazard and further details of the classification scheme.

A prospect refers to what can be seen from an observation post that commands a view of a piece of country. The extent of view that can be obtained is termed its *fetch*, and this dimension can serve to distinguish open and closed prospects, where the latter afford only restricted views, those of short fetch. Prospects can be direct or indirect. The former category includes those views directly observed from a particular location, and can be further subdivided into *panoramas,* broad and extended views, and *vistas*, that is, views that are bounded by conspicuous edges or margins. Indirect prospects are symbolic, as in our example of the tower on the distant mountain; they suggest, rather than provide views. The views that are provided are labelled *secondary panoramas* and *secondary vistas*. One kind of secondary vista that should be mentioned here is *deflected*, in that the continuity of perception of a direct vista is impeded by a change in direction in such a way that its continuation can only be anticipated; the point of change suggests a vantage point for further vistas.

Various types of refuges are proposed. A distinction is drawn between *hides*, whose essential function is to prevent the organism from being seen, and *shelters* which offer protection from wind and rain, heat and cold. Refuges can be natural or artificial; they may be caves or holes in the ground, forests (vegetation refuges) and nebulous refuges such as mist or smoke. Finally a relevant consideration is the degree of accessibility of the refuge.

The landscape painted by Richard Wilson in the eighteenth century (Figure 1) illustrates several of these elements of the scheme. In the foreground there is a refuge which affords a panorama over the lake and distant hills. The tower on the hill hints at a further prospect between its hill and the distant mountain. A similar suggestion is provided by the figure on the crag above the tent. There is also evidence of deflected vistas in that the continuation of the lake can be anticipated behind the rocks on the left foreground, and the spectator can imagine that this vista opens up for the figure on the crag.

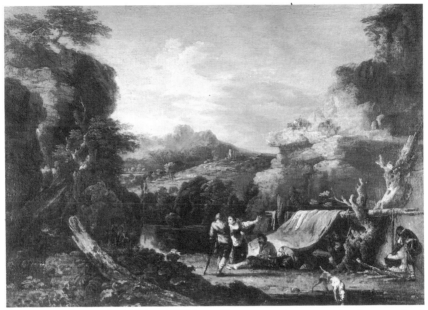

1 This landscape by Richard Wilson illustrates elements of refuge and of direct and indirect prospects

Any given landscape can of course contain a number of prospects, refuges and hazards of different kinds, and this will give rise to relationships among these elements such that their interaction may influence aesthetic reactions. Appleton labels some of these potential relationships. For example, *reduplication* is the relationship where two symbols of the same kind reinforce one another. The artist or landscape gardener may use reduplication to heighten some quality of the environment, augmenting the sense of prospect or of refuge, for example.

Communicating about the environment

Thus far we have considered a scheme that provides an opportunity to describe qualities of a landscape, whether a natural environment or the depiction of one. Such a scheme has many potential uses, enabling people to discuss and compare different landscapes, and to communicate significant features of the environment with each other. Any method of improving communication is of considerable utility, as it can be very difficult to describe environments in words, particularly

when the reference is to a potential rather than an actual place, as when plans for new buildings or roads are being evaluated. These difficulties can be reinforced when the interaction is between lay-persons and design experts, where the latter will have developed their own jargon and forms of communication, including plan and elevation drawings, which may be very difficult for the lay-person to interpret. Furthermore, professionals can often be unaware of their own expertise, so that they find it difficult to make allowances for the non-expert and fail to appreciate that the conceptual model that they have in their head, their drawing-board, or lap-top computer may not correspond to the model available to the person who lacks specialised training.

Several attempts have been made from time to time to overcome these difficulties. For example, development proposals can be simulated. McKechnie (1977) offers a typology of different types of simulation. There are conceptual simulations where researchers attempt to provide a model, perhaps a mathematical model of some proposed environmental change, where the consequences of the change can be traced. Thus the impact of the construction of a new road upon traffic flow in a village can be investigated through the analysis of sets of equations. Alternatively one can distinguish concrete or perceptual simulations such as scale models, artists' drawings, architects' plans, computer displays and so on, which will provide in two or three dimensions some 'picture' of the environment or of at least some of its features. Simulations can also vary in the degree to which they represent static or dynamic features; instances of the first type present a single unchanging view of the environment, whereas instances of the second type permit the consequences of any changes, including unforeseen consequences, to be incorporated. An example of such dynamic simulations are McKechnie's Berkeley Simulator, which incorporates a scale model of the environment through which a video camera mounted on a gantry can move in three directions to provide a range of different views. Lawrence's system provides a full-scale mock-up of modular houses based on lightweight, movable blocks, where potential residents can investigate the consequences of different arrangements of the modules.

Appleton's scheme provides a useful means of describing landscape, the more so because the scheme is based upon an explicit theory of human responses to landscape. Why is this important?

Consider that any simulation is only a model made to resemble the environment and not the environment itself. It offers a resemblance by selecting some features or elements; only the actual environment presents all features and elements. This raises the questions of how the selection is to be made and whether any given selection is as meaningful to the target person as it is to the selector. In many cases the selection is made to convey technical information from one expert to another, from the architect to the surveyor or builder, from the landscape designer to the gardener. A simulation would be a more effective means of communication if its selection were based on the most meaningful features, and that requires some theory as to where the meaning of landscape is to be found. This is not to say that Appleton's theory is the correct one, but it is promising to the extent that it is comprehensive, in providing a detailed description, flexible in describing all kinds of environments and requiring no specialist equipment, and close to people's own experience, in largely avoiding highly technical language.

Testing the theory

How can the correctness of the theory be established? The classical scientific method is to generate specific hypotheses from the theory and subject these to empirical tests. The truth or falsity of a particular hypothesis would not in itself validate or invalidate the theory but it would increase or diminish our confidence in it. Eventually we might have very little confidence in it or have greater confidence in some alternative formulation. One source of hypotheses would be the theory's position on people's preferences for landscapes. As we have seen, Appleton's scheme provides means for describing landscapes. It also permits the selection or construction of landscapes with specified properties and this can enable a more rigorous test of hypotheses. More generally, Rachel Kaplan (1985) has argued that the analysis of experiments in which people assess the environment on simple rating scales can provide insight into how people perceive and implicitly categorise the environment. For example, studies that have elicited ratings of preferences for a range of photographs of urban and rural scenes suggest that people prefer a balance between 'natural' and human-built habitats. They appreciate environments that appear natural but are the outcome of some design process ('landscaping') and they like least those that appear to have been

produced by intensive human intervention. Their judgements of the natural environment also reflect spatial definition, in that they are sensitive, for example, to apparent routes through the landscape, and, more generally, to human adaptation to the landscape:

> It is apparent that in the rapid and largely unconscious decision regarding preference, there is an assessment of the glimpsed space and its qualities. This rapid assessment appears to be heavily influenced by the potential for functioning in the setting. Thus, indications of the possibility of entering the setting, of acquiring information, and of maintaining one's orientation emerge as consistently vital attributes. (Kaplan, 1985, pp. 174–5)

Kaplan uses the experimental method here as a means of exploring a domain where the richness of potential information precludes any obvious means of prior categorisation. Appleton's theory proposes a categorisation but this has to be related to statements of preference. A study by Jack Nasar and his associates (1983) suggests the form of such experiments. Four sites were identified on a university campus that afforded either an open or a closed prospect of wooded parkland from an observation point (refuge) that was either protected by a concrete alcove or not so protected. A sample of college students rated how much they liked these prospects and how safe they were. As the theory predicts, their judgements were influenced by the location in which they were elicited; the safest view was where an open prospect was seen from an open observation point. However, preference judgements were as much influenced by the personal characteristics of the participant as they were by the location, implying a more complex relationship between preference and landscape than the theory proposes. Some research carried out by Woodcock at the University of Michigan and cited by Stephen Kaplan (1987) also offered only partial support for the theory: scenes that depicted direct prospects were preferred; indirect prospects and secondary refuges were only preferred for some landscapes, and primary refuges were generally disliked. Unfortunately, little research of this kind has been carried out. One reason for this may be that the theory does not make sufficiently precise predictions about the relationship between the variables of prospect and refuge and preference. It may prove to be more useful for interpreting responses than for making predictions about them.

Two further limitations of the theory should be mentioned here,

both of which are concerned with its incompleteness. The first is its neglect of formal properties of landscape. The painter, for example, unlike the photographer, rearranges the scene for purposes that cannot be explained solely by reference to prospect and refuge. Such considerations as balance, symmetry and so on play a part in the composition, and spectators are clearly sensitive to such qualities of landscape. Indeed viewers may even be sensitive to factors such as the right–left orientation of a picture (Gordon, 1981). Presenting a picture in reverse orientation can affect its appreciation, even though the formal relationships within the picture, and of course its prospect and refuge values, remain unchanged. The painter would also of course be concerned with colour and colour relationships in the picture. Thus a complete account of preferences for landscape pictures would need to incorporate a range of pictorial factors in addition to their residual adaptation significance.

The second limitation concerns the psychological meanings that can be evoked by landscape. Appleton is surely correct in highlighting the adaptive significance of the environment, and an atavistic perspective can draw attention to influences upon emotional reactions that would otherwise be neglected. However, human emotions are extensive and complex, and there will be countless ways in which landscape can connect with these emotions. One individual may see the same scene in many different lights; for example, a farmer appraising the state of the harvest, estimating the value of the estate, imagining it through the eyes of another, seeing it again after years of absence or prior to leaving it for ever, or recalling a love-affair, and so on. Consider the uses to which the description of the landscape is used by Thomas Hardy in novels such as *The Return of the Native*. In his introduction (to the Macmillan edition) Derwent May comments on how 'Hardy suggests with wonderful art the states of mind that this landscape [Egdon Heath] can so vividly reflect and isolate – moods of desolation or subdued peace that the characters are in due course going to experience'. The heath shapes the lives of the characters, particularly those whose livelihood depends upon it, but more than that it has a deep psychological and symbolic significance beyond the prospects and refuges, even though these presumably had real significance for the characters. The complex experience of the fictional landscape will be crucial for many readers' understanding of the psychological life of the characters. It is

possible for the contemporary reader of Hardy to visit these sites or what remains of them, armed with one of the many guidebooks available, and to reflect afresh on these landscapes, perhaps from the very same observation point as did Hardy or his reddleman. In what sense is it the same prospect?

Personal spaces

One of the most intensively studied aspects of adaptation to the environment has been territorial behaviour. More generally there has been sustained interest in animals' use of space and in analogous behaviour in humans. There seem to be regularities in the distance that members of the same species routinely keep from one another, and observation of human interaction in natural settings reveals similar phenomena. Such behaviour is of obvious interest to architects and designers of buildings, and research into this has been stimulated by Robert Sommer's key book, *Personal Space*, published in 1969. The reality of this phenomenon for humans is easily demonstrated; we may be just as angered by the person who sits too close to us on the beach as by the person who kicks sand in our face. The phenomenon seems trivial but explanations of such behaviour may be more complicated, as it is apparent that there are marked cultural differences in preferred interpersonal distance.

A related phenomenon is territorial behaviour, which is a more specific use of space, referring to the marking out, occupation and defence of a particular place. Such behaviour has been shown to be valuable for the survival of a species, in playing a part in regulation of the population, controlling the spread of disease, reducing sexual conflict, distributing the population, and so on. The application of this concept to human behaviour has been controversial. The sociobiologist Robert Ardrey popularised the notion in his book, *The Territorial Imperative* (1966), and made strong claims for its explanatory value. Research soon demonstrated that there seemed to be something akin to human territorial behaviour, particularly in institutional settings such as prisons, barracks, and residences for the elderly (Edney, 1974, provides a critical review of this earlier research). The application of this concept to environmental design has been stimulated by Oscar Newman, an American architect, in his influential book *Defensible Space* (1972).

Manufactured pleasures

Newman's concern was with the escalating crime rate in American cities, and he proposed that design was an important contributory factor to crime. His approach draws upon earlier work by Jane Jacobs (1961) who had used observational methods to examine the characteristics of neighbourhoods with high crime rates. She stressed the role of urban design; crime was discouraged where the environment was arranged to allow residents to maintain satisfactory levels of contact with others, through such means as opportunities for casual surveillance – 'eyes on the street' – and shared and frequently used pathways – 'sidewalk life'. She emphasised design features that reinforced community life. Newman proposed that four elements contributed to a safe environment: the territorial definition of space, opportunities for surveillance, the avoidance of building styles and materials that suggested the vulnerability and isolation of residents, and the location of developments away from threatening areas. Newman argued that traditional designs for houses had implicitly recognised the value of such features, which could be recognised in the buildings of the past and in different cultures, where territorial claims were typically expressed more by symbolic than by defensive means, through the use of porches, doorsteps, hedges and fences. However recent mass housing developments, particularly high-rise apartment blocks, had broken this link with the past and consequently, if unwittingly, had provided opportunities for anti-social behaviour that previously could be controlled.

In support of his thesis he reported crime statistics from two adjacent housing estates in New York which were similar in housing densities and in the socio-economic characteristics of the residents. One estate, Van Dyke, comprised mainly the high-rise double-loaded corridor blocks that are for Newman the prototype of non-defensible space; the other, Brownsville, was of mixed design and included many medium-size blocks where entrances served only a limited number of apartments and were naturally overlooked. Both estates had high crime rates, but that of Van Dyke was markedly higher. Further evidence took the form of crime statistics for the city of New York, particularly those related to the location of incidents within estates. Crime rate per capita correlated positively and significantly with the number of floors in a block, even when the increase in number of residents associated with increased height is allowed for. Crimes take place largely in lifts, places that lack territorial

definition and surveillance; more generally they occur in walkways, stairways and locations that don't 'belong' to anyone.

Newman's thesis has encouraged research and has also attracted hostility. We shall briefly survey relevant research before examining criticisms of the approach, particularly where those criticisms oppose biological perspectives in general and where they will serve to introduce alternative approaches. The evidence presented by Newman has been criticised for being selective, and for including only favourable findings. However, several independent studies seem to provide some support for the theory. Krupat (1985) reviews a number of American studies that have related measures of territorial definition to residents' perceptions of their environment and objective crime statistics, and that have identified a correlation between design characteristics and crime. Brown and Altman (1983) report a study where the researchers visited suburban homes that had been burgled within an eight-month period and were matched with similar but non- (or not yet) burgled homes. Despite the fact that the crimes had taken place in the past there were still statistically significant albeit rather small differences between the two groups of houses, and these differences could be linked to measures of surveillance and symbolic territory barriers. This study suggests that the concept of defensible space is not restricted to high-rise or high density inner-city housing. A study of vandalism in London housing estates carried out by Wilson (1980) found that building height (in terms of numbers of storeys) predicted the incidence of vandalism, and most incidents had taken place in non-overlooked public areas like lifts, stairways, roofs, and garages.

Perhaps the most sustained investigation has been carried out by Alice Coleman and the Land Use Research Unit at King's College, London, in their survey of council housing estates in London and Oxford. Fifteen design characteristics were examined, including eight specifically identified by Newman. These included building size, walkways, lifts and staircases, positioning and type of entrances, and spatial layout, all related to territorial definition and surveillance. An overall 'design disadvantagement' score could be derived from measures of these characteristics. A team of observers visited the estates and recorded the amount of visible vandalism, graffiti, litter and excrement, giving rise to separate and total indices of abuse. Interviews were also conducted with residents, and measures of

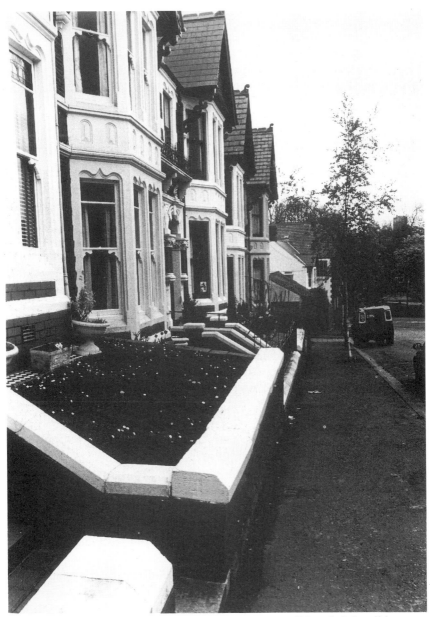

2 This terrace of Cardiff houses demonstrates traditional defensible space features of surveillance from windows and the symbolic marking of territory with front wall, private garden and porch

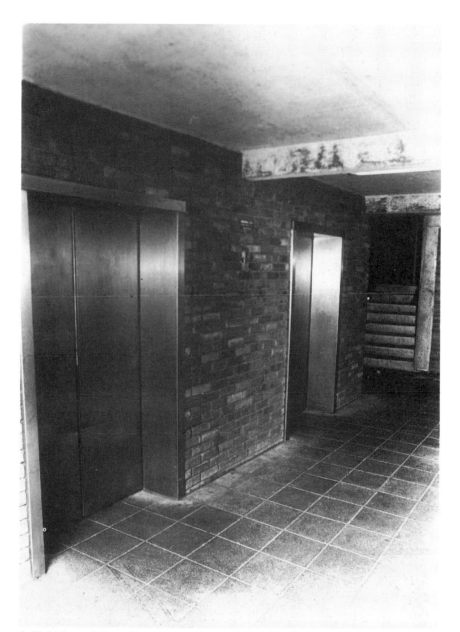

3 British and American research confirms that lifts and lobbies are prime locations for crime and vandalism. This example is poorly designed in terms of all four of Newman's defensible space features

socio-economic status recorded. Once again, the broad outlines of Newman's position were supported. Overall, the disadvantagement score correlated significantly with the total abuse score. The specific design features most associated with abuse were number of storeys, number of dwellings served by an entrance, corridor types, and lifts and stairways. The features identified by Coleman have been incorporated in design guidelines published by the Home Office (with slogans like 'Individual front gardens encourage responsibility'; 'Proper fences create a sense of privacy'; 'This is the alley that scared the child who told the teacher who spoke to the police who contacted the owners who asked the builder to make it safe'). Many Local Authorities have invited Coleman to recommend improvements for their housing estates.

Despite the apparent vindication of the argument that human territoriality is associated with the contemporary use and abuse of buildings, it attracted criticism from the outset. It is argued that the notion of territoriality is poorly defined. The relationships among the four elements of defensible space are not specified, and these may contradict one another; increasing territorial rights may decrease surveillance, for example. The thesis neglects any consideration of the people involved, and is an instance of architectural determinism, the idea that people are moulded by their environment. Neglect of the people involved extends to the perpetrators of crime, who remain invisible opportunists in Newman's book. Mawby (1977) has argued that there is a strong relationship between offence rates and offender rates, in that most incidents take place close to where the offenders themselves live, and this variable must be taken into account in any explanation of the incidence of crime.

The residents too are ignored and insufficient attention is paid to socio-economic characteristics that are correlated with crime and vandalism rates. There is an implicit suggestion in the defensible space thesis that people somehow choose their environments and, once chosen, these then mould their subsequent behaviour. However, the fact is that these are studies of poor quality housing which is allocated to families who tend to have little choice of accommodation; the studies are largely of American public housing and British council housing. Crime rates were high in both the New York estates studied by Newman, and both included a large proportion of the economically deprived. In Coleman's research socio-economic

characteristics were associated with abuse scores. In Wilson's study, 'child density was the single most important factor in explaining variation in the observed vandalism rate' (1980, p. 52). It must be said that these correlations have added significance in that they are found *within* a population that is already likely to score low on socioeconomic indices.

Ellis (1982) rejects the architecturally deterministic character of defensible space, proposing instead that people impose their own meanings on the environment rather than react passively to it. He argues that even when researchers have interviewed residents they have done so in terms of their own frame of reference rather than attempting to identify the residents' point of view. Finally, E. Wilson (1991, p. 153) rejects the implications of the biological basis of the approach:

> He [Newman] argued that individual residents were more prepared and better able to police space surrounding their dwelling if it belonged to them, and developed a concept of 'territory' that was taken up by Alice Coleman. This relies on a profoundly reactionary belief that human beings, like certain animal species, have an inbuilt 'territorial instinct' and will only defend their own territory. The reverse side of this belief is that there can be no public or social responsibilities or obligations . . . Pitched roofs, red tiles and ornamental brickwork symbolise an unbalanced explanation of the ills of public housing – unbalanced because deep-seated causes such as poverty, unemployment, alienation and isolation are left out of the picture, pushed aside by racial and gender stereotypes and fantasies of a lost past.

There are several senses in which theories like those of Newman and Coleman may be said to be 'reactionary'. One argument is that they denigrate people as selfish and self-centred, having little concern for others. A second is that the theories represent the conservative view that ownership of property is the key factor in attitudes towards it. Theorists hanker after an ideal of a golden past that ignores the realities of contemporary urban life, as in, for example, the contributions of the Prince of Wales to architectural debate as reflected in Leon Krier's plans for the expansion of the English town of Dorchester as a set of small self-sufficient wards built in traditional materials (Cruikshank, 1989). There is an obvious correspondence between the Newman thesis and the Prince's view as delivered to the 1988 Remaking Cities Conference: 'Man seems to

function best in small recognisable units – hence the village – where he is part of a community of people to which he can relate' (reported in Architectural Design, 1988, 58, IV). Undoubtedly any explanation of the problems of urban living must take into account the economic inequalities that are at the heart of social problems of all kinds, and a simple-minded pursuit of panacea does as great a disservice to the most deprived groups in society as does the search for scapegoats. Finally there is the fear that notions of territory and territorial rights can be recruited to provide a justification for nationalist and racist views that provoke discrimination and violence against foreigners, immigrants, 'guest workers' or others who are perceived as 'not belonging'.

It is, I think, a misrepresentation of Newman's thesis to identify territorial rights with property ownership, as these can just as well be a function of communal living as of private property. Gauvain, Altman and Fahim (1984) provide an example from Tarong in the Philippines. The community is connected by a system of footpaths but the paths adjacent to houses are controlled by their residents in that users are obliged to ask permission to pass. A similar phenomenon can be seen in 'temporary' territories where a passer-by might wait or ask for permission to pass between a photographer and his or her subject or between a customer and a shelf of goods. Is reference to innate territorial 'instinct' in itself reactionary? First it should be said that there may be alternative explanations of the findings reported by 'defensible space' researchers, and we should distinguish between challenging the findings and the thesis. Second, in itself a biological explanation is neutral, unless it is seen as overriding all the factors that contribute to the complexity of human social life. Indeed people may be more trapped by their socio-economic circumstances than by their biological endowment, as is evident in the wars and famines that are the scourge of much of the world and whose historical origins are plain to see. It is often forgotten that a proper biological explanation takes into account the *differences* between species and between individuals and is not an assertion of their inherent similarity. It is clear that territory serves different functions in different species (the invasion of others' territories that is so evident in human history is not at all widespread in nature) and that the symbolic function is critical in explaining human patterns of behaviour.

For example, the *eruv* is, for many Jews, an enclosure of walls or of symbolic walls that defines a community. The physical space enclosed may be a district of a city whose population includes both Jews and non-Jews: Capitol Hill including the White House is within an *eruv*. In practice it marks out an area through a combination of natural boundaries like rivers or roads and symbolic barriers, like thin wire stretched between a series of poles to indicate a fence. For those who are not aware of its significance the enclosure may not even be noticed, but it will have clear implications for the behaviour of believers, allowing them to participate in activities that would otherwise be prohibited on the sabbath. More generally, it serves to reaffirm the faith of believers and to strengthen their identification with other members of their religious group. The *eruv* has symbolic significance but it is more than that, in that it is an actual place. There is no uncertainty about the extent of its enclosure and it would not be sufficiently defined if its boundaries had to be imagined.

Privacy and personal identity

Alternative perspectives have been adopted on human attitudes to control of space. Altman has suggested that among humans territory serves functions of enhancing a sense of personal identity and regulating privacy. Privacy is regarded as a dynamic process directed towards maintaining control of social interaction, so it is not only a means of keeping people out of one's territory. Many of the features of buildings that have been considered as territory markers or defences can equally be interpreted as providing the opportunity to monitor potential social interaction rather than merely shut it out. This approach also views territorial behaviour as only one of many mechanisms that can be used to regulate social interaction. Other mechanisms include verbal behaviour, gestures, posture and signals such as avoidance of eye contact. This point about the equivalence of different behaviours is an important one. For example, those who adopt the biological perspective emphasise the nature of people's responses to an invasion of their physical space, as when someone comes too close to them or their territory, or when they occupy their seat or trespass on their land. However, consider the case of sexual harassment. Certainly this unwanted intrusion can take the form of excessive physical closeness or unwanted touching, but it can just as

well take the form of what someone might say or insinuate. It is the intentions of other people and our response to these that count, not the particular action. The anger that we feel in cases of intrusion or harassment is better understood in terms of what Harré (1979) calls the moral order. People believe that they have rights and entitlements, and anger is their response to breaches of these rights. The conventions for appropriate behaviour include an entitlement to personal space and to recognition by others of our right not to be harassed, and this is sufficient to explain the anger that is experienced without any need to draw upon a concept of innate territorial needs.

Gauvain *et al.* (1984) conceive of privacy regulation as a dialectic concept, in that it is a system of opposites that are in dynamic relationship. In the case of privacy there is a contrast between openness and closedness. The degree of openness desired will vary from one occasion to another, and hence the means of regulating privacy will need to be flexible and adaptive. The concept of dialectic is extended by Altman and Gauvain (1981) to compare the design of homes in different cultures. They regard the underlying tension as between individual needs and desires, on the one hand, and societal pressures on the other, and this gives rise to a second opposition between identity and communality. Altman and his associates have used these oppositions as a framework to analyse the homes of different societies, and the study by Gauvain *et al.* (1984) examines how Nubian people in Egypt, who were forced to move to new accommodation because their village would be flooded by the construction of the Aswan Dam on the Nile, modified their new homes to reflect a preferred balance of openness and of individuality.

These concepts have wide applicability for the analysis of environments. Consider the more familiar example of an adolescent's bedroom in a family house. The location of the bedroom already serves to regulate openness since it is typically placed upstairs (or away from the entrances in a single-storey dwelling or apartment) but even within the family the young person and/or parent will take steps to regulate the free access that a parent has to the room of a child. This may be done by negotiated agreement and reinforced by a closed door or a humorous (?) 'Keep Out' sign. Within the room, drawers, letters and diaries might be regarded as out of bounds to anyone cleaning the room. This is a dynamic process in that the preferred level of privacy will be variable and different means

are available to regulate it. Typically the young person will decorate the room with posters and personal belongings. Although there is individual variation in this, including gender differences, typically an effort is made to distinguish the room from the other rooms in the dwelling. While the choice of decoration will reflect personal interests and tastes it will also reflect the person's ties with peer groups and their interests – the pop posters, records, football pictures will be topical and their significance will be a shared one. The design of houses reflects similar processes of identity and community. Modern semi-detached houses are often built with mock-Georgian or Tudor features to emphasise their continuity with past traditions, yet their owners immediately introduce 'unique' features and invite their friends to admire their alterations. In traditional terrace houses, a room was frequently set aside as a 'best room', seldom used except for special visitors or occasions, and furnished with family heirlooms and mementos. The front doorstep was very significant, as is the threshold in many cultures, and it would regularly be scrubbed.

The regulation and control of openness and identity are not ends in themselves, and Altman suggests that they serve to maintain the person's identity and feelings of self worth, issues to which I return in a later chapter. The relevance of these to identity and status can be briefly illustrated by considering that people's status in an organisation is often correlated with their right to control access to their working space, to have sole rather than shared occupancy, and to be permitted the privilege of 'personalising' or having a say in the design of their space. These privileges are not restricted to the use of space but are also revealed in personal appearance and clothing; senior medical consultants will forgo the title of doctor and the white coat and stethoscope that are so important to the identity of the junior, and instead choose to emphasise their personal name and clothing.

Home. The idea of 'home' is a complex one that cannot adequately be contained in the concept of territory. Clichés like 'there's no place like home' and 'home is where the heart is' suggest that it has a deep emotional significance, and while it often elicits sentimentality, affection and a sense of belonging and identity, it can also elicit a more intense emotional response. The idea of returning to one's home and 'roots' is a major theme in the world's literature, as is the notion of the exile, the person forced to live away from home. The

concept is not restricted to a dwelling but also encompasses one's home town and one's homeland.

An impression of the subtlety of the concept may be gleaned from analysis of the German notion of *Heimat*. This term refers to one's home or homeland but, as Applegate (1992, p. 65) points out, 'the word contains within itself a whole cultural history that its seeming simplicity and naturalness hides from both insiders and outsiders'. The concept was revived in Germany in the late eighteenth century and gave rise to organisations, to literary output, and to a general interest in objects that provided reminders of the continuity and vitality of people's roots, of rural life, folklore, and of community. It provided a sense of place-identity. These movements have added significance if we view them in the context of the industrialisation and urbanisation that accompanied the growth of the unified German state in the nineteenth century. Later, with the rise of the Nazis there was tension between different perspectives on the meaning of homeland, as the notion of home came into contact with the growth in nationalism and in modernism. In the post-war years there was continuing nostalgia for a rural life that had disappeared. For example, more than 300 *Heimatfilme* were made in Germany between 1947 and 1960 (Wickham, 1991). Today the meaning of Heimat is again problematic in the light of the unification of Germany. The concept of home can be a subtle one, related to cultural, economic and political factors.

Psychological research has investigated something of the breadth if not yet the depth of the concept. Sixsmith (1986) invited people to provide her with descriptions of their present and past homes, and categorised their responses. There seemed to be three basic dimensions of meanings. Personal meaning reflects the values places have for a sense of personal and family continuity, as the location of significant milestones in personal development, and as providing an opportunity to relax without being required to put on a 'front'. The social dimension of meaning emphasises the home as the centre of the family and as somewhere to which to invite one's friends. The physical dimension emphasises the person's familiarity and comfort with the design and fabric of the place.

The concept of home should also be treated in dialectical terms as it acquires much of its meaning from the contrary notion of

'not-home'. Home is the place that people leave to discover themselves, just as the mother-figure provides the young child with a base from which to explore. The lack of a secure base produces timidity and uncertainty, but, equally, an inability to leave home is a failure to realise one's potential. According to Bowlby (1988) the early experience of 'home' provides a model that, consciously or unconsciously, guides future transactions with the environment. People leave home to find themselves, and also at times of stress. Again, literature provides many examples of the significance of travel and wanderings dating back to before 700 BC when Homer described the journeys of Odysseus. Travel was undertaken even at times when it was difficult and dangerous, and by people who were more vulnerable or who defied convention in order to do so – see Robinson's account (1990) of women travellers and explorers across many centuries.

Leaving home symbolises a turning-point in a person's life. In his film *Heimat* (1984), Edgar Reitz explores both the literary and cinematic traditions of the concept from the First World War to recent times, and traces the fortunes of the Simon family through several generations. The film contrasts home with 'not-home', *das Fremde*, both through outside influences which come to the village – soldiers in the war, the building of the highway, radio and telephone, industrial development – and also by people leaving the community. Thus in the first episode, *Fernweh* ('the call of far away places'), the young Paul Simon leaves the village without any warning and emigrates to America, subsequently to return as a rich industrialist to influence the lives of his children. Leaving home to take part in the Second World War has profound effects on the Simon children, effects which shape their lives and that of the community when they return to the village. Throughout the film these arrivals and departures are set against the stability of the *Heimat*, the continuity of old ways of life. Thus the second episode is entitled *Die Mitte der Welt* (referring to the local inhabitants' belief that their village is the centre of the world). This continuity is threatened by the modernisation and industrialisation of post-war Germany, bringing up to the present the theme of *Heimat* which, as we have seen, experienced such changes in the last century.

There are countless examples of the theme of the psychological

significance of a sudden tearing away from one's roots. The heroes of John Updike's *Rabbit, Run* and of James Kelman's *A Disaffection* each set off on a car journey at night, without any clear purpose or destination, at a key point in each novel. Television's *Coronation Street* character Don Brennan responds to an amorous rejection by driving recklessly into the countryside, again at night and without a destination in mind.

Finally, no discussion of territory would be complete without consideration of nomads and travelling people who, by definition, have no fixed home and who have sustained this way of life across countless generations. Chatwin's compelling examination of Australian Aborigines, *The Songlines*, draws upon literature, mythology, folklore and anthropology to advance the thesis that the human is essentially a migratory species, and that this is reflected, for example, in the invariably hostile references to settled urban life that are found in early sources such as the Old Testament.

Summary

We have considered the impact of the environment upon human experience from two broad perspectives – the biological and the social. We have examined these as exemplified by two approaches to environmental design that have drawn upon the biological metaphor, Appleton's theory of responses to landscape and Newman's theory of the role of urban design in crime. The value of these approaches is not that they are necessarily correct but that they can guide research that will have practical value and that have the potential to illuminate the complexities of human interaction with the environment. These theories have stimulated research and have contributed to the ongoing arguments that constitute the scientific method. The research they have encouraged takes many different forms, some of it objective and quantitative but some more subjective and qualitative. Opponents of the biological approach stress the cultural diversity that is to be found in apparently universal phenomena and assert the need to give due weight to the cultural and economic conditions that provide the context for the interaction between people and the environment. They propose that the findings of studies can be interpreted in terms of social relationships without the need for recourse to biological factors. According to this

perspective, it is impossible to do justice to concepts like home, *eruv* or *Heimat* relying on notions of place or territory that are drawn from studies of animal spatial behaviour. It is argued that humans inhabit a world rich in meanings, meanings that are connected with a tension between people's sense of identity and their sense of community. I shall return to this theme in chapter 3.

2 Form and design

Therefore let us call a face that launches a thousand ships a *Helen*. But what is a face that launches only one ship? Obviously a *millihelen*. There must be a rating for all other faces between those two that have any pretension whatever to beauty. (Robertson Davies, *The Rebel Angels*)

Formal laws of beauty

How can we explain people's responses to particular shapes, proportions and colours? If there are regularities in their responses are these acquired through learning and cultural convention, or are they innate and due to some inherent qualities of the human nervous system? These questions have intrigued psychologists from the birth of their discipline, and are central to the area of enquiry known as empirical or experimental aesthetics. The origins of experimental aesthetics can be traced to 1876 and the publication of Fechner's book, *Vorschule der Asthetik*. Fechner is regarded as one of the founders of modern psychology, and in the field of psychophysics, which was his pioneering attempt to investigate scientifically the relationship between mind and matter, he had formulated the first psychological laws to have a rigorous mathematical form and that were capable of being tested empirically. He believed that the question of the nature of beauty could be expressed in scientific terms, and he offered his own formal theory of beauty. However, he is best remembered for his recommendations of empirical analytical methods that included the study of people's reactions both to art objects and to specially constructed stimuli. This approach had two novel features. First, theories were to be tested against the judgements of samples of lay-persons, as opposed to the reliance upon the introspections of sophisticated judges that had characterised previous studies of aesthetics. The second feature was an analytical research strategy which held that objects could be broken down into their elements and that

causal relations could be identified between these elements and responses. These features have characterised most psychological research since Fechner's time.

One application has been an ambitious if ultimately unconvincing attempt to quantify the concepts of order, unity, variety and symmetry that have long characterised aesthetic discussion. For example, Leibnitz wrote in 1714 that 'Perfection [is] to obtain as much variety as possible but with the greatest order that one can'. The American mathematician Birkhoff expressed the relationship between preference [Aesthetic measure = M], order [O] and complexity [C] by the mathematical relationship, $M = O/C$, where order and complexity are defined in terms of measures taken on many-sided figures, or polygons, such as the number of sides, equality of angles, degree of vertical and rotational symmetry, and so on. A number of studies, critically reviewed by Zusne (1970, pp. 402–4), attempted to verify Birkhoff's equation for judgements of the pleasingness of polygons. These found, as ever, considerable variation in the preferences of different individuals, but there did seem to be a statistical tendency for people to prefer figures that are *both* complex and orderly and to be averse to those that are simple and less ordered, a result that is better described by a multiplicative relationship between order and complexity than by the Birkhoff ratio. Despite, or perhaps even because of the ingenuity and statistical sophistication of these studies they remain a footnote in psychology textbooks, and have had little if any impact upon the practice or discussion of design. They have been divorced from theory, in that such equations can at best only describe relationships. They offer no explanations. The aesthetic concepts that they tried to capture remain of interest, but different approaches have been adopted.

Before examining further research carried out within this paradigm, let me draw attention to a critical stance towards Fechner's analytical strategy, or 'aesthetics from below' as it has been termed. This alternative approach was that of the Gestalt psychologists, a group including Kurt Koffka, Wolfgang Kohler and Max Wertheimer who worked in Germany in the 1930s before being dispersed by the persecution that followed Hitler's consolidation of power. This group made substantial contributions to psychology as a whole, although they are now best remembered for their demonstrations of a range of figural phenomena that illustrate the importance of organisation

in visual perception. These principles of organisation were also applied to aesthetics, by Koffka in particular, and the influence of this approach has been promulgated by the American psychologist, Rudolf Arnheim, whose books, including *Art and Visual Perception* (1974) and *The Power of the Center* (1982), make important contributions to these debates. Later I shall examine two of the concepts of this group – the 'good gestalt' and the expressiveness principle, but first I should emphasise that this approach is fundamentally opposed to Fechner's premise that objects can usefully be broken down into their components. According to the Gestalt position, the whole is more than the sum of its parts, and it has an organisation that has its own dynamic properties that cannot be reduced to the parts or found within the parts. A melody has an identity for its listener that is not merely the sum of the successive notes, and it can be recognised despite missing notes or transformations and distortions in the notes. A vase is perceived as a vase even if seen from different viewpoints or when partly obscured by intervening objects. The same 'elements' can take on a radically different meaning or have a different perceptual quality, dependent solely upon perceived changes in their context, as in the classic figure–ground demonstrations that were explored by Escher. For example, one and the the same line can serve to depict either the cheek or the bridge of the nose in the well-known young woman/old woman illusion (see Figure 4). The Gestalt psychologists argued on the basis of these and related observations against any approach that proposed to examine parts of an object in isolation. I return in a later section to the positive recommendations of this group, but first consider the achievements of Fechner's strategy, concentrating on research stimulated by the golden section and on attempts to quantify traditional aesthetic concepts such as order and proportion.

The golden section

The golden section, also known as the ratio of Phidias, is expressed mathematically as the ratio $1 : 1.618$ (the colon here is a mathematical symbol to be read as 'to'), or alternatively as $0.618 : 1$ This ratio has many properties. If a line is divided into two parts so that the ratio of the smaller part to the larger part is equivalent to the ratio of the larger part to the whole, then the line is said to divide in its golden section. This can be expressed in symbolic terms. If *a* stands

4
Boring's *young woman/old woman* puzzle-picture

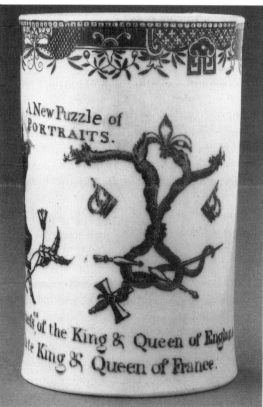

5
The depiction of the king and queen anticipates by over a century the phenomenon of figure-ground reversal explored by the Gestalt psychologists

43

for the length of the smaller part and b for the length of the larger part, then the overall length will be $a + b$. The golden section refers to the identity $a/b = b/(a + b)$. It can be demonstrated that if $a = 1$, then $b = 1.618$. If a rectangle is formed with sides in the ratio a/b then it is said to be a golden rectangle.

This ratio is ubiquitous. It recurs in mathematics; if one takes any series of numbers beginning with an arbitrary pair, say, 9 and 4, and constructed so that the next number in the series is always the sum of the two preceding numbers, as in the series 9, 4, 13, 17, 30, 47, 77, 124 ..., then the ratio of any two successive numbers gets progressively closer to 0.618 as the numbers increase in magnitude. The ratio $4/13 = 0.307$, $13/17 = 0.764$, ... $30/47 = 0.638$, $47/77 = 0.610$, $77/124 = 0.620$. The particular series that begins 0, 1, 1, 2, 3, 5 ... is known as the Fibonacci series, after Leonardo Fibonacci of Pisa, a mathematician active in the thirteenth century, and its properties have been extensively explored by mathematicians. The golden section and the Fibonacci series are not restricted to the realm of numbers. Huntley (1970) gives many fascinating examples from patterns found in the natural world, in the arrangement of leaves on plant stems, in the structure of petals and sea shells, in the honeycomb, in the genealogical table or 'family tree' of the honey-bee. It is also to be found in music, where, for example, listeners tend to find the musical interval known as the major sixth particularly pleasing: its ratio of frequencies is $512 : 320$, again close to the golden ratio (actually 1.60).

Further examples may be found if people are asked to make evaluative judgements. Consider the relative frequency of use of pairs of evaluative words such as good–bad, honest–dishonest, kind–unkind, where there is a positive evaluative word and a corresponding negative word. The negative may be *marked*, as in honest–dishonest and kind–unkind, in the sense that the negative is formed by the addition of an affix to the positive word. Research has identified a tendency for the positive member of the pair to be used more frequently than the negative, and if one looks more closely at the relative frequencies and assigns the number a to the frequency of the positive and b to the frequency of the negative, then the obtained ratio $a/(a + b)$ approximates to the golden ratio 0.618, particularly for marked words (Benjafield, 1984). To take a concrete example: If I ask you and a sample of people to draw up a list of your

6 Le Corbusier drew upon the golden section for the Modulor, the modular measurement scale that he developed for relating proportions in design to an idealized human form

acquaintances and to divide these lists into those whom you feel positive about and those you feel negative about, then a count of the relative frequency of positive and negative items that you produce will again reveal a division according to the golden section (Benjafield, 1992, p. 246).

The significance of the golden section for aesthetics was recognised in Greek cosmology, which held that the universe was coherent and obeyed fundamental laws. Concepts of number had a crucial role in this cosmology, as expressed, for example, by Pythagoras (*c.* 582–507 BC), so the notion that beauty could be captured in numerical relationships was a telling one. Phidias, who was largely responsible for the Parthenon, incorporated the golden section in various ratios; for example, its frontal dimensions (with pediment intact) forms a golden rectangle. Fresh attention was given to these relationships and their significance for aesthetic judgements in the Renaissance. Luca Pacioli (in *De Divina Proportione*, 1509) proposed that the golden section was the fundamental proportion in aesthetics.

In more recent times this proportion has received new emphasis. Le Corbusier was stimulated by contemporary discussions of the golden section to develop the Modulor (1948), a system drawing on the Vitruvian human figure and on the golden section to form a modular measurement scale for design. The system of modules is

based on a human figure, six feet or 183 cm in height, with the left arm extended above the head and the right arm stretching to the thigh. The total height of the figure including the raised arm is 226 cm, and this can be bisected at the navel. Following this section many of the further divisions approximate golden sections. The total height of the figure is divided at the level of the hanging wrist into the ratio 140/84 or 1.62. The ratio of the distance from the top of head to the navel (70 cm) to the that from navel to feet (113 cm) is 70/113 or 0.619. The Modulor can also be seen to incorporate the quasi-Fibonacci series, 6, 9, 15, 24, . . . and 11, 18, 30, 48, 78, . . .

It is difficult not to experience a sense of awe as these numerical relationships recur across a range of mathematical and natural phenomena, but is there evidence to support Luca Pacioli's assertion of the role of the golden section in aesthetic judgement? This question seemed to Fechner to be amenable to his analytical strategy. His approach was as follows. Ten rectangles of card, including a square and a range of different proportions of sides, were produced, and people were asked to choose the rectangle that they found most pleasing. Fechner reported that the rectangle with sides of lengths 34 and 21 (a ratio of 1.619) was chosen most often. It was not invariably chosen, however, and subsequent research into the aesthetic pleasingness of the golden section has not produced unambiguous results. It turns out that such studies are not as simple to conduct as they seem. For example, preference judgements among a set of figures of varying proportions are influenced by the range of proportions that are included in the set. Changing the proportions included will result in a different figure being preferred. McManus (1980) has conducted a number of experiments following Fechner's approach, where participants were asked to indicate their preference between pairs of simple figures differing in the ratios of sides. On average there was a preference for ratios close to the golden section, although the most frequently preferred figure was not actually the section itself but a ratio slightly discrepant from it. However, as in much previous research, there was only a statistical tendency towards preferring this ratio, and closer examination of the data revealed substantial differences between judges' preferences, in that there seemed to be groups of judges who shared preferences that conflicted with those of other groups of judges.

The presence of demonstrable differences between people's

judgements makes it difficult to believe in universal aesthetic principles such as the golden section. More recently, Boselie (1992) has offered even more damaging evidence against the golden section hypothesis. Participants in his study indicated their preferences for proportions based upon the painting by Mondrian, *Painting I*, that, according to Bouleau's analysis (1963), was constructed according to the golden section. Boselie redesigned the figure to substitute the ratio of 1 : 1.5 for the section 1 : 1.618, and also varied other aspects of the composition, such as the relative size, orientation and spatial relationships of its principal elements. If the golden section played a crucial role in the composition of the painting and in spectators' responses to it, then the change in the ratio would be expected to have a considerable impact on preference. This was not the case; it had in fact a negligible effect in comparison with the other compositional variations introduced by Boselie.

Advocates of the golden section could argue that these experiments fail to confirm preferences that do exist in the world outside the artificial conditions of the psychological experiment. Perhaps presenting people with a set of rectangles fails to elicit sufficient involvement, and the repeated presentation of quite similar stimuli may dull their perceptions or induce routine or stereotyped responses. The analytical strategy could itself be at fault in that preferences are related to, and cannot be abstracted from, objects in their context. In fact, supporters of the golden section are impressed at the degree of consensus in judgement that is revealed by these experiments and have looked for explanations as to why this particular ratio should be preferred to other ratios.

A variety of explanations has been proffered, ranging from the simple to the complex. People tend to prefer what is familiar, and many of the most frequently encountered objects in everyday life such as books, cards and envelopes are designed with ratios that approximate to the golden section. This of course raises the further question of what determined these particular choices of design to which we have become habituated – were they arbitrary choices made by designers, or do they themselves reflect preference for the golden section? Stone and Collins (1965) propose an account in terms of the construction of the eye, more specifically the shape of the binocular visual field, which is defined as what is visible when both eyes are fixed on a point. These researchers claim that the

average rectangle that can be imposed on the shape of the binocular field has a ratio of height to width of 0.665. However, an account purely in terms of visual perception is necessarily incomplete given the reality of the golden section in other sense modalities and in conceptual processes. Berlyne (1971, p. 232) proposed that the golden section 'allows the minor element to occupy a portion of the whole that makes it maximally striking', that makes it stand out or be salient. The notion of how 'striking' an event may be can be expressed in statistical terms within that branch of mathematics known as information theory, as we shall see. Within this theory an event is defined as having maximum informativeness when it occurs with a frequency of 36.8 per cent of occasions (this is a proportion of 0.368, or $1 - 0.632$).

The reader may have noted how consistently the proportions that emerge in these studies are somewhat discrepant from 0.618 or 0.382 ($1 - 0.618$), and research suggests that preferences tend to be expressed for a range of proportions that includes but is not restricted to the golden section. Tuohy and Stradling (1987) presented evidence on evaluative judgements to support their assertion that to have focused attention on the golden section may have been misleading and that the psychological effects are mediated by the relative informativeness of events. The difference between the golden section proportion of 0.382 and the information theory statistic 0.368 is small in numerical terms, but it may reflect a meaningful psychological difference, suggesting that quite different psychological processes underlie preferences. To summarise, research into the golden section hypothesis has obtained mixed findings. There are considerable differences among people in their preferences for shapes and proportions, but these preferences are not entirely arbitrary, and converge upon proportions that are quite close to, but consistently discrepant from the golden section. Explanations of tendencies towards particular preferences might be better construed in terms of the maximal contrast of proportions than in terms of the divine proportion.

The good gestalt

Gestalt psychologists are, as we have seen, opposed to the idea that perceived order and complexity can result from arithmetical

operations like addition and multiplication. They regard the qualities of order and complexity as dynamic emergent forms that are not passively received but elicit a sense of equilibrium or else evoke in the spectator feelings of tension or discomfort until some equilibrium can be established. The best-known concept of this theory is that of the 'good gestalt'. The good gestalt is a 'whole', an organisation of parts, whether these be lines, points, tones or colours. The basic tenet of the theory is that there is an inherent tendency in perception towards achieving a good gestalt, to perceive a given stimulus in such a way that its structure is as simple as possible in the given circumstances. Simple structure refers to such characteristics as unity, symmetry, regularity, and harmony. This tendency is revealed in numerous mundane ways – for example, when we try to copy an object or draw a figure from memory there is a tendency to 'correct' any deviations from simple structure, and to produce a better gestalt than is actually present in the model. Ask someone to draw a line that is pleasing or beautiful, or ugly or displeasing, and the product often demonstrates gestalt qualities. The good gestalt is also capable of transposition; its simple structure can transcend changes in colour, size, and orientation. The Gestalt demonstrations illustrate this tendency towards 'good form' in a particularly convincing way. Figure 7 presents the demonstration of subjective contours known as Kanizsa's triangle (Kanizsa, 1979). The triangle has a palpable presence in that there appears to be a clear perceptual difference between the whiteness of the foreground triangle and the whiteness of its background, although there is no basis for this difference in the light reflected from the page.

There are several important principles in design that are related to the notion of good form, such as balance and symmetry. Picture compositions, objects and buildings that have balance or symmetry have, for centuries, been said to be particularly pleasing. Zee (1986) has explored these ideas in his book on the search in modern physics for the principles that underlie the design of the universe. He argues that physicists would be uncomfortable if they could not find unity amid the apparent diversity of Nature, if they could not identify some simple, fundamental law. He suggests that progress has indeed been made in this direction: 'physicists have glimpsed both beauty and simplicity in Nature's design' (p. 14); 'as physicists explore Nature at ever deeper levels, Nature appears to get ever simpler' (p. 75).

7 Kanizsa's triangle. The impression that there is a complete triangle superimposed over a second triangle is quite striking even though the outline of the figure is incomplete. Consider the apparent difference in brightness between the triangle and its background

8 This carpet design by Passoja and Lakhtakia shows the close relationship between number and symmetry. It was generated by computer, with the program implementing an algorithm based on square arrays of positive numbers

According to Zee, simplicity and beauty imply symmetry, and symmetry is there to be found, not only in the design of artefacts that have universal appeal, but in the principles that govern life itself.

The notions of balance and symmetry are themselves capable of further analysis. For example, Zee provides a formal definition of symmetry in terms of the invariance of a figure that results from transformations in it. Thus a circle can be said to have greater symmetry than a square because it remains invariant under more transformations; it remains the same whatever the angle of rotation around its centre, whereas only four angles of rotation will leave a square unchanged, the angles of 90, 180, 270 and 360 degrees. Two kinds of symmetry are distinguished: symmetry of rotation, as described above, and of reflection, the invariance of figures under left–right transformations. If a figure exhibits rotational symmetry the design appears the same, however far it is rotated. In reflective or bilateral symmetry the design's reflection in a mirror would remain the same, and printing a photograph the wrong way round would make no difference to its appearance; it would of course look entirely different if the photograph or object were turned upside-down. Figure 8 illustrates a carpet design by Passoja and Lakhtakia (1992) that has rotational symmetry. The pattern is based on the application of a mathematical algorithm that permits the computer generation of an array of integers. Figure 9 illustrates the use of reflective symmetry in architectural design.

It would be impossible to present an adequate demonstration of the uses of these kinds of symmetry in the designed world – they are ubiquitous. Nevertheless, we should be careful in proposing that symmetry of appearance should be adopted as a fundamental design principle. As we shall see below, studies suggest that people have preferences for some degree of order that is less than absolute. There are grounds for this caution other than those of people's preferences. If symmetry is defined in terms of invariance, and maximal symmetry is resistance to change, then little scope is given to the designer for producing novel pleasing forms. As Zee points out (1986, p. 211) symmetry has to be loosened to allow more interesting designs. Indeed, the symmetry that physicists detect in nature is symmetry of *action* rather than symmetry of *appearance*; strict bilateral symmetry is less common than we might think in nature as a whole and in those aspects of nature that we find aesthetically pleasing.

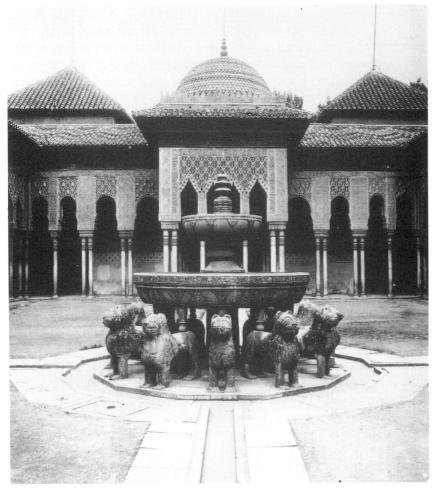

9 Aesthetic form produced by reflective symmetry is apparent in this view of the Court of the Lions in the Alhambra, the Muslim fortified palace in Granada, Spain

Consider, for example, the human face, which is certainly symmetric in simple terms; two eyes and ears, the nose in the centre, and so on. We seem to think of the face as symmetric, yet more careful observation suggests asymmetries. Each person's nose, for example, points slightly either to the right or to the left. Asymmetry of the face may be illustrated more graphically if we take a

photograph of someone, print two copies, one as taken and one reversed, cut the photograph carefully down the middle, and then combine the two images of the same side of the face. That is to say, one picture would combine two images of the right side of the face, and another picture would combine two images of the left side of the face. If the face really were symmetric these two pictures would appear identical to each other and to the original photograph. However, as should be apparent from Figure 10, this is not the case.

Asymmetry also rules inside the head; the brain had long been thought to be symmetric in that there seemed to be duplication of function in the two hemispheres. A huge corpus of research, drawing upon patients who have suffered brain injury, upon patients who have had the two hemispheres surgically separated to control epileptic conditions, and upon members of the general, non-injured population who have carried out laboratory tasks under carefully controlled conditions, has confirmed that specialised mental functions are divided in an asymmetric way between the two hemispheres. We should have reservations about any appeal to a universal principle of symmetry, or about simple explanations of preferences for symmetry in terms of nature.

Despite the considerable amount of speculation as to the nature of balance and symmetry there have been few empirical studies of people's judgements of these attributes. One would predict that balance and symmetry are not interchangeable, since a form might appear balanced without symmetry. Locher, Smets and Overbeeke (1992) have recently examined this question, and their research suggests that perceived balance can be described in three subjective dimensions: global organisation, equilibrium, and shape. In their study, a group of students of industrial design produced a large number of solid three-dimensional moulded clay objects, as illustrated in Figure 11. These objects were independently rated for their perceived degree of 'balance'. On the basis of these ratings, fourteen forms were chosen to reflect a range of judged balance and these were then presented to further groups of students (students of design and other students). These students rated all the forms on ten bipolar scales. Thus, for example, a student would inspect a form and assign it a number from one to five, where a response 'one' would indicate that the form was perceived as symmetric and the response 'five' would indicate that it was perceived as 'asymmetric'. Statistical

analysis of the sets of ratings made by several groups of judges suggested that subjective balance could be described in three dimensions: the first dimension related to forms that were perceived as 'symmetric', 'even' rather than 'uneven' in their distribution of weight, 'inorganic' (as opposed to 'organic') and 'simple', and this dimension was interpreted by the authors as reflecting the global organisation of the form. The second dimension related to forms that were judged to be 'stable,' 'static' and 'compact', as opposed to 'precarious', 'dynamic' and 'dispersed', and was interpreted as perceptual equilibrium. The third dimension was related to the overall shape of the forms, as reflected in the scales 'smooth', 'orientation important' and 'simple'. It is clearly important to explore people's judgements of attributes such as simplicity, balance and symmetry. These attributes have long been considered to be basic to design yet we have very little evidence about their nature.

It would be erroneous to equate the tendency towards simplicity with either dullness or lack of vitality; according to Gestalt theory it is an equilibrium of forces. As Arnheim writes, 'The sense of

10
These three photographs demonstrate the asymmetry of the face: (*a*) is the original; (*b*) combines two images of the right side of the face; and (*c*) combines two images of the left side of the face. Two apparently different faces are produced. The combination of the two right sides may appear to have closer resemblance to the original, perhaps because this side tends to be processed by the right hemisphere of the brain

a

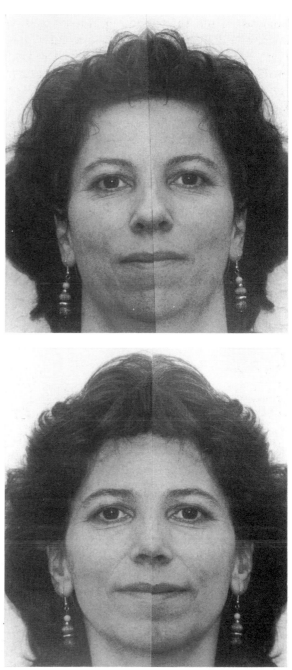

b

c

55

11 The moulded clay objects in pictures (*a*) and (*b*) were rated by observers to be well-balanced, symmetric, and stable. The objects in pictures (*c*) and (*d*) were unbalanced, asymmetric and precarious

a

b

c

d

proportion is ... dynamic. Rightness is seen not as dead immobility but as the active equipoise of concerted forces' (1955, p. 44). The notion of an inherent tendency towards simplification in perception also needs consideration, as it might be thought that the successful outcome of such a process would be monotony. This issue is debated by Beardsley and Arnheim (1981), who bring out two further points. The first is that emphasis should be placed upon the conditional statement in the principle of the good gestalt, that is to say, it is the simplest figure *permitted by circumstances*. Perception is a matter of the resolution of tensions of 'concerted forces', and the tendency towards simplification is invariably constrained by other tensions in the perceptual field and by other factors, such as, say, the goals of the perceiver or of others involved. For example, product designers have to work within constraints of function, safety, size, shape, materials, budget and marketing but will attempt to produce the simplest or 'best' design that is possible within these constraints, a design that looks or feels 'right'. In the process of achieving this the designer will visualise solutions, make drawings or models and test these against her or his sense of the good gestalt. The second point is that an equilibrium of opposing forces or tensions implies that the principle towards simplicity requires a complementary principle towards complexity, that 'the human mind [is] an interplay of tension-heightening and tension-reducing strivings' (Arnheim, 1974, cited by Beardsley & Arnheim, 1981, p. 220). This interplay, which we have seen in the attempts of empirical aesthetics to relate order and complexity to preferences, and to which we return in considering Berlyne's theory, is one of the recurring themes in psychological research.

Gestalt theorists argued that the principle of simplicity is inherent in perception, and reflects the workings of the brain. Space does not allow us to pursue consideration of this aspect of the theory, except to point out that this argument has always been controversial as a theory of perception, and it has not been accepted by more recent physiological accounts of perception. The demonstrations and 'laws of organisation', however, remain of scientific interest and these phenomena still require explanation. One implication of the view that this principle is inherent in perception is that we should be able to find evidence of it in artefacts that themselves reflect perceptual processes, such as works of art and design. Many writers (e.g., Kreitler

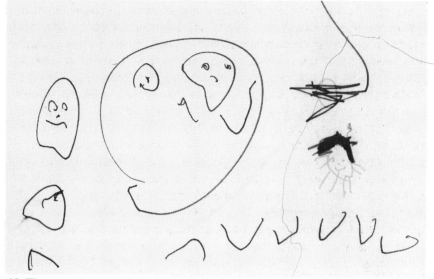

12 The recruitment of the circular form to stand for the human figure can be seen in the early drawings of young children from many cultures

& Kreitler, 1972) have drawn attention to the widespread preference for good gestalts, particularly in the products of children and in so-called 'primitive' art (see Figure 12 for the circular form that characterises children's first figure drawings). Kellogg (1970) collected over one million drawings by children from across the world in an attempt to chart the process of the development of drawing. According to her findings, drawing begins with scribbles which quickly take on a regular form, particularly the circle. Scribbling is followed by early 'diagrams' such as a mandala (a circle containing a cross) or a 'sun with rays' or 'hub with spokes' that can clearly be described as good gestalts.

However, it would be misleading to conclude that this is a universal trend as there is also evidence of cultural variation in the development of drawing. Crucial influences upon this variation seem to be the attention that is given to visual art in the parent society and the penetration of indigenous traditions of art by Western graphic styles. Alland visited and recorded the drawing activities and products of children from several diverse societies. In the island of Ponape, one of the Micronesian islands in the western Pacific Ocean, there

was little evidence of indigenous visual art, as the local traditions had been largely eradicated by colonisation. Alland reports (1983) that the early drawings of the children whom he contacted there showed no spontaneous use of the circular form that is so common elsewhere. It remains an issue for research whether the tendency towards simplicity of form in drawings holds for different cultures and times. Wilson and Wilson (1984) have argued for cultural diversity, proposing that drawings in any culture are shaped by local traditions; that children appropriate these modes of representation. Their own work shows that the popularity of particular drawing styles may wane and that the drawings of children exposed to Western graphic styles differ from those who are only exposed to the products of older children.

As is well known, the psychoanalyst Carl Jung collected artefacts from many different cultures as well as paintings and drawings produced by (Western) patients hospitalised for schizophrenia and untrained in art. He too reports the widespread incidence in these products of circular patterns, often subdivided into four segments. To these he applied the term 'mandala' because of their resemblance to the images used for meditation in Eastern religions. For Jung, of course, it was the psychological symbolism of these images that was important, the simplicity and symmetry of the pattern standing for the balance between opposing forces that could be achieved in the psyche. He accounted for the apparent universality of symbolism among such varied groups of people in terms of archetypical ideas that reside in what he termed the collective unconscious. His speculations indicate that the interpretation of these ubiquitous images may not be exhausted by reference to Gestalt principles of perception. Whatever their origins, there does seem to be widespread evidence of the visual effectiveness of simple, well-organised patterns.

Complexity and familiarity: Berlyne's theory

Contemporary research in psychological aesthetics has been stimulated by the theorising of Daniel Berlyne, born and educated in Britain but based in Canada until his death in 1976. His background had been in the study of animal behaviour, where he had investigated curiosity and exploratory behaviour. Psychological theorising at the time had emphasised the role of rewards such as food and sexual

gratification as instigators of animal behaviour, and these were interpreted in terms of their capacity for reducing basic needs. Berlyne had observed that much of behaviour is of a more diverse exploratory nature that is not conspicuously in pursuit of particular rewards or directed towards reducing specific needs; indeed the opportunity to examine novel situations and events could function as a reward in itself, in that animals would learn and exercise behaviours that produced such a reward. In the light of these observations Berlyne distinguished two kinds of behaviour: specific exploration that was directed towards need reduction, and diversified exploration that was directed towards providing the animal with an optimal level of stimulation. He linked human aesthetic behaviours to this latter form of exploration.

Berlyne was no doubt influenced in this formulation by research into the brain and nervous system that was at that time illuminating processes of physiological arousal. A human can be described as having at any given moment a state of arousal that can vary from sleep, at the lowest level, to high alertness and emotional excitement. Increases in arousal can be detected in many ways; through measurable changes in electrical activity in the brain, changes in perceptual sensitivity and in bodily movement. They are correlated with activity in those parts of the nervous system that are involved in emotional responses, such as blood pressure and heart rate, and that underlie subjective reports of heightened excitement. Patterns of arousal are observed in a large number of species, and have clear adaptive significance for an animal's survival, in preparing it for 'fight' or 'flight' responses. Berlyne's insight was to suggest that the pleasure that is derived from works of art could be related to the arousal level, and he undertook to express this relationship in a systematic way. He was prepared to accept that works of art are complex objects that affect the spectator in many ways. For example, he recognised that artworks have symbolic content and that they communicate meanings. However, his most influential contribution was his characterisation of art in terms of changes in the level of arousal, a position summarised in his own words:

> A work of art is regarded as a stimulus pattern whose collative properties, and possibly other properties as well, give it a positive intrinsic hedonic value . . . it is hypothesized that aesthetic patterns produce their hedonic effects by acting on arousal. This is, of course, a counterpart of

the old belief that works of art generate pleasure through their emotional impact.

(Berlyne, 1974, p. 8)

The technical terms in this quotation require some explanation. What does 'hedonic value' mean, and why not simply refer to 'pleasure'? Berlyne preferred to coin a new expression because of the postulated links in his theory between reactions to aesthetic objects and the nervous system. Since arousal entails many psychophysiological reactions, it can be measured in a number of different ways, including the recording of responses that would not normally be encompassed by the term 'pleasure'. Indeed one of the strengths of Berlyne's position has been that it permits tests of hypotheses about the effect of art objects that are not restricted to people's subjective reports of their experience; his theory also makes predictions about changes in physiological measures. The term 'collative variables' also requires explanation. There are many environmental sources of changes in arousal, over and above the diurnal pattern of wakefulness and sleep, sources, for example, in particular innate or learned signs of danger or in stimulation related to bodily states, such as the sight or smell of food or drink in those who are hungry or thirsty.

However, and of more direct relevance to his account of art, Berlyne also identified sources of arousal in certain physical properties of environmental stimuli such as intense colours or sounds, and also in properties that he labelled collative variables, so called because they require the perceiver to collate or combine information from more than one source. These collative variables include the properties of ambiguity, complexity, novelty and potential for surprise. Thus, according to the theory, a more ambiguous object will produce greater arousal than a less ambiguous one, and reduction in the novelty of an object with increasing familiarity will decrease arousal. Do these changes have corresponding effects upon hedonic value? Berlyne argued that the relationship between hedonic value and arousal was not a straightforward correlation; rather he proposed that hedonic value would be greatest at a moderate level of arousal – too little or too much arousal would produce less pleasure. This relationship can be described in terms of an inverted 'U' curve, as in Figure 13, known to psychologists as the Wundt curve. This figure reflects the tendency for moderate increases in arousal to be

Berlyne's model of aesthetics

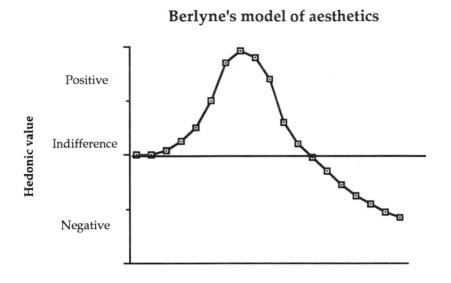

Arousal potential

13 Berlyne proposed that the Wundt, or inverted-U, curve could summarise relationships between people's ratings of the hedonic value or pleasure they find in objects and the measured arousal potential of those objects. Each point on the curve represents a preference rating for a given level of arousal

pleasurable and extreme rises in arousal to be aversive, and also a tendency for reductions in high levels of arousal to be pleasurable.

As Berlyne recognises in the quotation above, this formulation recapitulates some long-standing ideas in aesthetics; the link between aesthetic reactions and emotion and the notion that the most pleasing designs achieve some balance of simplicity and complexity, unity and diversity, order and variety. This is reminiscent of Freud's account of art in its emphasis upon hedonism and in asserting the balance between what Freud would identify as ego and id or the reality and pleasure principles. What was new in Berlyne's approach was its attempt to specify just what was meant by terms like complexity, diversity or pleasure, the explicit location of these relationships in the nervous system, and the articulation of functional relationships between properties of objects and events on the one hand and emotional responses on the other. The theory was

described in sufficient detail for testable hypotheses to be derived from it, and over the years considerable effort has gone into testing it. Typical investigations have taken the form of an experiment in which the researcher selects pictures, objects or musical pieces that vary in their collative properties (such as their novelty or complexity) and assesses the impact of these variations upon people's statements of preference, their willingness to explore them or some psycho-physiological measure of emotional arousal.

Three trends can be identified in this research. The first involves empirical investigations of the proposed inverted 'U' relationship between hedonic value and collative variables, particularly those of complexity and novelty. A second strand is concerned with the relationship between the two exploration-linked concepts of pleasure and interest; limitations of space will permit only brief reference to this topic. The third strand reflects the more general change in psychological thinking from explanations like Berlyne's, that were essentially behaviourist, to more cognitive explanations. This concerns the attempt to express functional relationships between properties of objects and responses to them in terms of the meanings of objects. We examine this approach in the following chapter.

Complexity

The notion that people do not enjoy objects that are either too simple or too complicated is hardly novel or startling, though it does appear to contradict the principle of maximum simplicity that was emphasised by the Gestalt psychologists and that underpins so much design practice; the simplest mechanical design is often the most effective in that it provides less opportunity for breakdowns and more scope for easier and cheaper repair. It is unfair, however, to trivialise the theory in this way. After all, it is a theory of preference that relates phenomena that have proved difficult to understand to known qualities of the human nervous system. It has the advantage of being all-embracing, applicable to mundane objects and to artworks of this and other cultures. One might as well dismiss Freudian theory on the grounds that the concept of the sexual symbolism of objects is 'obvious' or is an idea much older than the theory itself. In each case the effect is to close down debate, a refusal to address questions rather than answer them. A more productive response is to explore these ideas and consider their implications. For psychologists like

Berlyne this is a matter of the empirical testing of hypotheses that can be derived from the theory. A considerable body of research has been directed at this, more than we can hope to summarise here (a book edited by Hy Day, *Advances in Intrinsic Motivation and Aesthetics*, 1981, provides a useful collection of papers). We restrict our discussion to issues raised in the study of two of the collative variables, complexity and familiarity.

Testing hypotheses concerning complexity obviously requires some definition of complexity. Although this is a collative variable and thus implies some relationship between an object and its user, in that attributes of the object are compared with prior experience or expectations, research has defined complexity in terms of the object's properties. One candidate has been number, on the assumption that the more sides a geometric figure such as a polygon has, the more complex it is. However, most definitions have relied upon concepts offered by information theory. This theory had originally been developed by electronic engineers concerned with the transmission of information, along telephone lines, for example. It introduced precise definitions and measures of concepts of uncertainty and redundancy to psychologists. The information carried by a message could be measured in terms of the predictability of an item of information given the preceding one(s). The most informative message is the one that most reduces uncertainty and is least redundant. These measures can be applied to visual figures and to sequences of sounds and pieces of music, so researchers could use them to investigate the impact of variations in uncertainty upon preferences. If one identifies complexity with uncertainty this provides the basis for a test of Berlyne's theory. Berlyne's own research showed that increases in the uncertainty of visual figures were positively correlated with people's ratings of how complex the figures were. They were also associated with ratings of pleasingness according to the predicted Wundt curve; the most pleasing figures were those of moderate levels of uncertainty and rated as being moderately complex.

However, Berlyne's account has met increasing criticism, largely because of its definition of complexity. First, it is not clear that complexity can be located in the object without some consideration of the observer. The car engine or the workings of the television set look horrendously complicated to me but not to the engineer. Some musical compositions sound complex or incomprehensible to the

novice listener but not to those familiar with them. Music is a particularly telling example, in that research influenced by Berlyne has examined the relationship between preferences for pieces of music that vary in their complexity (defined in terms of uncertainty; in this case the transitional probabilities between notes). But Western listeners hear these pieces within the context of familiar patterns of uncertainty, within a *language* of music, and so they find it difficult, at least initially, to hear music that has a different structure, such as the twelve-tone system introduced by 'modern' composers such as Schoenberg and Berg and the serialisation consequently explored by Stockhausen, among others. Berlyne's definition of complexity is a structural one that tries to avoid the influence of semantic complexity, yet, as we have seen, structure has its own semantics that varies among individuals and among cultures. Only a minority of researchers, for example Heyduk (1975), discussed below, has allowed for differences among individuals in their preferred level of complexity.

Martindale, Moore and Borkum (1990) have developed these criticisms of the theory in posing two questions. How important are collative variables as determinants of preferences in comparison with the semantic properties of objects? Can the apparent impact of, say, complexity be influenced by the meaning of objects? For example, one might program a computer to generate a set of random polygons with varying numbers of sides, and the set produced could include familiar figures like the letters T, X and H, an arrow, a triangle or square (all in fact polygons included in the studies by Birkhoff and Eysenck discussed above) or the swastika. Should these polygons be included in the experiment, where they might have an effect upon preferences apart from their measured uncertainty? Or should they be excluded, implicitly admitting this effect? A series of experimental investigations carried out by Martindale and his colleagues showed that measured complexity had only a slight relationship with preferences, and that this relationship tended to disappear when respondents' ratings of the meaningfulness of the polygons were taken into account. Overall, the meaningfulness of figures was a much more significant determinant of judgements than was complexity. I shall postpone consideration of this idea of the central role in preferences played by the semantic properties of objects, and turn to the next collative variable, familiarity.

Familiarity

Berlyne predicts that people will most like objects and places that are moderately familiar and will be more averse to the novel and the over-familiar. Common sense is ambivalent on this matter, suggesting that we like 'the old favourites' and also that 'familiarity breeds contempt'. It is a truism in advertising and marketing that labelling a product as 'new' can lead to an increase in its sales. There are contradictory views among psychologists, and one school of thought (that can be traced to Fechner) proposes that preference is positively correlated with exposure; the more often we experience an object or event the more we come to like it. A body of research supporting this notion was gathered by Zajonc (1968). Naturally the fact of competing predictions concerning people's preferences attracted considerable attention from psychologists. The question is nevertheless of more than theoretical interest, given that one of the most salient features of design is change; change in style and change in fashion. Indeed, the term 'fashion' is applied to a design industry (clothing), a branch of that industry or enterprise (fashion, as opposed to casual clothes) and alludes to an inherent feature of that industry (the *Concise Oxford Dictionary* defines fashion as 'prevailing (usually transient) custom, especially in dress').

Such changes scarcely need exemplification. The most frequently cited example among (largely male) psychologists is the length of women's skirts, which has changed over the centuries and more particularly in recent years with the appearance, disappearance and subsequent reappearance of the mini-skirt. These changes take place against a complex social background and are also associated with technological developments in human-made fabrics. For example, prevailing customs of modesty meant that a shorter skirt was incompatible with girdle and stockings; the rise of feminism called into question the wearing of such constricting garments; the substitution of tights for stockings called for developments in new human-made fabrics. Wearing skirt and tights was challenged by the huge increase in the popularity of blue jeans, which was also an illustration of a change in use from utility to fashion clothing. Although they have always had connotations belonging to practical wear, they have more recently been designed to be more luxury items by fashion houses like Calvin Klein or Gloria Vanderbilt. As an item of apparel common

14 Madonna as fashion leader. Individuals can influence changes in fashion and personal appearance by challenging the conventions of the time

to both sexes, they reflect twentieth-century changes in women's roles. But even jeans are subject to fashion. The 1980s saw a huge increase in the sales of jeans, encouraged by strong advertising campaigns, resulting in a British market worth around one billion pounds; there are now suggestions that this growth has peaked. Finally, items that go out of fashion do not necessarily disappear. Stockings were revived as a 'glamorous' item, and even the girdle has reappeared, in the 'underwear as outer-wear' fashion popularised by fashion leaders like Madonna and Cyndi Lauper.

Changes in fashion are not of course restricted to women's dress, to clothing or to this century. Design of the exterior and interior of buildings, of aeroplanes and automobiles, of typography, are all characterised by changes in the popularity of different styles. It should be noted that these changes can have large effects on the *perception* of these artefacts. What is commonplace for one generation can look odd or even funny to another. Consider the flared trousers of the seventies, popular cars of the early sixties such as the Vauxhall

Victor or the Ford Prefect, radios and televisions of the twenties and thirties. It is risky to provide examples, because any of these designs may become fashionable again, and look pleasing or 'normal'. For instance, very recently viewers to a popular children's television programme were invited to send in as items of amusement photographs of their parents in flared trousers; as I write, these are becoming fashionable again and may soon appear 'normal'. To complicate matters still further, some designs seem timeless, as fresh today as when they first appeared – there have been few real changes in Lego, or in the Jeep, the Landrover or the Citroen 2CV. It is important to bear in mind that we are not dealing merely with a matter of preference in the sense that one design is liked more than another – unfashionable designs can *look* 'wrong', an observation to which we shall return.

There have been many attempts to explain changes in fashion. There are conspiracy theories, in which manufacturers and the media are seen as colluding to manipulate the perceived attractiveness of products in order to enhance sales; examples might be the fashion seasons and *haute couture* shows in Paris, Milan and London, the motor shows, toy fairs, and so on. There are many pressures for change; for example, pressures 'from below' when manufacturers follow trends that begin among ordinary young people, as in punk fashions. There are theories expressed in terms of social psychological factors, such as people's desire for conformity or wish to emulate the appearance and behaviour of those of high status. What if these reasons are superficial and fashion changes in fact reflect an innate preference for novelty that is related through evolutionary processes to exploratory behaviour? This is the gist of Berlyne's theory, with the proviso that too much novelty is aversive, a proviso that is compatible with notions that changes in fashion are gradual, and that many styles that eventually become popular are greeted with hostility when they first appear. One can envisage that Berlyne's theory would predict a cyclical process. We do not particularly like new designs, but with increasing familiarity we come to like them. Eventually with even greater familiarity we like them less, and look to other designs. As long as there are new designs or new products to emerge, preferences should wax and wane. Indeed, Martindale and his associates (e.g. Martindale & Uemura, 1983) have tested such predictions in the fields of literature, music, and painting, and have

presented an explanation of stylistic change that is influenced by Berlyne and the theory of creativity developed by the psychoanalysts Sigmund Freud and Ernst Kris.

Two ideas are central to Martindale's thesis: that aesthetic preference is linked to the arousal potential of artefacts and that preference is diminished by increased familiarity, because of habituation. Accordingly there is pressure on artists within any tradition to develop novel forms that increase arousal potential through changes in collative variables such as complexity, novelty and ambiguity. Artists develop these by drawing upon two processes of creativity – inspiration, where they find in their unconscious the raw material for their products, and elaboration, where this material is worked into an appropriate or conventional form. When their public is habituated to this elaborated work, further regression into the artist's unconscious must take place, followed by yet more elaboration, and this two-stage process of inspiration and elaboration continues until no further regression is possible. At this point, novelty can only be produced by a change in style, that is, in the rules governing appropriate or conventional form.

Given these processes, two predictions are made about trends in artworks over extended periods of time. If artworks are rated in terms of their collative variables, their novelty, complexity and so on, then these ratings should increase steadily over time, reflecting the continuing pressures towards increased arousal potential. On the other hand, if the degree of inspiration or regression could be measured, say, by an assessment of their unnaturalness, meaninglessness, or disorderliness, then these measures should have a cyclical relationship with time. There would be more regression with time until it reached a maximum, at which point there would be a significant stylistic change, when the amount of regression would reduce to a low level, increasing again to a further maximum. If this explanation is correct, predictions can be made about the shape of the graph relating regression to time, and also about the timing of stylistic change, which should coincide with the maximum regression points. Martindale has tested these predictions by collecting examples of artworks across centuries (from the fifteenth to the twentieth century) and having judges rate these in terms of their arousal potential and level of inspiration–regression. Naturally, given the extended period over which the works were produced, problems in sampling

artworks from different periods, and the variability involved in rating any artefacts, the resultant graphs will never be as definitive as suggested by Martindale's hypotheses. Nevertheless, statistical analysis of the trends does tend to offer positive support for the theory, for all the artistic media investigated.

These were ambitious studies, and we need further research that will compare these hypotheses with alternative accounts of stylistic change. We have as yet no comparable evidence for design changes, as in dress fashions. For many products, of course, insufficient time has elapsed for these long-term studies to be undertaken. It would nevertheless be interesting to see if these trends also showed short-term but rapid changes, as in the dress and musical preferences of young people in the industrialised world. The notion of habituation followed by processes of inspiration and elaboration that result in changes in conventions or 'ground rules' does seem relevant to a range of contemporary phenomena. Engineers who design 'white-knuckle rides' for fairgrounds and theme parks are asked to produce increasingly frightening rides. There are clearly pressures upon designers of computerised three-dimensional animated environments such as Virtual Reality to give us more and more excitement. Journalists write of 'compassion fatigue'. Our television screens bring pictures of suffering and violence that can shock public opinion, but in a short time we become immune to them, so that, for example, donations to relevant charities fall back to previous levels. Journalists always have footage of even more suffering than has yet been transmitted, and editorial decisions that such images are too disturbing for the public (the 'ground rules') need constant reconsideration. Public taste also seems to tolerate more and more explicit violence and sexual scenes in drama; the codes of conduct specified in the Hays Committee recommendations that governed cinema practice for so many years now seem to come from a different world.

Psychologists have examined the influence of relative familiarity and preference in experimental settings as well as in longitudinal studies of the kind favoured by Martindale. Again, the research has been influenced by Berlyne's theory, addressing in particular the dispute between Berlyne and Zajonc as to whether there is a linear or inverted 'U' relationship between measures of familiarity of preference. Such experiments require some manipulation of familiarity. For example, people are asked to respond to words that vary

in their frequency of use in the English language. Alternatively, preferences among letter-forms expressed by children who are learning to read can be compared with those of more experienced readers. The resulting graphs seem on the whole to demonstrate the inverted 'U' shape (see Sluckin, Hargreaves and Colman, 1983, for a review of this research). As in the studies of complexity, these graphs depict trends in the data, not an exact reproduction of the idealised Wundt curve.

Several issues have arisen in this research. One concerns the need for studies to sample different levels of familiarity; the researcher has to ensure that highly novel or highly familiar stimuli are included in the experiment. If, for example, only moderately novel stimuli are rated in a study, these ratings might show an increase in preference as familiarity increases, results that would appear to contradict the Berlyne hypothesis. But if more familiar items are included, then the theory predicts that preferences will reach their peak and begin to decline, and this trend would have been missed by the researchers. This is a handy stick with which the supporter of Berlyne can beat his or her academic opponents! There is also evidence to support the hypothesis that the collative variables of complexity and familiarity might interact with each other to influence preferences. For example, Heyduk (1975) examined listeners' liking for four tape-recorded piano compositions that represented different degrees of structural and rated complexity and which were played to listeners with varying frequency. The relationship between the complexity of the pieces and the initial ratings of how much they were liked could be described by the Wundt curve. Increasing exposure to the music resulted in decreasing liking for simpler pieces and in increases in liking for more complex pieces. More generally, Walker (1973) has proposed that repeated exposure to a complex event results in its psychological simplification, and this can lead to either increases or decreases in preference depending upon the individual's preferred level of complexity.

Something of the dynamics of the effects of familiarity is evident in a study by Colman, Hargreaves and Sluckin (1981) of the well-known phenomenon of fluctuations over time in the popularity of first names. These researchers examined responses to sets of boys' and girls' names that varied in their rated familiarity. Liking was positively correlated with familiarity – the most familiar names were

most liked. This might lead the reader to the conclusion that the inverted 'U' function could not describe preference for names. However, the authors point out that this pattern of results may well reflect a self-regulating process in the choices that successive generations of parents make in naming their children. The best-liked names come to be chosen more frequently, so that at any point in time there is a positive correlation between liking and frequency. No names can ever become so common as to be disliked because as any name reaches the peak of the familiarity preference curve parents begin not to assign that name to their new-born. This feedback process cannot hold for surnames, as people have very little choice over these and they do not fluctuate in their frequency. Research does confirm that preference for surnames does indeed show the predicted inverted 'U' relationship.

Interest

Thus far, we have concentrated on people's preferences for, or degree of liking for stimuli. People also differ in their expressed *interest* in stimuli. Interest is a concept with many ramifications. It can be synonymous with preference ('I'm really interested in modern architecture') or with the expression of little preference ('It has an interesting taste', we comment upon our host's home-made wine). At other times it expresses a rather different idea, a notion of involvement or concentration of effort. Interest was relevant to Berlyne as a further instance of exploration, and researchers have investigated the relationships between judgements of preference and interest, and between these judgements and collative variables. Research has tended to conclude that judgements of interest and pleasingness are positively correlated and that both may have an inverted 'U' relationship with complexity and familiarity. As with preference judgements, people lose interest in objects that are too complicated for them, or too familiar. Eckblad (1980) has proposed that judgements of how pleasing a stimulus is has a lower peak on the scale of complexity than do judgements of interest. This suggests that people find objects and events interesting before they come to like them. It also indicates that in order to persuade consumers to like a particular novel product an advertising campaign should first aim to arouse their interest; with increased exposure their interest should turn into liking. This advice would be particularly appropriate if the producer

envisaged consumer resistance to the product or to significant changes in the design of an existing product.

Teigen (1987) has offered an alternative formulation, arguing for the importance of the *informativeness* of an object or event for determining interest. He defines informativeness as a combination of the novel and the familiar. Objects are rarely simply either novel or familiar, they typically comprise both novel and familiar aspects; an object can tell us something new about something familiar, or something familiar about something new. Teigen proposes that intrinsic interest in an object is related to its information value, which is a function of the joint presence of novel and familiar elements. If an object is very familiar we prefer to learn something new about it, if novel, something familiar. The public has an appetite to learn new things about familiar characters in television soap operas and about members of the Royal Family. If new characters are encountered, the public needs to be reassured that their attitudes and behaviour are familiar.

Summary

We have considered in this chapter the view that there may be something inherent in the form of objects that produces a positive emotional response. Many psychologists have followed this line of enquiry and have subjected it to empirical investigation. Library shelves full of data have emerged, but none of the findings is clear-cut. There does seem to be something pleasing about simple, symmetrical forms. The golden section does not seem to exert as strong an influence upon people's judgements as was anticipated. There is some support for the effectiveness of designs that achieve a balance between order and complexity. Berlyne approached this question in a somewhat different way, by considering the relationship between qualities of objects and the experiences that the perceiver brings to the object, and this approach quickly raised the question of the role of the meanings of objects. To what extent is our response to the form of the object and to what extent to its meaning? Psychologists have often preferred to work with designs that minimised the influence of past experience, but in everyday life, of course, meaning and form are invariably linked.

Perhaps the notion of inherent responses to pure form is a mirage.

Certainly the trends in psychological theory have been towards the view that it is a person's experience of the world rather than the world's objective properties that counts. This was the thrust of Neisser's seminal book, *Cognition and Reality* (1976). Many every-day experiences support this hypothesis. How hot water feels to the touch depends on whether the hand has just been dipped in a bucket of hot or cold water. Once I couldn't drink tea without sugar; now tea with sugar tastes unpleasant. One obvious objection to the formalist position is the existence of widespread individual and cultural differences in taste. Theorists like Berlyne have attempted to accommodate these in their accounts, but whatever the strength of their arguments, the accommodation invariably moves away from locating the source of people's responses solely within the object. A counter-argument is to suggest that differences in tastes have been exaggerated, to advocate standards of good design and good taste, and propose the existence of design 'classics'. However, good design might turn out to be merely the preferences of particular elite groups and just as subject to changes in fashion as is popular taste. A further defence of formal properties suggests that psychologists have ap-proached the question in too simplistic a manner. There is perhaps no single ratio of lengths that is invariably pleasing, no arrangement of facial features that is inevitably beautiful. Rather, the question of form may have to be investigated 'case by case'. When, say, Mackintosh was designing his chair (Figures 15 and 16), he had to make a decision about the height of the chair back. There may not be a Platonic 'ideal' height for this, no equivalent to the golden ratio. The choice will be constrained by other characteristics of the chair and by the goals of the designer, and these in turn will be influenced by the social and historical context. On the other hand, the height is not arbitrary, and some alternative choices would pro-duce a less satisfactory chair. The designer pursues the optimal solution for this particular case, and the solution may not be widely generalised, not even perhaps in other chairs. Such a case-by-case approach has not been popular among psychologists; I shall consider its merits further in the final chapter.

The last objection to formal explanations that I consider here proposes that advocates of phenomena such as the golden section have neglected the meanings that they were intended to convey. For example, the section has its origins in Greek cosmology, in the beliefs

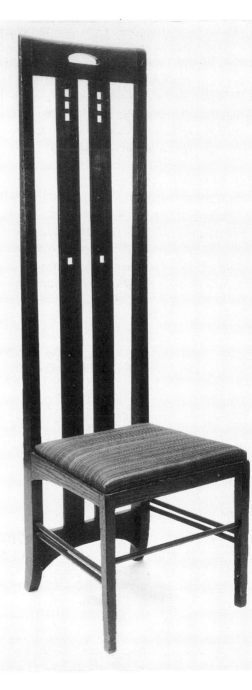

15
High-backed chair for
the Ingram Street Tea
Rooms, Glasgow,
designed by Charles
Rennie Mackintosh, 1900

76

of Plato or Pythagoras that simple, symmetrical forms symbolised the origins of the world. And the revival of interest in Greek thought in the Renaissance, together with a theoretical interest in geometry and perspective encouraged artists like Piero della Francesca to incorporate the golden section into their paintings. The formal organisation of paintings such as Piero's *The Baptism of Christ* in the National Gallery, London, or, *Flagellation* in Urbino has been analysed by historians such as B. A. R. Carter in terms of the *symbolism* of perspective and of forms like the circle, the square, the Pythagorean star, and the golden section. The arrangements of these forms reflect a particular theory of beauty, a theory that was linked to wider philosophical beliefs of the time. Spectators who shared these beliefs could respond to the meanings conveyed by these forms. We are no longer familiar with those ideas and have lost sight of the meanings conveyed by form. We tend in consequence to attribute their recurrent use in art and design to formal properties, and in doing so we may unwittingly exaggerate the importance of these properties.

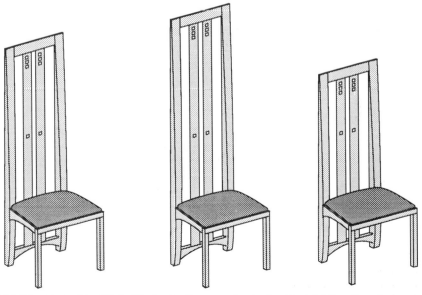

16 Mackintosh's High Chair. Is there a single *best* height for the chair back, in terms of formulae, or does the designer produce a specific solution for a particular problem?

3 Meaning and design

Apart from satisfaction of biological needs man shares with animals, he lives in a universe not of things but of symbols. (Ludwig von Bertalanffy)

A respect for basic forms has characterised much of this century's design theory, but as we saw in the previous chapter, psychologists' attempts to identify necessary relationships between formal properties of objects and human reactions have often foundered on the intrusive effects of the meanings of objects. It remains to be seen whether such relationships are there to be identified. Perhaps these relationships hold only for particular objects rather than at the level of generalisations, or perhaps psychologists' conceptual and methodological tools have been insufficiently sensitive. It may be that the strategy of isolating abstract formal qualities that appear to be shared by pleasing objects is inappropriate. Perhaps pleasing objects share family resemblances, in Wittgenstein's sense, rather than having defined, isolable qualities. I pursue this point further.

Meaning and emotion

The idea that responses to works of art are fundamentally emotional in character is a very old one, but Berlyne was the first psychologist to attempt to piece together knowledge about the role of the nervous system in emotion and people's responses to art and music. This attempt has not been without its critics, as we have seen, and one target of this criticism has been the concept of arousal, which is at the heart of Berlyne's approach. One objection to his thesis is the argument that emotions involve a wide range of intensities of arousal, yet great intensity of emotion is rare in responses to works of art. Adherents to this position do not dispute that these works can elicit powerful emotions, but they suggest that much of our intercourse with the designed world does not involve such extremes. In defence

of Berlyne's position, it can be pointed out that *changes* in the level of arousal may be more significant than its absolute level in mediating responses. An incongruous or surprising event will produce a change in arousal, and it is the magnitude and direction of this change, and not the absolute level of arousal, that determines the pleasure that is experienced. Incongruity or surprise are classified as collative variables, as they involve comparison between current and previous states of affairs.

More recent work in empirical aesthetics has focused on this process of comparison. There have been several influences. As discussed in my introduction above, psychology as a whole has become interested in cognition, the mental processes that underlie behaviour. More specifically, this cognitive orientation has been directed to the long-standing psychological problem of what it is that distinguishes one emotion from another. It has seemed to psychologists that physiological processes, including variations in arousal levels, are not in themselves sufficient to discriminate between emotions, but that cognitions, beliefs or attributions are also necessary. That is to say, an environmental event will elicit an undifferentiated state of arousal, but this requires further 'processing' or labelling of that event, understanding of its significance in the particular context, and the person's memories (or 'stored representations' of previous events), before a specific experience results, whether of fear or surprise, interest or pleasure. Mandler (1975) suggested that arousal of the autonomic nervous system is produced by an interruption in a sequence of cognitive processes, and one important kind of interruption occurs where there is a mismatch between the state of the world and the expectancies or 'model' of the world that is guiding the person at that time. This formulation is of course similar to the account of incongruity provided by Berlyne, but there is a shift in emphasis to studying the person's internal model of the world.

Briefly, it is proposed that these models can usefully be conceptualised in terms of *schemas* which are defined as 'coherent units of structured representations of environmental regularities. They are not carbon copies of experience, but abstract representations of environmental regularities' (Gaver & Mandler, 1987, p. 264). These schemas are built up through experience, the individual's transactions with the environment. Because each individual's pattern of life experiences is unique, schemas are personal to the individual;

however, they share common features to the extent that particular cultures and socialisation processes provide shared environments. Environmental events are inevitably interpreted in terms of the individual's existing schemas, so apparently similar events will be experienced differently by different people or by the same person at different times. Schemas are not rigid structures but are modified by experience, and this is understood in terms of principles as explained by Piaget. New experiences can be *assimilated* to existing schemas, but schemas themselves also change and *accommodate* to new experiences.

A schema must have some structure of its own, and a popular form among psychologists is the hierarchical structure, where abstract schemas subsume more concrete ones, with the most abstract at the top of the hierarchy (say, 'modern architecture') and the most concrete at the bottom ('Canary Wharf', 'Lloyds' Building'). Consider, for example, the hierarchical structure that might characterise a classification scheme in design history. A schema for Arts and Crafts could subsume schemas for particular classes of artefacts such as architecture, furniture design, fabrics, and so on. A person's schema for each of these might subsume schemas for particular designers, such as Morris, Godwin or Owen Jones, and each in turn would subsume further schemas, for, say, particular objects. One can imagine that there are different ways in which such knowledge might be organised 'in the head'; that a design historian, an expert in William Morris, or a lay-person might have different schemas and different organisations of them. Expertise may involve more differentiated schemas.

Schemas are clearly organisations of meaning, or, to put it another way, psychologists like Mandler are offering a theory of how meanings are organised in the mind. Schemas are hypothetical mental structures, but are akin to old-fashioned concepts, and some psychologists have approached the question of the organisation of schemas in terms of recent thinking derived from Wittgenstein's analysis of the nature of concepts (see, for example, Johnson-Laird, 1988, chapter 13). What defines a concept? What leads instances of a concept or members of a category to be instances of that concept or to belong to that category? What makes Lloyds' Building and Canary Wharf both examples of 'modern' architecture, when they look so different, one from the other? One answer is that all

instances of a concept share some common attributes, that there is something that all examples of modern architecture or of Arts and Crafts chairs share, qualities over and above their idiosyncratic features. Wittgenstein disputed this view of category membership, most famously in his account of games, proposing instead that concepts are defined in terms of 'a complicated network of similarities overlapping and criss-crossing: sometimes overall similarities, sometimes similarities of detail. And I can think of no better expression to characterise these similarities than "family resemblances"' (Wittgenstein, 1953, pp. 31–2).

As Johnson-Laird explains, these ideas were adopted by psychological research for concepts and their formation, with variations on a recurring theme: 'a concept specifies the typical characteristics of members of the class; it does not have necessary and sufficient conditions; and it does not have clear-cut boundaries' (1988, pp. 244–5). Rosch (1975) argued that instances of a category differed in their degree of representativeness: some would be prototypical, in that they are the best examples or clearest cases, or have the strongest family resemblance, whereas others are less prototypical, less good examples. More prototypical members have more attributes in common than less prototypical members; also, more prototypical members share fewer attributes with members of other categories. Thus, a Voysey chair might be, for me, a clear example of the Arts and Crafts movement, and mention of that movement would readily bring it to mind. Another chair, say, by Mackmurdo, would be a less clear-cut example, and I might be uncertain as to whether it was an example at all. Finally, Rosch offered a method for eliciting people's category structures, by asking them to judge how good an example of a category various instances of the category are.

Let us return to the question of affective reactions to the environment. The ideas outlined above have influenced recent thinking here. Gaver and Mandler (1987) offered an account of variation in the intensity of emotional responses to music in terms of the amount of incongruity between the music and the listener's schemas. Pieces of music that are moderately incongruous but can still be assimilated into an existing schema or into an alternative available schema will elicit pleasure. A greater degree of incongruity may not be readily assimilated and will require accommodation to an existing schema. This will elicit a more intense emotional reaction, which will be a

positive or negative response depending on whether or not the accommodation is successful. This account appears to make predictions similar to those of Berlyne in that it proposes an optimal degree of incongruity, beyond which the increased arousal is associated with less pleasure and eventually unpleasantness (the reader should recall the shape of the Wundt curve relating hedonic value to collative variables). However, readily assimilated material is mildly pleasurable according to Gaver and Mandler, so the shape of the curve for the slightly incongruous and for low levels of arousal should be different for the two theories. Consequently, schema theory predicts that familiarity should enhance liking, in that it provides an opportunity for elaboration of schemas. It also predicts that there should be an interaction between familiarity and complexity, in that more complex material is likely to be congruous with existing schemas. Furthermore, what is most familiar is often most prototypical – it is after all exposure to a category of music that establishes the prototypical examples.

These notions have also been applied to responses to furniture (Whitfield & Slater, 1979) and to buildings (Purcell, 1984; 1986). Purcell assembled sets of photographs of houses and churches, and asked participants to rate these in terms of how attractive they were, of how interesting they found them, and of their degree of goodness of example as houses or churches. How are these ratings interrelated? First let us concentrate upon ratings of houses. Perceived attractiveness was closely related to goodness of example, with the best examples (the prototypical houses) being judged most attractive. However, degree of *interest* was negatively correlated with prototypicality, that is, interest was greatest for the poorest examples. Overall interest was slightly positively correlated with attractiveness. The houses that were judged to be the least attractive and were also perceived to be poor examples included designs by 'modern' architects, Mies van der Rohe and Philip Johnson. The most preferred and most typical houses included traditional Victorian and Georgian styles. Interestingly, as would be predicted by schema theories, these relationships were different for 'expert' judges, in this case architecture students. For these students, attractiveness was positively correlated with interest, but interest was negatively correlated with goodness of example. They found the less conventional designs to be the most interesting and attractive.

Purcell (1986) has elaborated a theory of environmental aesthetics similar to that of Gaver and Mandler. An emotional response arises from a discrepancy or mismatch between the attributes of a currently experienced object or event and the values of those attributes in the prototype example (the 'default' values). This theory is supported by studies of ratings of buildings and furniture as indicated above. It also accommodates many of the principal findings of empirical aesthetics, such as relationships between complexity, familiarity, and preference, and it shows how individual tastes can change over time and differ among individuals.

These cognitive approaches are not without their critics who take the position that perception is direct and does not require any mediating information processing (Gibson, 1979). Zajonc (1980) has protested that preferences do not require any elaborate cognitive processes such as access to stored representations of information like schemas or prototypes. He believes that emotional reactions are immediate and usually precede such processes; it is only afterwards that people explain or rationalise their reactions in the language of mental processes such as thoughts and judgements. Zajonc has attempted to support his position with experimental evidence. In typical studies, stimuli are presented for very brief exposure times (fractions of a second), and for a variable number of occasions. Participants judge these stimuli in terms of whether or not they like them and also whether or not they recognise them. Participants tend to like best the stimuli they have most often encountered, whether or not they recognise them; that is to say, liking appears to be independent of subjective recognition.

The implications of Zajonc's thesis for cognitive and indeed all analytical approaches to explaining preferences are profound. Zajonc distinguishes between *preferenda*, those features of stimuli that produce affective reactions, and *discriminanda*, those features and components that are revealed in analysis. For example, in any given place and time, people might agree as to the relative attractiveness of photographs of faces, and these judgements could be defined as being triggered by some qualities in the face (preferenda). Yet it does not seem possible to identify these qualities though measuring lines and angles, shape of the eye or curvature of the mouth. These dissected faces could be used to study recognition processes, as in the use of photofit techniques by the police. Zajonc argues that 'The

stimulus features that serve us so well in discriminating, recognizing, and categorizing objects and events may not be useful at all in evaluating these objects' (p. 159). Preferenda, if they exist, have so far evaded identification; indeed, their existence surely calls into question many of the strategies of investigation that we have been considering.

Despite Zajonc's strictures, cognitive approaches have become dominant in the study of affective reactions. In his study he restricted himself to evaluative reactions, the extent to which something is liked or disliked. Other reactions are more complex, yet still immediate and apparently direct or involuntary. For example, blushing appears to be an immediate and uncontrollable response. Yet it surely has to follow some kind of categorisation of the situation and an understanding of its implications for the image that the person is trying to present. Castelfranchi and Poggi (1990) have presented a detailed analysis of blushing in terms of the blusher's beliefs about himself or herself and the nature of the situation. Clearly it is not necessary that the blusher is aware of this activity, most of which is presumably unconscious. However it is hard to understand this reaction without reference to this kind of categorisation – why does the person blush rather than go pale; why does one person blush in this situation when another does not? Also, it is not unreasonable to talk *as if* the blusher has such a categorisation in the head, even though we understand that he or she might not be able to articulate this knowledge. Speaking, reading, driving a car, improvising in jazz are all 'fast' activities that have become automatic and unconscious over a period of time. Analysis of these skills is, on the other hand, slow and difficult. We should not therefore be pessimistic, believing that we can never illuminate their complexity by analytical means. This issue is one that will continue to preoccupy psychologists, especially so as further progress is made in the computer modelling of complex human activities.

The complexity of meaning

So far our discussion has been restricted to the role of meaning in determining affective reactions that can summarised in terms of liking and preference. Objects and events elicit responses over and above these, and indeed they seem to be trivial aspects of our responses in the context of the significance to people of, say, their war

medals, the photograph of a dead partner, a 'priceless' old master, an image of the Buddha. These objects are all rich sources of psychological meaning. Belk (1991) has pointed out that even contemporary mass-produced objects may be conceived to have 'magical' properties, with the capacity to protect their owners from harm, to cure, to empower, to bring good luck. However, consideration of these possible meanings of objects within a single book, never mind an individual chapter, would be an impossible task. There are several reasons for this. The first reason is that it would not be possible to do justice to the extensive and rapidly growing literature on the meanings of material objects, as taken from anthropological, economic, historical, philosophical, psychological and sociological perspectives. Reviews of this literature may be found *inter alia* in two collections of papers edited by Appadurai (1986) and Rudmin (1991).

A second, more daunting reason is that 'meaning' has been the major preoccupation of intellectual study in this century. This preoccupation has one antecedent within psychology, in the psychoanalytic movement whose influence spread from psychiatry into the humanities, offering concepts for the study of meaning in many disciplines; literature, art history, anthropology, cultural studies, feminism, history, sociology, and so on. As psychoanalysis developed into an extensive field of study in its own right more recent scholars such as Lacan have made further significant contributions. There are other approaches to meaning that draw upon research into the nature of language. Researchers have looked beyond the diversity of human languages to consider language as a highly complex system dedicated to the communication of meaning. Meaning is conveyed by the structure of language in that a word takes its meaning from the words that surround it, and changes, for example, in the order of words or in the emphasis that is placed on different words can produce marked changes in the meaning of an utterance. Comprehension of language also requires knowledge of the world, and a computer program that enables a computer to understand even simple statements would have to incorporate quite extensive knowledge about the world.

Psychologists have proposed that such knowledge may be represented in humans in the form of scripts or prototypes for routine sequences of events such as shopping or eating at a restaurant. Each of us has such extended knowledge and this can be utilised with

effect by communicators in politics or in advertising who can suggest meaning without having to spell out all the details. Investigations into the structure of language by Saussure and into the philosophy of meaning by Peirce have been extended into the fields of structuralism and semiotics, the study of cultural products as systems of *signs*. Here a sign is regarded as an object with meaning that can be analysed into two components; the signifier, the material object, and the signified, which is its meaning (Williamson, 1978, p. 17). Semiotic approaches have been taken to the study of everyday objects, most notably by Barthes (1973). It is unfortunately well beyond the scope of this book to review these approaches to meaning.

The unconscious meanings of objects

Freud has had a remarkable impact upon cultural life in this century. Art history, sociology, literary theory and feminism have all absorbed the ideas of Freud and his followers such as Jung and Lacan. Only psychology has resisted, largely on the grounds that psychoanalysis is 'unscientific', as discussed in the introduction. Study of psychoanalysis has led many to believe that the theory is true, that its arguments are convincing or its observations telling. The criterion of truth to one's experience has been sufficient for many. Certainly the theory has attractive qualities. It is broad in sweep where so many psychological theories are narrow; it deals with sex and death, the central preoccupations of our secular world. It offers an explanation of the fragmentation of experience, a concern for any industrialised society. It offers insight into family life, into the relationship between the individual's wishes and society's constraints. I shall look briefly at some of its observations on the psychology of the material world.

The most significant period in the development of psychoanalysis comprised the few years between 1897, when Freud revised his theory of the origins of hysteria to emphasise the role of infantile sexual wishes, and the first decade of this century when he produced in rapid succession *The Interpretation of Dreams* (first published in 1900), *The Psychopathology of Everyday Life* (1901) and *Jokes and Their Relation to the Unconscious* and *Three Essays on the Theory of Sexuality* (both in 1905). During this period Freud augmented the observations from his case studies with findings derived from

self-analysis, particularly the interpretation of dreams. The elements of his theory were to be elaborated over many years but are already evident by 1902. The motives for human behaviour, he held, are normally inaccessible to introspection and are to be found in the unconscious part of the mind. These motives are inherently sexual. The unconscious is not an inert residue, but is dynamic and exerts a powerful if unrecognised influence on behaviour. The sources of sexual gratification have a developmental history within the early life of each individual, and the turning-point in this history is the Oedipus complex. This refers to a conflict between child and parents that takes place in the mind of the child, and the form of its resolution has lifelong consequences. One corollary of this thesis is that human behaviour that has no apparent connection with sexuality nevertheless has its source in unconscious sexual wishes. For example, the aesthetic sense is explicitly linked with sexuality; 'the concept of beautiful has its roots in sexual excitation'. Or the pleasure that is derived from possessing objects can be traced to the anal stage of human sexual development.

A further assertion of the theory is that sexual wishes are unconscious because their conscious recognition would be traumatic, and so only disguised images of unconscious material can ever be admitted to the consciousness. This was one of the major themes of *The Interpretation of Dreams*, in which it was argued that careful analysis of the contents of dreams would reveal repressed sexual wishes. Errors, slips of the tongue, jokes and many apparently trivial products of the mind could be revealing. Dreams were not direct representations of the unconscious but were the product of 'dreamwork'; the wishes were 'worked upon' to preserve their secrets. Freud described several components of dreamwork. In displacement, the central elements of the recollected dream are less significant for interpretation than are the more peripheral elements, so apparently incidental details can be the most revealing. Incidents in the dream may reflect a process of condensation in that a particular incident may be replete with meaning and give rise to many interpretations. Dreamwork also entailed representation devices, which operate much like conventions familiar from the cinema: cause and effect may be represented by a sequence of images or by one image transformed into another; several persons who are linked together may appear as one person; and finally there were fixed symbols – parents might

Manfactured pleasures

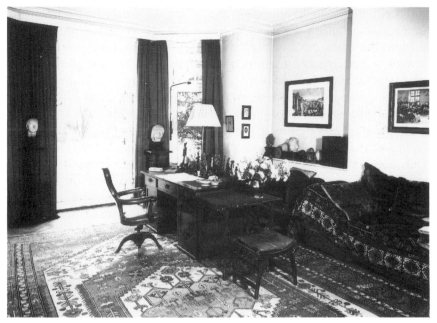

17 Freud was a passionate collector of antiquities. His study desk was
replete with objects from his extensive collection. He recognised the
parallel between the historicism of psychoanalytical research and his
interest in objects as relics, writing of his 'fondness for the prehistoric
in all human manifestations'

appear as kings and queens, sticks and swords were phallic symbols,
and containers of all kinds could represent the womb.

The so-called Freudian symbols are the best known contribution
of his theory in regard to the consideration of objects. Many com-
modities are said to be pleasing because of their symbolic sexual
qualities. This approach seems especially applicable to automobile
design, and no discussion of high-performance cars seems complete
without reference to Freud's theories. The most conspicuous exam-
ple is surely the E-Type Jaguar, introduced in 1961, whose combina-
tion of sleek lines, elongated bonnet and high performance is
invariably described as phallic. Such is our familiarity with these
symbols and their role in design, particularly in advertising (a book
title like Packard's *Hidden Persuaders* shows the concerns of many
that the consumer's unconscious can be contacted directly via an

appropriate choice of message) that it is difficult to be certain that these postulated qualities have not been acquired by more direct means; that they have, in fact, been learnt through association. The sexual connotations of automobiles, from Pirelli calendars to the obligatory under-dressed women who accompany the display of new models at the Motor Show, may owe more to repetition and the conscious fantasies of company directors than to Freud. In any case, such blatant imagery seems remote from the subtleties of dreamwork. In a more fruitful approach, Williamson (1978) has drawn upon Freudian theory as well as upon concepts from semiotics in proposing that the meaning of advertisements can be understood or 'decoded' in terms of an analysis of 'advertising work'. For example, products can be provided with an image that differentiates them from other, highly similar products; by portraying them in conjunction with images that already carry meaning outside the world of advertising. One of her points (and her expressed reason for applying the concept of dreamwork), is that this process connects *systems* of meanings, not isolated products and their individual associations.

A further, if less direct, legacy is the theory's influence on modern art and design practice, and this may be demonstrated through examination of that imagery which is commonly described as surrealist. There is a very close historical connection between psychoanalysis and the Dada and Surrealist movements in literature and the visual arts. Breton, the author of the 1924 Surrealist Manifesto, had some experience in psychiatry during the First World War, was familiar with the first French translations of Freud's writings and visited him in Vienna in 1921. The emphasis upon hidden sexuality and the unconscious and techniques of free association and the analysis of dreams were seized upon by Dadaists and Surrealists who were eager to challenge and ridicule conventional values. Psychoanalysis could provide a justification for the depiction of dream imagery, as in the work of Dali, Ernst and De Chirico, and for the use of techniques which were claimed to minimise conscious control and to provide an equivalent of free association, as in the use of chance findings and 'automatic' processes utilised in the work of Ernst and Masson or the 'photogram' invented by Man Ray to produce images by exposing to a light source objects that were placed on light-sensitive paper. Heartfield in Germany and Rodchenko in Russia used photomontage and the juxtaposition of images to telling effect. Incongruous

juxtaposition, visual puns and representational devices of many kinds are now commonplace in many areas of design. In contemporary graphic design many successful advertising campaigns, notably for Guinness and for brands of cigarettes have made much use of these techniques. These are just a few examples of the influence of psychoanalysis upon design practice. In addition, the theory offers accounts of the 'psychological meanings' of objects, and we can illustrate these through consideration of two phenomena, transitional objects and fetishism.

Transitional objects

Psychoanalytical accounts of human development suggest that in the period following birth the infant is unaware of any distinction between him or herself and the mother. Psychologically, there are no objects separate from the self. Gradually there is a process of individuation which involves an awareness of the separateness of self and mother, and, according to one branch of psychoanalysis (object relations theory), the first external object to be perceived is the mother's breast. This object is imbued with significant properties, and this first relationship between infant and object is regarded as having important implications for long-term psychological development. Winnicott (1953) was the first to investigate the psychological significance of young children's early 'not-me' objects; their attachments to objects often being called 'comforters' or 'pacifiers', like the corner of a familiar blanket or a soft toy. Winnicott observed that these attachments are very common and take a predictable form. The infant comes to depend on the object to the extent that she must not be separated from it, particularly at bedtime or when she is upset. She assumes rights over the object, which must never change, unless changed by the infant, until, with time, the object loses its special meaning. The object seems from the infant's point of view to have 'a life of its own'; it has warmth and texture and may be moved in habitual and stereotyped ways by the infant. Research indicates that this relationship with objects is widespread and can be observed in many different cultures. There is nothing to suggest that there is anything unhealthy or maladaptive in these attachments (Tabin, 1992). There has been much debate about their significance, but there is a consensus that they play a positive and significant role in development.

Winnicott used the expression 'transitional objects' to indicate not only that these occupy a place in the transition between early fist- and thumb-sucking and later play with toys, but that they help the growing child to develop her separation from the mother by enabling her to form a reliable mental representation of the mother. This representation is related to the possibility of illusion and, later in life, to creativity. Tabin (1992) relates transitional objects to the child's integration of a sense of self in that they offer a means of *objectifying* the self; they are part of the self but at the same time are under the child's control. At a time when linguistic abilities are rudimentary they offer the possibility of a 'dialogue' with the self. Gulerce (1991) argued that this phenomenon should be not be seen in isolation from its socio-cultural context. The development of attachments to transitional objects may be influenced by socialisation practices that interact with the child's (innate) temperament. More generally, societies differ in their orientation towards autonomy or dependence, and accordingly they may promote the use of transitional objects to a greater or lesser extent. There is indeed some evidence that the incidence of transitional objects varies across different societies (Gulerce, 1991).

Fetishism

The term 'fetish' is often used to refer to magical properties of objects, where the source of these properties is attributed to a god or to the object's seeming to possess a will of its own. In Freudian theory the term fetishism refers to a sexual perversion, where a person depends on some material object, particularly clothing, for his sexual gratification. In typical cases, a man may seek gratification through masturbation with items of women's underwear, stockings or shoes, or require his partner to wear such apparel for satisfactory sexual intercourse. Such behaviour is not uncommon and is familiar to counsellors and psychiatrists; although fetishism is a 'perversion' in Freud's usage of that term, it often only becomes a problem in conjunction with other sexual or relationship difficulties. We still, of course have to ask why such fetishes have developed and why particular garments are chosen, and Freud offered an answer to these questions. His answer is related to castration anxiety, a concept that plays a key role in his account of the Oedipus complex. Here a boy takes his mother as the object of his love and perceives his father as

his rival. The boy's observation that his mother has no penis is a shocking and frightening one, giving rise to the fear that he will be castrated, that is, he will lose his penis in the conflict with his father. This conflict and fear are driven into the unconscious, but remain there to determine future adult behaviour. One method of coping with this fear is to make a fetish of the last object seen before the traumatic sight of the mother's genitals, and this is why 'fetishistic' objects are very often shoes or stockings, because of the child's low viewpoint; or panties, the last garment to hide the genitals. In a more symbolic way, fabric, like fur or velvet, may stand for the mother's pubic hair. As a corollary of this theory fetishism should be associated with an aversion to the female genitals themselves. To summarise, in the words of Bronstein (1992, p. 241): 'the fetish object represents the female phallus and ... it serves the defensive function of alleviating castration anxiety through the mechanism of denial in fantasy'.

We have only sketched out the theory; the best-known full account is provided by Freud (1928/1961). Nevertheless, the sketch does suggest many distinctive features of his thought. First, it relates a fairly common but puzzling phenomenon to one of the crucial events in human development, the Oedipus complex. It suggests the source of the fascination for the individual concerned, and also how the fetish offers an apparent solution to a deep conflict, in that it can be enjoyed in two ways. It is readily accessible in that it relates to the everyday experience of clothing; yet the awful origins of the pleasure need never consciously be acknowledged. Furthermore, this account illustrates Freud's reliance upon interpretation rather than prediction. For example, the castration complex is also hypothesised to be a cause of homosexuality; but whether fetishism, homosexuality or neither of these is the outcome is not specifically predicted by the theory. Freud does, however, provide an explanation of why the fetish, acting as a substitute penis, offers a resolution of the Oedipus complex that does not result in homosexuality. In fetishism it is the woman who is assigned the characteristic that gives sexual gratification (Freud, 1928/1961, p. 154). Finally, the theory demonstrates the subtlety of Freud's thinking in that the most obvious place to look for the explanation of fetishism (the look and touch of the material fabric of underwear or of shoes) is eschewed in favour of the temporal context in which these items were first seen; their psychological

function is emphasised: what is important is what they hide, not how they feel or look.

We have seen that the meanings of these two kinds of objects, transitional objects and fetishes, are essentially symbolic, and the origins of this symbolism are to be found in childhood. There has been some discussion of the psychological relationship between these two kinds of objects (Winnicott, 1953; Bronstein, 1992) that emphasises their differences; transitional objects are in a sense more optimistic in that they are associated with human growth and with the origins of creativity; fetishes are more pessimistic, backward-looking and associated with lack of sexual fulfilment.

Fetishism does, however, raise more general issues than those of minor personal sexual perversions. It follows from Freud's account that fetishism must be restricted to males. But see McClintock (1993) for an argument that psychoanalysis has ignored evidence of fetishism in women. This leads us to consider, first, the role of gender in psychoanalysis and, second, the part played by fetishism in contemporary society. There is a conspicuous asymmetry in Freud's explanations of male and female development. The crucial event is the Oedipus complex and the associated castration anxiety, but this must take different forms for males and females. The mother is the love object for both sexes, and a child's awareness of the mother's lack of a penis must have different implications for boys and girls. Freud struggled to provide a convincing account of female development, and the female version of the Oedipus theme, the Electra complex, is a more cumbersome, two-stage process. His account gives the distinct impression that male development is the norm and that female experience is a deviation from that norm. It might be thought that this problem would in itself be sufficient to condemn Freud's approach, but such is the robustness, or elasticity, of his concepts that some feminist writers have been able to accommodate his theory (see, for example, Mitchell, 1975). Certainly his account of human development makes the proposition that adult sexuality is achieved in the course of that development and is not determined by biology.

The observations that fetishism is a male perversion and that it is associated with an aversion to the embodiment of female sexuality highlights a further sexual inequality. It is the woman's body as well as her clothing that is the object of male desire, and rather than this being the fantasy of individual men, it is built into contemporary

culture. Fetishism in this broader sense takes many forms. One is the relentless depiction of the 'beautiful' woman, dressed or undressed. A second is the size and pervasiveness of the fashion industry. Of course there is a large fashion industry which is directed at men, but this has always been secondary to the marketing of clothing for women. A third is pornography. Where can the line be drawn to distinguish perversion from 'normality'? Can the term 'perversion' be applied to a society as well as to an individual? At first sight the distinction seems easy to draw. Fashion magazines or television programmes like *The Clothes Show* are at first sight a world away from the culture of pornographic magazines with their blatant exploitation of women's bodies. Closer inspection suggests a blurring of the distinction.

One can approach this question by asking what are the consequences of this imagery. Pornography has often been cited as a factor in violence against women. The literature of psychological research does not offer a straightforward answer to this question, and there is a counter-argument that pornography may act as a catharsis, offering a 'safe' outlet for inescapable male sexual urges. This claim calls as evidence the lack of association between access to pornography and aggression against women that is found in Scandinavian countries and in Japan. On the other hand, it may be simplistic to look for a direct causal relationship in which exposure to pornography makes an individual more likely to be violent; rather, the dissemination of such imagery may help promote a climate of attitudes towards women that may result in sexual violence being more prevalent then it would otherwise be.

This imagery is frequently believed to reflect, as well as to promote, hostility towards women, but this assumption has recently been challenged, notably by the videotapes and book of photographs by Madonna which make use of techniques common to pornography but which, it has been claimed, represent an increased control by women over their own depiction, or alternatively an ironic or sophisticated taking over of these techniques. This is, I think, a complex issue. There are problems with such a claim, given that these techniques are so well entrenched and spectators have well-prepared responses to them. Furthermore the argument that the images have different meanings simply because they are controlled by women is not in itself compelling, in that there are instances, for example in

the running of brothels, where women have exploited other women for financial gain. This would lead some to argue that depictions of women must be judged by their effects rather than by the identity or gender of their authors. On the other hand, if information is available it can alter a person's response to imagery. A spectator responds to all the information conveyed by a picture, and research has shown that the meaning of a message or picture is influenced by knowledge of its source or author. This suggests the conclusion that meaning will depend strongly on what the spectator brings to the act of perception, and, as a corollary, that the message as intended may not be picked up by many viewers. The same work may be both pornography and an ironic comment upon it.

Supportive arguments notwithstanding, pornography arouses distaste in very many people that is not elicited by conventional representations of women. Rather than presenting the humiliation of women, fashion imagery seems to promote an idealisation, and is life-enhancing rather than destructive; the ability to choose her appearance is a right of all women and a source of pleasure for many, and the industry that serves that pleasure adds interest and diversity to life. Yet here too there are negative consequences. The promotion of an ideal can create shame and anxiety among those who perceive themselves unable to attain the standard, and the emphasis on a youthful 'attractive' appearance is narrow and contemptuous of those whose age, physique, disability or ethnicity places them at variance from the ideal. The subject of individual choice has been challenged by De Beauvoir (1949/1987, p. 543):

> To care for her beauty, to dress up, is a kind of work that enables her to take possession of her person as she takes possession of her home through housework; her ego then seems chosen and recreated by herself. Social custom furthers this tendency to identify herself with her appearance ... [a man] does not normally consider his appearance as a reflection of his ego ... The purpose of the fashions to which she is enslaved is not to reveal her as an independent individual, but rather to offer her as a prey to male desires; thus society is not seeking to further her projects but to thwart them.

Women's dress has undoubtedly changed since De Beauvoir wrote *The Second Sex* (trousers, she observes, are being worn by women 'at the seashore – and often elsewhere', p. 692) but it is difficult to believe that the thrust of her argument, that the concept of femininity

is imposed upon women by social convention, and that it is not possible to dress for oneself, is not valid today. The concept of femininity is, as she suggests, linked with male desires, and the design of woman's clothes is to a large extent a matter of attaining a balance between exposure of the body and modesty, with the point of balance shifting with changes in fashion; the mini-skirt goes out of fashion and the long, split skirt comes in. The parallels between this process and the fetish are striking. In anthropological research there is a frequent connection between the fetish and the taboo, with explicit rules about what can and what cannot be seen. The glimpse of bosom or of leg may act more directly as a fetish in the Freudian sense. The glimpse of a woman's thigh above her stocking top is a signal for arousal, but her thigh exposed at the beach or at the swimming pool carries no such message. Finally, and more generally, there is in the concept of the fetish the notion that a sexual object is a poor substitute for life as it is, that a complex of defences, of evasions and denials prevents us from coming to terms with each other as individuals.

The classification of meanings

I restrict myself here to some psychological perspectives on the meaning of objects, and recognise that much less attention has been paid to this question in comparison with the attention paid by psychoanalysis and the other disciplines I have mentioned. Graumann (1974) has argued that psychology has been impoverished by its neglect of the 'concrete typical or particular things of our everyday world'. Psychologists have isolated physical attributes of objects for measurement and manipulation, but in the process they have abstracted behaviour from the world in which it takes place, which affords opportunities for it and shapes it. Thus, for example, memory is studied as something that goes on within an individual's head, with little consideration of the alarm clock, diary, scribbles on the back of the hand, knotted handkerchief, or personal organiser that form parts of the person's memory.

Since Graumann's article there has been much research, and an issue that has attracted attention is the recognition that one and the same object may have different meanings. Can these meanings or different aspects of meaning be classified? One approach has been

the straightforward one of asking large numbers of people to evaluate sets of 'stimuli', such as pictures and objects, in terms of bipolar descriptive adjectives ('good–bad', 'fast–slow') and to apply statistical techniques to these evaluations to see if they can be reduced to a smaller number of more basic dimensions. Research of this kind into a variety of stimuli has suggested that three such dimensions can be reliably identified, and these have been labelled Evaluation (good–bad), Potency (strong–weak) and Activity (active–passive). The reader may note that there is some similarity between this approach and that of Berlyne discussed earlier. Sets of adjective scales that characterise these three dimensions can provide the basis of a measurement scale known as the Semantic Differential Scale, for the assessment of any stimulus, and this has been widely used both in psychology and in consumer research, where, for example, the possible meanings for potential customers of a new product or of changes in the packaging of an existing one can be assessed before it is put into production. A concrete example is provided by Kasmar (1970) who has developed a sixty-six-item semantic differential, the Environmental Description Scale, which provides a means of assessing people's reactions to architectural spaces. Developments of these techniques for assessing what might be termed the 'connotative' meanings of objects have been most closely associated with the American psychologist Osgood. He has argued that this reliable tendency to identify these three dimensions should be explained in terms of evolutionary processes, in that survival for animals and humans requires rapid evaluation of such environmental events as potential predators or sources of food in terms of their positive or negative implications, their strength and activity (Osgood, May and Miron, 1975).

The goal of data reduction techniques such as the semantic differential is to detect order underlying diversity, and these methods have practical value for eliciting meanings that may be difficult to articulate or may otherwise remain unnoticed. Conversely, these techniques must also *lose* meaning, in that the distinctions connoted by the original adjectives are lost. Languages have a large number of words in order to make distinctions in meaning, including shades of meaning, and the problem for any psychological account is to attend to these, while also recognising that the vocabulary does not in itself provide a theory of meaning. Hans and Shulamith Kreitler

(1990) have responded to this challenge by offering a scheme for the study of meaning that is based on a psychological theory of cognition. This theory is a development of the contemporary information-processing paradigm. The concept of meaning is central to their theory in that they argue that cognitive processes have not merely evolved to abstract meaning from the environment but are also themselves systems of meaning that influence the processing of information. Thus the cognitive contents of the mind shape the course of the identification and elaboration of meaning in the environment, and the 'meaning value' of any object or event, or 'referent', can be evaluated in terms of cognitive contents. Kreitler and Kreitler propose that the meaning value of any referent must be evaluated in terms of five variables: Meaning Dimensions, Types of Relation, Modes of Meaning, Forms of Relation, and Shifts of Referent. Each referent can be characterised in terms of twenty-two specified dimensions of meaning, including its function, actions or potentialities for action, material, structure, sensory qualities, and the feelings and emotions evoked by the referent. Thus any referent could elicit from any individual a profile of meanings on these dimensions. Not all dimensions will be equally relevant to every referent, and individuals will differ in their relative use of dimensions. Types of referent-meaning value relations range from attribution ('Madonna is a pop star') and comparison ('Madonna is the world's best pop star') to exemplification and metaphor-symbolic (Madonna as a 'true feminist' whose blend of 'the dynamic Dionysian power of dance and the static Apollonian power of iconicism' embodies a brilliant riposte to 'the puritanism and suffocating ideology of American feminism' (Camille Paglia, quoted by Worth, 1992)). Two modes of meaning are distinguished, the lexical, interpersonally shared mode, typically making most use of the attributive relationship, and the personal-subjective mode, which more frequently uses exemplification, metaphor and symbol. Seven Forms of Relation are distinguished: positive, negative, mixed positive and negative, conjunctive, disjunctive, combined positive and negative, and obligatory. Finally, the system identifies ten Shifts of Referent, listing categories for instances where meaning values are assigned to variants of the referent.

This scheme for describing the meaning values of referents has wide applicability. It provides an opportunity to examine the meanings people attribute to objects and places. Thus a child or

group of children could say or write what the Nintendo game *Super Mario 3* meant, and this description could be classified in terms of the five meaning variables. Some dimensions will be emphasised more than others; perhaps the game's potentialities for action and its sensory qualities. Other dimensions such as the game's size, structure and material may not appear in spontaneous description but the child might be said to have passive command of these dimensions in that she is able to respond to questions about them. Many meanings will be widely shared, others may be more personal and idiosyncratic. They might involve shifts of reference to other characters, games, or activities. Kreitler & Kreitler (1990, p. 195) suggest that adults who have experienced typical secondary schooling 'make active use of 11–13 meaning dimensions, with idiosyncratic differences in frequency, the attributive and exemplifying types of relation, at least two forms of relation (assertion and negation) and some shifts in reference.' We should not give the impression that these researchers construe meaning as a list, however complex, that we can consult to determine the meaning of an object. The assignment of meaning value is regarded as a dynamic process, changing with interactions between the cognitive contents of the individual's mind and his or her environment. The dimensions are strategies for applying these contents to some referent, and the referent in turn achieves its status by virtue of the assignment of meaning to it. Thus the coding scheme should not be considered as a lexicon but as a method for glimpsing meaning values at some point in time.

There is more than one approach to the identification of personal-subjective meanings of objects and places. Rather than have some pre-existing scheme for describing meaning, the researcher may pursue a less structured strategy, to discover which aspects of meaning emerge from spontaneous description. Each approach has its strong and weak points. A scheme like that of the Kreitlers permits comparisons to be made among objects and people. It also relates meaning to an underlying theory. On the other hand, this is at the cost of imposing that theory upon participants. A more open approach may be sensitive to fresh meanings and may accommodate differences in the salience of meanings that cannot necessarily be summarised by counting the frequency of references. However, it may not be possible to generalise from the results obtained from a single study. Furthermore, the interviewer may introduce personal bias

into the interview procedure or an idiosyncratic reading of the material.

Personal meanings

We now consider some attempts to classify the personal-subjective meanings of objects using a less structured approach. Bih (1992) interviewed a sample of Chinese students about their experiences after they had been living in New York for one semester. The interviews were not planned beforehand to facilitate the identification of any particular themes, but the transcripts were subsequently scrutinised, and the meanings of every object mentioned were coded using a scheme that evolved during successive readings. Seven dimensions of meaning were identified: (i) objects with a predominantly functional significance (for example, a radio); (ii) objects that embodied cultural or personal values or ideals (Buddhist scriptures); (iii) objects that marked some personal achievement (a degree certificate); (iv) objects as an extension of memory (a photograph from the past); (v) objects for deepening experience (a teaset, as taking tea can be a shared experience, an activity to be cherished); (vi) objects for social exchange (keepsakes or photographs with significance for personal relationships or as aids to conversation); (vii) objects as extension of the 'core' self (where the boundaries between self and object become blurred; for example, soft toys that can be described as 'transitional objects', and personal diaries).

There was little evidence in the interviews of the social status symbolism of objects. The particular interest of this study was the possible changes in the meaning of objects that might be associated with the change in the participants' environment, and in the function of objects in maintaining continuity in personal identity and helping the person to relate with the past and to adapt to the new circumstances.

The meanings of objects for a group of graduate students living in a new country may not be generalisable beyond the particular study, but there are similarities between Bih's analysis and several other studies. In these studies people were asked to list their most treasured possessions (Dittmar, 1992; Prentice, 1987), 'the things in your home which are special to you' (Csikszentmihalyi and Rochberg-Halton, 1981), and they were also asked why they had named particular objects. The most frequently mentioned objects were what

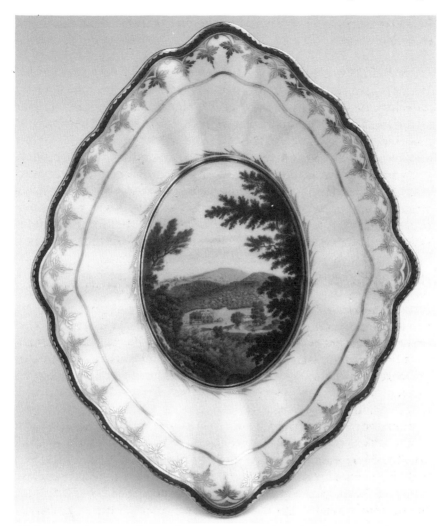

18 Layers of personal meanings: one possession, the dessert service, portrays a further possession, the house. Centrepiece of dessert service, 1787, made for Thomas Jones and painted with a view of his estate at Hafod

one might expect: furniture, jewellery, photographs, art objects, electrical equipment such as televisions or sound systems, and so on. Of greater interest is the analysis of the reasons why particular objects were named, as these are indicative of their meanings for their owners.

People's reasons were assigned to different categories, such as mementos, physical qualities, uses, and self-reference. For example, Csikszentmihalyi and Rochberg-Halton (1981) elicited from their 315 respondents a total of 1,694 objects and 7,875 reasons why the objects were special, and these reasons were assigned by a pair of coders to one or more of thirty-seven meaning categories. That is, each participant named approximately five objects, and each object could be placed in roughly four categories. Dittmar's coding scheme involved thirty-four categories. Categories themselves can be grouped into a hierarchical scheme where higher-order classes include lower-order ones, and it is at these higher levels that one should be able to identify the core meanings of everyday objects. As an illustration of such a hierarchical scheme I present below a tree diagram that I have based upon the categories proposed by Csikszentmihalyi and Rochberg-Halton (1981, pp. 268–76)

What can be learned about the meanings of objects from such classification schemes, and how do these meanings relate to their design? First, it is apparent that there are recurring distinctions in meaning in the different studies. One basic distinction (Prentice, 1987) is between the instrumental purposes of objects and their symbolic value. Many of the objects named are essentially utilitarian, in that they serve particular functions; furniture, kitchen appliances, electrical goods, cars, and so on. The effectiveness with which they fulfil these functions plays a large part in their evaluation, and much consumer behaviour is directed at searching for information about such effectiveness. For example, recent years have seen a large increase in the number of specialist magazines which regularly include tests and evaluations of products of interest to their readers. Advertisements too frequently include technical and other information about products to give the impression that these are reliable and score highly on performance indicators. Intrinsic properties of objects, the quality of their materials, whether an object is handmade or mass-produced, are also a source of meaning. Utilitarian objects also have symbolic value, and much advertising is directed at this, aiming to create or confirm an image for the product. Empirical studies of meaning give insight into these images.

This kind of study also has its limitations in that the classification scheme can only reflect the responses that people make, and these in turn are determined by the questions that are posed and respondents'

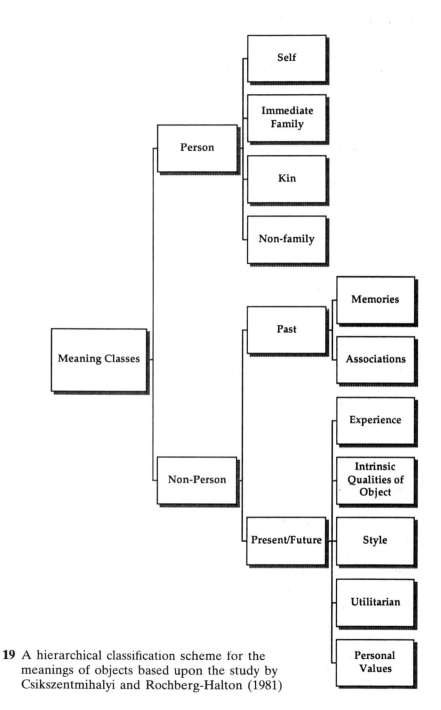

19 A hierarchical classification scheme for the
meanings of objects based upon the study by
Csikszentmihalyi and Rochberg-Halton (1981)

interpretations of these questions. Respondents may be unable to articulate aspects of their possessions, or they may be unwilling to reveal themselves as perhaps snobbish or mean. The wording of questions may lead people to give more emphasis than they otherwise might on certain aspects; for example, they may focus more upon the personal significance of objects because they believe that that is the area being probed by the investigator.

Objects as symbols of the self

Much of the discussion has concerned the relevance of belongings to the individual's self-concept or sense of identity (the subtitles of the books reporting the studies we have discussed here are 'To have is to be' and 'Domestic symbols and the self'). The meaning category 'self' in the study by Csikszentmihalyi and Rochberg-Halton was the most used of all the categories, referred to by some eighty-six per cent of respondents. Self-expression was also a superordinate category in Dittmar's study, with its subordinate categories: self-expression for others to see; individuality and differentiation from others; symbol for personal future goals; symbol for personal skills or capabilities (1992, p. 131). Additional categories in these studies are also clearly relevant to the self, for example the sentimental value of objects as souvenirs, gifts that have been received, mementos of childhood or of one's parents, or reminders of specific past occasions. Personal experience can of course imbue any object with these connotations, though some might attract them more readily than others, such as photographs, works of art, furniture and crockery, the most commonly cited examples in the Csikszentmihalyi and Rochberg-Halton study. Products can be designed or marketed to elicit such connotations, through choice of materials and packaging, historical references in the name, colouring or labelling, or their associations derived from advertisements. Many commodities are advertised as being traditional, long-established, or originating in some golden past, and the skills of arranging costume and setting to produce period dramas are used effectively to create the illusion of such a provenance. Related ideas have emerged from researchers into the built environment. We have already mentioned Altman's proposal that the regulation of privacy serves to maintain a sense of identity and enhance self-esteem. Proshansky *et al.* (1983) define the

concept of place-identity as an aspect of one's self-concept that summarises the understandings of place that have been acquired through experience. This is important to a person's well-being in that it helps to maintain a sense of self and gives meaning to the environment. It also provides an outlet for the expression of the person's tastes and preferences.

The self is a complex concept, and for a long time psychology shied away from the philosophical difficulties entailed in its study. Yet the notion that one's belongings play an important part in the definition of self is a long-standing one, which received perhaps its clearest expression in the analysis of the self proposed by William James in 1890. James argued that the self was not unitary but comprised different aspects, including the bodily self, the spiritual self and the empirical self. He wrote on this final aspect: 'In its widest possible sense, however, a man's Self is the sum total of what he can call his, not only his body and his psychic powers, but his clothes and his house, ... his land and horses, and yacht and bank account ... If they wax and prosper, he feels triumphant; if they dwindle and die away, he feels cast down.' One can bring to mind countless examples of the role that material possessions play in an individual's sense of who he or she is, of the emotions of pride or shame that may be felt for one's home and belongings, of the sense of loss at leaving one's home, of the anger and hurt experienced by the person whose home has been burgled. In a sense, then, possessions are part of our definition of the self, but this still leaves unanswered the question of how different possessions reflect upon the self in different ways, giving rise to preferences for some objects over others.

The self-concept

What ideas are communicated by attributing to someone the concept of self? From the perspective of the development of the person, the most basic idea is that of the infant's awareness of his or her separate existence, the distinction between self and other, the understanding that one is not part of the mother. As the child matures, the concept of self encapsulates further qualities of experience. First is the notion of continuity, the idea that one is the same person now as in the past. Adults have many grounds for this belief; for young children it may be based on their name and their appearance rather than on beliefs and values. A second notion is distinctiveness; one is different

from other people, and cannot change from being one person to another, for example, one cannot change gender. Third is the idea of uniqueness; I am different from everyone else in that there is not, and has never been, another person exactly like me. Again, this is a truism for adults, but only a gradual achievement for children. Finally, psychologists have suggested that there is an evaluative component, usually labelled self-esteem, the individual's sense of his or her worth. There is an obvious correspondence between these attributes of the self and the meanings of things identified in Dittmar's study; our possessions affirm our sense of continuity, that we are distinctive, unique, and worthy.

However, our account gives a false picture of our present understanding of the development of the self, in that it suggests that a sense of these self-qualities is an inevitable outcome of maturation, achieved by the child simply through the process of growing up. This is not the received view in psychology, which stresses that the self is *constructed* rather than an inevitable consequence of growth, and that other people play the key role in establishing the self-concept. This view may be traced to the American philosopher G. H. Mead, who proposed that the self is formed in the process of interactions with others and is our internalised conception of others' perception of us; we come to see ourselves as we believe others see us. This theory of the social origins of the self has several implications for the relationship between the self and the meanings of objects, implications that can perhaps be brought out most clearly by examining the meanings conveyed by clothes.

Richard Sennett (1976) has chronicled changes in fashion from the eighteenth to the nineteenth century. At one level the historian can document changes in the appearance of clothes, in the use of drab or bright colours, in the degree of exposure of the body, in the constraints upon the body imposed by the corset or the bustle. At another level one can try to understand the reasons for these changes and their implications for the self. Sennett suggests that in the eighteenth century clothes indicated social status to a precise degree. A person's occupation could readily be identified from their dress, and indeed in both England and France people were forbidden by law to wear clothes that were not appropriate to their station in life. There was a marked distinction between clothing worn in public and in private, where different social groups tended to dress

in broadly similar ways. In the next century public dress became much more uniform and seemed to reflect people's wish to appear less conspicuous. At the same time it was believed that clothing was expressive of a person's character and that variations in small details of dress could be revealing of personality. This gave rise to anxiety over appearance and increasing self-consciousness that can be contrasted with the earlier period when 'appearances were put at a distance from the self' (Sennett, 1976, p. 167).

There are two notions of self here; the social or public self that is related to a person's appearance in society, and the private self. This is a distinction that is apparent in much of our thinking about the self. The term 'personality', derived from the word for an actor's mask, refers both to personality as seen and to some inner quality. The related notion of identity also shares this. The psychoanalyst Erikson (1968, p. 22) conceives of identity as psycho-social: 'We deal with a process "located" in the core of the individual and yet also in the core of his communal culture'. What are the implications of this? First, there is the idea that the relationship between the self and appearance is not fixed but is affected by broader cultural changes, as in the growth of urban life and changes in relationships among social groups. Hence it is unwise to attempt to make definite inferences about the meanings of objects, since these too may be expected to change.

This may particularly be the case with respect to women's appearance, as we are living in a period of marked changes in women's roles in the economy and in the family and in women's view of themselves. Second, it is not the case that appearance can only express either personality *or* social status. In our own time clothing is regarded as indicative of both; people dress to 'be themselves' and may become angry if they are advised that a particular form of dress is unacceptable, believing that their rights are being infringed. People often rage at rules and conventions, seeing them as obstacles to authenticity. At the same time conventions about the form of dress that is appropriate for particular occasions are perhaps as widely respected as ever, and there remain differences in the clothing that is worn and valued or disparaged by different social groups. Slight variations in garments can have great significance. Similar pairs of jeans can be sold for very different prices depending on the label attached to them.

Erikson regarded adolescence as the period in which a person's concerns over his or her identity were at their peak, when the person had to make choices about occupation and 'lifestyle'. This is evident in adolescents' self-consciousness and anxiety over their appearance, and in their assertion of individuality and strong conformity, particularly to groups and ideas that are not valued by, or that challenge those of their parents. It is difficult to illustrate this since fashions can change so rapidly, but one only has to think of a sudden surge in the sales of baseball caps of the International Stussy Tribe, or watch secondary school pupils' modifications of the uniforms they are obliged to wear.

The self as actor

Consideration of the dual nature of the self immediately brings to mind the idea of the stage, where the actor consciously plays a performance and adopts an identity other than his or her own. The word personality reflects this idea, and Sennett draws effectively in his analysis upon similarities between theatre and public appearance. In his seminal work, *The Presentation of Self in Everyday Life*, Goffman proposed that a person's identity is linked with the impression that she makes upon other people, in the sense that she cannot assert this identity without the other's acceptance of her in that particular role. In order to explore these aspects of identity Goffman found it useful to adopt a dramaturgical metaphor, to use the theatre as a means of focusing upon otherwise unnoticed but important aspects of everyday life. Consider stage set, props, and costume; to play the role of a doctor it is not sufficient to have the required diploma (nor may it be necessary – one hoary chestnut in the tabloid press is the story of the fraud who manages to convince an entire hospital that he is a qualified doctor); one's bearing, appearance, dress, the design of one's consulting room and so on must be appropriate. Naturally one does not have to discover what is appropriate by a process of trial and error; the process of becoming a doctor involves learning the part, learning how to be in character. The role of the doctor readily lends itself to a dramatic account, but Goffman's thesis is that all routine behaviour, including making choices about one's dress and belongings, can equally be understood in such terms. Naturally there are stock characters known to every repertory company; the business woman in her sharp suit, the harassed school

teacher, the hard-drinking journalist; but more generally, all our actions are regarded as providing information about the kind of person we are.

Our gestures and postures are revealing of status and of gender. Goffman (1979) identifies gender differences in advertisements that epitomise John Berger's remark that *'men act* and *women appear'*. Berger continued, 'Men look at women. Women watch themselves being looked at. This determines not only most relations between men and women but also the relation of women to themselves. The surveyor of women in herself is male: the surveyed female. Thus she turns herself into an object – and most particularly an object of vision: a sight' (1972, p. 47). Goffman's analysis supports this thesis, drawing attention to how men and women are depicted. Women are often depicted as passive, lost in thought, with gaze averted or looking as it were, out of the page at the reader looking at her. They withdraw from the current situation by hiding or turning the face, looking into the distance or 'nuzzling'. They adopt deferential postures like the 'bashful knee-bend' or the lowered head . It might be thought that such representations would become less frequent as journalists and their readers reflect changes in women's roles. Yet inspection of contemporary magazines suggests that this is not the case. This stability in representation is presumably because boys and girls are socialised from birth into gender-appropriate gestures and postures which then come to seem 'natural' and resistant to change in the short term.

One of the most striking examples of the depiction of women in recent years has been the treatment in the media of the Princess of Wales. She is probably the most photographed woman of all time, and her appearance and dress are subject to intense, daily scrutiny. Much of this interest is due to the mystique attached to the role of princess, with all its fairy-tale associations, but it is noticeable how much her portrayal resembles that of models in advertisements. Many of the categories that Goffman identifies apply very readily to her, particularly in pictures taken in the first years of her marriage. In one sense this is a style of photography that is imposed upon her – she *is* a model, and is photographed like one. Yet these postures, the distant gaze, averted eyes and lowered head, can also be seen in the past, in portraits of women by Pre-Raphaelite painters like Burne-Jones, for example, and are not merely the clichés of contemporary

a

110

b

20 The ritualization of subordination. Goffman argued that
advertisements tend to portray women as appeasing and dependent,
using a code of postures and gestures like smiling, head cant and
lowered eyes. This image remains pervasive (*a*). The same
contemporary magazine shows, humorously, a more assertive woman
(*b*) – a change in role, or a refinement of the code?

111

fashion-photographers. There has surely evolved a language for the depiction of women, and it may be hard to think of a woman or to be a woman outside of this language. I take it that this is Goffman's point. Does it make sense to talk of the *real* Princess Diana?

The dramaturgical approach has been very influential within social psychology and it does provide tools for the analysis of meaning. Its thesis that appearance is revealing of personality, and perhaps those unconscious or spontaneous gestures and choices are particularly expressive, can itself be seen in Sennett's terms as reflecting current cultural conditions. Current thinking about the self emphasises that it is socially constructed, that the concepts that we use to understand our everyday reality have come about through a social process and that they are not determined by 'human nature' or by the nature of the world. It suggests that there is a close and reciprocal relationship between the individual and society in that, on the one hand, the particular social world into which we are socialised provides the concepts through which we view the world; but, on the other hand, the individual is an active agent in the social world who is not completely determined by society. This view draws attention to the most striking phenomenon in people's tastes: everywhere we see differentiation and also regularity and conformity; everywhere we are assured that individuals are exercising their freedom of choice. The trick will be to explain tastes and styles without dehumanising their owners.

The social self

An important part of a person's identity is his or her association with actual or imagined groups in society. When social psychologists ask people to define themselves, their most common answers are in terms of their group memberships. They respond in terms of their gender, their family relationships, their affiliations, nationality and so on. Preferences among objects must also reflect this aspect of identity. Parents have very clear ideas as to what kinds and colours of clothing are appropriate for their baby boys and girls. They can take gender differences in clothing as cues for their reactions to children. For example, Smith and Lloyd (1978) dressed boy and girl infants in either a dress or a 'babygro' and assigned them either a boy's or a girl's name. When the children, whichever their gender, wore masculine clothing and had a boy's name mothers tended to

choose for them such toys as a hammer or rattle and they were more encouraging of their active behaviour. When the infant appeared to be a girl, on the other hand, dolls were more likely to be chosen as toys and calmer activities were encouraged. That shops and catalogues have separate sections for boys' and girls' clothes, games, toys and so on is almost too obvious to mention, as is the observation that these objects correspond to gender stereotypes.

The concepts of masculine and feminine can be applied to a wide range of objects in ways that are widely understood. Dittmar (1992) reported marked gender differences in the favourite possessions that were named and in the reasons that were provided for their choices. Men placed greater emphasis upon instrumental and use-related reasons whereas women made more use of the relational and emotion-related categories. These differences could be summarised along two dimensions, one of which contrasts the symbolic and the functional use of objects while the second contrasts an active, self-oriented emphasis and an other-oriented emphasis. The reasons offered by men and women occupy different locations in the space defined by these dimensions: 'women tend to construe their relation to their favoured objects in a relational and symbolic manner, compared to men's activity-related, functional and self-oriented concerns' (p. 135).

One of the clearest examples of identification with a group is the wearing of a uniform. A uniform is a sign of membership of the group, indicating that one is, say, a judge, nurse, or pupil at a school; it serves to distinguish groups in that different regiments, teams or schools have their own uniform or a variation upon a uniform; it provides information about rank and status within the group. Members of organisations may have access to or rights over particular places or they may have exclusive use of certain objects. There are many types of groups. A group may have a precise definition, like soldiers in the Salvation Army, or it may be loose, like supporters of the New Model Army. Perhaps there are particular qualifications that govern membership, or this may be open to anyone who shares particular values, beliefs or aspirations. Social psychologists propose a distinction between primary groups that are based on face-to-face interaction and secondary groups which are larger organisations such as nations or supporters of football clubs. Reference groups are groups with which a person feels an identification and which provide a source of definition for beliefs and values. For all these kinds of

groups, articles of clothing and material objects of many kinds can have profound significance. People's tastes and preferences are expressive of and reflect upon their social identity. One of the most discussed concepts has been that of status. Commodities are valued because their ownership or use confers status; people are worthy or admired because of their tastes or conversely their preferences can reveal their deficiencies and produce embarrassment or shame.

Summary

My account of the meanings of objects has of necessity been selective given the large literature and the diversity of approaches to these issues. I have highlighted three aspects. Explanations of the psychological impact of formal qualities of objects have paid increasing attention to their meanings, and these have been defined in terms of mental models that people have built up through their everyday transactions. There has been a movement away from locating the sources of this impact within the objects towards an emphasis upon the contribution of the spectator or user. I believe that this is a productive move, but will argue in the final chapter that it has not yet gone far enough. Much psychological discussion has been influenced by Freudian theory and I attempted to provide an introduction to this by considering its explanation of two kinds of objects, transitional objects and fetishes. This approach is at the other extreme in that it neglects formal characteristics in its concentration upon explaining the origins of preferences for these kinds of objects and on their functions in the psychological life of the individual. This does omit much that makes designed objects distinctive, and this is a problem that faces explanations in terms of self-processes. We have seen that the self is a complex multidimensional concept, and that empirical and more speculative studies suggest that many objects have their significance in their implications for the self, the person's identifications with others and the identity that they present to others. Many of the concepts that figure in everyday accounts of taste, for example the view that people's choice of objects and environments to maintain and enhance their status and their 'lifestyle' can be assimilated to this kind of explanation. It also has the advantage, in my opinion, that it is properly sensitive to the historical and cultural context of objects and their explanations, and takes a

21 'The way the Ted "came on" was no more aesthetic in intention than
the scarlet throat of a robin ... It provided a warning, a provocation,
a sexual flag, a recognition signal ... What on the surface may
appear to be eccentric individualism is obviously the contrary:
conformity within a group' (George Melly)

reflective stance upon its own status as a theory. Clothing and pos-
sessions reflect our sense of who we are or our authenticity and
individuality, but there is nothing inevitable about this, as has been
shown by Sennett, for example. And yet there are qualities of ob-
jects that remain elusive. Why does this object relate to the self and
another does not? I return to this challenging question after consid-
ering the role that the functions of objects play in mediating their
psychological significance.

4 Function and design

If an object is made of appropriate materials to an appropriate design and perfectly fulfils its function, then we need not worry any more about its aesthetic value: it is automatically a work of art. (Herbert Read cited in Kinross)

Ergonomics and the effectiveness of design

Much of the pleasure to be derived from objects and places is in their use: we sit on the furniture before buying it, we try out the tennis racket, we walk through the new house, perhaps visualising the potential of the different rooms as living spaces. Appearance can be deceptive, and the goods that look so attractive in the showroom or catalogue can be disappointing once we have lived with them: they may not be well made, they may be uncomfortable or awkward to use. Designers need to devote a considerable amount of attention to these aspects, as the commercial success of a product may depend on its perceived superiority in these respects over similar alternatives. How is an effective design arrived at? One possibility is by trial and error, and manufacturers may build up over the years an expertise that owes more to their experience than to theory. For many products, of course, considerable technological knowledge is required if improvements are to be made in their design, and this is true not only for high technology goods like automobiles and electronic hardware, but also in tackling the recurring mundane problems of joining together different materials or of controlling 'bounce' and movement: problems that face the designer of a bra or a saucepan as much as a bridge or a roof structure. Many products are thoroughly researched from functional and marketing points of view.

The notion that the aesthetic success of a design is essentially a matter of its effectiveness in fulfilling its function, that 'form follows function', is a controversial one in design theory, and debates

concerning its validity have been central to discussions of modernism in design (Benton, 1990). There are many problems with this notion. In practical terms many of the buildings that were guided by this philosophy have proved unattractive to very many people. The thesis also neglects the role of meaning and symbolism and of those formal characteristics that are not determined by function. Furthermore the concept of function is itself a slippery one that can be extended to refer to very many aspects of a design. The function of a building may refer to its structural characteristics or to the uses to which it is to be put. The thesis also seems to imply that there is an optimal solution to any design problem, that there is one design that will meet the needs of users. In real life, people adapt to circumstances and often respond to changes in their environment with inertia, so it may be difficult in practice to gauge how well a building or object fulfils its function. And of course people have different needs and may require the building or object to fulfil different functions. Functions themselves change over time, and the meaning of 'functional' has to be understood within a given historical and cultural context.

Nevertheless, it is obvious that many products could be better designed, particularly from the point of view of the user. One persistent advocate of the need to take users into account in the design of buildings has been the American architect and writer, Robert Sommer. He has argued that designers need to study the actual behaviour of their future clients. For example the preferences for personal space and privacy that were examined in chapter 1 have implications for the design of public spaces in restaurants, waiting areas and so on. The number of people who can comfortably use a space will depend on the design's respect for those preferences much more than on some calculation as to average space needs per person.

Many solutions to design problems require some assessment of the characteristics of the user; for example, ranges of furniture and clothing must be of an appropriate size for the typical dimensions of the human body, and the driver of a vehicle must be able to reach all the controls easily. For relevant data the designer might look to the discipline of ergonomics, which is explicitly concerned with 'the application of scientific information concerning human beings to the problems of design.' (Pheasant, 1987, p. 2). This discipline is also

known as 'human factors' or 'man–machine' studies. A concern with the effectiveness of tools and of living spaces must be as old as the human species itself, but its scientific examination is a modern phenomenon and a product of industrialisation. In the 1880s Frederick Taylor applied such techniques to the analysis of workers' performance in an attempt to enhance productivity by eliminating what he perceived to be unnecessary movements. Ergonomics became established as a distinct scientific discipline during and immediately following the Second World War, when engineers, medical researchers and psychologists came together to tackle the problems of the interface between operator and machine that were highlighted by the war, problems brought about by the rapid introduction of new weapons and control systems and the need to select and train large numbers of users. Ergonomics has been very much concerned with the design of machines and equipment to 'fit' their users, but it became clear that the description of users could not be restricted to their physical characteristics, and that their psychological and social needs had also to be taken into consideration.

The role of the psychologist was to provide information about these characteristics of users, about their perceptual abilities and limitations and their skills. At that time psychology was a relatively new field of study and the need to apply its knowledge to real-life problems provided a boost to the development of its ideas and methods. However, there had already been some research along these lines, particularly in typography where studies date back to the 1920s, and the experimental methods that psychologists had been developing proved an effective tool for examining the implications for the user of variations in the parameters of design. In this chapter we can only sample some of this research, as I cannot do justice here to this enormous and expanding body of knowledge. Overviews are available *inter alia* in publications by Grandjean (1986), Pheasant (1987) and Salvendy (1987).

A large part of everyday life is spent in our acting upon the environment in countless ways, although most of our actions are 'automatic' and require little if any conscious attention unless we encounter some problem. These actions may be thought of as skills that involve a controlled sequence of component actions. Some mundane tasks like turning a tap or a doorknob are quite simple (unless you are very young or very old or have difficulty in muscular

control); others are complex but appear simple because they have been so thoroughly mastered, like reading or riding a bicycle. Driving a car is such a practiced activity for the experienced motorist that he or she can sustain a conversation while driving. This may be contrasted with the novice who devotes all attention to the controls and the road and is often unable to comprehend what a passenger or instructor is saying. Inability to divide attention between the two activities may also affect the skilled driver, who may have to pause in conversation to concentrate on a complex event like overtaking. Other tasks remain difficult because they have not been sufficiently practised, like programming a video recorder; or because the skill that has been learnt is not optimal for the task as when, for example, one attains a relatively good level of performance with two-finger typing but cannot progress beyond that level because efficient typing is based on different principles. The design of any object can aid or hinder our transaction with it (see Norman, 1988, for an entertaining and informative analysis of the shortcomings of many everyday objects) and the designer has to understand something of the processes that underlie human skilled performance.

The act of perception is at the heart of any skilled activity. Is the tap on or off? Is the light red or green? Am I playing too loud? Can I reach that shelf? Questions like these are addressed all the time and are often stimuli for action. Perception involves detection or identification of a stimulus or the discrimination of one stimulus from another, and it lends itself to experimental investigation. Consider the design of everyday objects like coins. It is obviously important to be able to identify a given coin on its own and to tell apart coins of different values, and these tasks should be quick and error-free under a variety of lighting conditions. The visual appearance of the coin will provide necessary cues but touch also has to provide sufficient information, so that the coin can be identified in the dark or by those who are blind or have poor eyesight. The range of design options is limited since there are many constraints on the acceptable dimensions of coins, their production costs, their suitability for coin-operated machines, their ease of counting, their size relative to one another and to their relative value (Bruce, 1989). The size, colour, weight, texture and shape of coins provide the main cues for telling them apart. The influence of variations in these cues for discrimination can be assessed by presenting samples of

people with tasks such as looking or feeling inside a purse to count specified types of coins, or requiring them to sort collections of coins into different denominations, and measuring how quickly and accurately they can perform these tasks. The information provided by these studies can be very useful for the final selection of a design from possible alternatives, as small differences in the dimensions of coins can have marked effects upon their perception. Bruce points out that increasing the thickness of the new British one pound coin from 2.88 mm to 3.1 mm greatly helped the blind to identify it. The studies also illustrate more general psychological principles. They show how the associations that people make between coins and their monetary value can influence perception. A well-established finding in studies of size perception is that people overestimate the size of more valuable coins, that is, they perceive them as being larger than they actually are.

Making sense of visual displays

One perceptual task that has become prominent with increasing reliance upon machines is assessing the state of the world from a visual display. Driving a car offers a good example. Perception of the environment, of the position of the car in the road and relative to other vehicles and objects, and of the speed at which one is travelling can be based upon direct environmental cues, but these can be misleading. People's perception of speed can be unreliable and is heavily influenced by contextual factors. The experience of 30 mph is not the same in a narrow city street and on the slip-road coming off the motorway. A speedometer provides a display of this information within the car, and much additional information can be provided, including signals that warn of the malfunctioning of the vehicle or alert the driver to potential problems such as a low level of petrol. Such displays are commonplace in domestic objects of all kinds, and in industry their use may be crucial in informing operators of the state of the world which they cannot experience for themselves, as in power-stations or in air or rail traffic control. Research into the effectiveness of visual displays is directed at a number of aspects, including the size and location of the display relative to the operator, the legibility of alphanumerical material, the comprehensibility of symbols, the effectiveness of different display

indicators, and the optimal arrangement of displays when a number of them is required. There are now standard recommendations made by the International Standards Organization (ISO) for various parameters of the design of visual displays; for example a symbol that is to be approved for international use must be tested in at least six countries, and sixty-six per cent of those interviewed must be able to identify the given symbol.

Visual displays

One long-standing area of research in ergonomics is in the relative effectiveness of different types of visual display. There is a wide choice of indicators of the state of a system being monitored by a display. There are different types of digital and analogue mechanical or electromechanical indicators: direct reading counters (as in the milometer of a car or an electricity meter); a moving pointer on a fixed index (as in an analogue watch or the speedometer of a car) where the index may be a dial or linear scale; a fixed pointer on a moving scale (as in the timer on a central-heating control). There are bulb warning lights, for example on a domestic freezer or the oil warning light on the car dashboard. More recently there has been the application of light-emitting diode (LED) displays, as in segmented numeral displays, for example in a pocket calculator or in public notices at railway stations. In contrast to alphanumerical displays symbols or icons can be used to convey information, about appropriate temperatures on washing machines, or providing instructions and advice on road traffic signs.

Which kind of display is best? Clearly there is no single answer to that question, as different kinds of display will be appropriate for different functions. Is the specific value on the numerical display important or is the user to be warned of a change in the state of a system, from normal to abnormal or from safe to dangerous? Do changes in these values occur rapidly? Or are trends, rates of change, directions more important? Is the symbol required to provide concrete or abstract information? How familiar are people with the concept being symbolised? What kind of response is required from the operator? All these questions are pertinent to the choice of display, and the effectiveness of displays can be studied empirically in a variety of ways. Errors and speed of responding to different displays may be studied under controlled conditions, as can accuracy

rates for the identification of different symbols. These studies can be carried out in the psychology laboratory or in the real environment – the driver of a car may be stopped by the police and asked to describe the most recent road sign he or she had passed.

We can illustrate this research by considering a problem that is encountered with increasing frequency, where the operator has the task of attending to a number of different displays. The tasks facing an aircraft pilot or the controller of a power-station spring most readily to mind, but more mundane activities like driving a car may also require the motorist to monitor several visual displays on the dashboard while continuing to survey the road ahead and behind. Developments in technology are making available to the motorist an increasing amount of information about the state of the car. Baber and Wankling (1992) addressed this problem by considering the possibility of a single reconfigurable display that would be capable of providing the information that currently requires a number of different kinds of displays. They evaluated warning displays that incorporated either icons alone or icons in combination with additional textual information. The extra information aided the driver's decision-making, particularly when the symbol was accompanied by a title and a recommended action. The display might read 'Right indicator/No action needed' or 'Charging fault/Check battery'. Figure 22 presents the set of visual displays used in their study. In fact, providing the additional information actually reduced drivers' response times; more generally, the provision of extra or even apparently redundant information can often improve performance.

A further approach to multiple displays is to combine them into one integrated display. For example, an operator might have to monitor information about the state of three components of a system and take appropriate action when that information indicates that any one of these components is deviating from normal. Rather than have the operator attend to three different sources of information these could be combined to form a triangle. The centre point of each side of the triangle would indicate the normal and the shape of the triangle would indicate the correct working of the system. A breakdown in the system would be indicated by a change in the shape of the triangle and closer inspection would reveal which of the three components was deviant. This is known as an object display (Carswell & Wickens, 1987). The justification for this kind of display is provided

Screenwash low Fill up soon	Seatbelt not on Put on seatbelt	Handbrake on Release handbrake	Boot open Close boot	Brake pads worn Change pads soon
Sidelights on No action needed	Front foglight on No action needed	Rear foglight on No action needed	Right indicator No action needed	Hazard light on No action needed
Engine oil low Stop and turn off engine	Catalyst temp.high Stop and turn off engine	Engine temp.high Stop and turn off engine	Antilock brake failure Drive to dealer	Brake failure Drive to dealer
Petrol low Service Fill up soon	Coolant low Service Fill up soon	Charging fault	Fuse failure Drive to dealer	Bulb failure Drive to dealer

22 Each display in the set provides the driver with a symbol and related text providing a title together with recommended action. In evaluation research each display was presented singly on a computer screen and the person had to appraise the urgency of the message and respond as quickly as possible

by research into visual perception. People have a remarkable capacity for object recognition and identification, and the qualities that bind an object together or make it an object rather than a discrete set of elements (its Gestalt qualities, in a sense) seem to allow people to process information about objects quickly and accurately. This can be contrasted with the difficulty that people can have with attending to different sources of information. Current psychological thinking makes a distinction between parallel processing, where

different items of information are dealt with simultaneously by the nervous system, and serial processing, where the items are dealt with in sequence and inevitably more slowly. The idea is that object displays can capitalise on the benefits provided by parallel processing, and avoid the errors that can characterise behaviour when operators have to attend to different sources of information.

A number of such displays have been designed and subjected to empirical analysis and this has suggested several principles for their design. It is important to distinguish three components of a display. There is the *process* or state of the system. There is the *display* of that state. Finally there is the *operator* who relies upon the display in trying to understand and control the process. What is the primary task of the operator? This may be to assess the overall functioning of the system or to monitor the state of individual processes. If the operator has primarily to integrate the information then the object display will enhance this, but it could be that if the task is to focus attention on one of the sources of information then performance may be impeded. There may be several reasons for this. Objects have what are called *emergent* properties; they are greater than the sum of their parts (another notion that owes much to Gestalt thinking) and correspondingly the elements of a display can interact to produce emergent features. These can be a valuable aid to performance if these properties map on to the task in a meaningful way. Conversely they could also have unwanted effects, the wholeness of the object serving to obscure the reading of details if focus on individual sources of information is required. Bennett and Flach (1992) suggest, however, that there is in fact little evidence that focusing on a single dimension is negatively affected by object displays. They suggest that the parts of the display are never completely submerged by the whole, and, because of this, the term 'configural display' rather than 'object display' may offer a better summary of its qualities.

The notion of mapping properties of the display on to the response is an important one with many implications for design. Wickens and his colleagues have used the term *proximity compatibility* to refer to a compatibility between similarity in the properties of the display, such as physical proximity or a common colour, and similarity in the responses required by the operator. Bennett and Flach (1992) emphasise the mapping between the process and the display, and propose that the elements of the configural display should

have a meaningful relationship with the properties of the system of processes. They recommend that each variable in the process should be represented by a discrete element in the display, and that if a precise reading of the state of that variable is required, then supplementary information should be provided. This was the case for Baber and Wankling's reconfigurable dashboard displays. The features that result from the interaction of the individual display elements should in turn have a meaningful relationship with the constraints that exist within the process, so that faults in particular process variables produce equivalent faults in the configuration.

The principle of stimulus–response compatibility is a powerful one. To turn the car to the right we move the steering-wheel clockwise, i.e., the top of the wheel is moved to the right. If the indicator is on the steering-column we pull it downwards or clockwise to indicate right. As we go faster the pointer on the speedometer should move from left to right, and the pointer should move from right to left or from top to bottom to indicate less petrol. The general tendencies are to move clockwise on a dial and to indicate an increase in a variable by this clockwise movement or by moving an indicator upwards or to the right. A further compatible relationship is that of congruence. Where a set of controls has to relate to a set of displays then the arrangement of controls should be congruent with the displays. An everyday example is the control of gas or electric rings on a cooker. The controls are typically not adjacent to the rings but are mounted in a line at the front and the most effective design maintains a congruent relationship between the order of controls and the spatial layout of rings. On my own gas cooker the linear order of controls is typical: back left, front left, front right, back right. This is not altogether successful: I had to go into the kitchen to remind myself of the arrangement; the controls are also labelled, and have to be; and, despite having owned the cooker for many years I still sometimes attempt to light the wrong ring! When there is a large degree of consensus about compatible relationships psychologists describe these in terms of 'population stereotypes' (Wickens; see Salvendy, 1987). These stereotypes can place constraints upon designers, and indicate the 'meanings' of functional properties of objects that have to be taken into account.

Specifying the relationship between processes of a system, the cognitive processes of the operator, and the interface between the

operator and the system is an important task for ergonomics. A breakdown in this relationship can produce frustration for the operator and is a common source of errors. The designer therefore has to be aware of potential problems that may be built into the system. Norman (1986, 1988) summarises these problems in terms of the Gulf of Execution and the Gulf of Evaluation. The first gulf is where the operator has a clear idea of what she wants to achieve, a goal, but does not know how to act upon the system in order to realise that goal. For example I recently typed in the command to my computer to enter a spreadsheet program that I had not used for some time. This produced a screen containing a number of rows and columns with a cursor flashing at the top left. I couldn't remember what was the next step. I knew I wanted a menu and tried pressing a number of different keys without success. Eventually I had to borrow a manual to learn that pressing the '/' key would produce the menu, and thereafter the program was quite self-explanatory and made available help files and so on. This gulf of execution was large in that the system gave no clues as to the next step to take to realise my goal. There is a gulf in evaluation when the operator is unable to understand the effects of a change in the system. To take another example from the computer interface, the user might choose the appropriate command to save a file, and no sign appears to indicate that any response has been produced by the system. Is the file saved or not? Can the user safely exit from the program? Norman (1988, p. 52) has argued that these gulfs are not restricted to interaction with computers but are 'present to an amazing degree in a variety of devices'. The gulfs can be bridged either by changing the machine or by changing (informing or teaching) the user. The designer should be hesitant about taking the latter approach, as it may place unacceptable demands upon the user.

Reading the display

Decisions about the optimum size and location of displays require information about the distance from the display normally adopted by the operator, for example the distance of the driver from the dashboard, together with knowledge of relevant characteristics of visual perception such as the normal viewing angle, the field of view and visual acuity. Light enters the eye through the cornea and is focused by the lens on the retina, which contains the light-sensitive

cells which transmit information to the brain. The eye can adjust to targets that are located at different distances because the shape of the lens can be changed by the surrounding ciliary muscles to accommodate to distance and to bring the visual image of the target on to the retina. The capacity of the lens to accommodate is affected by age as the lens loses its elasticity over time, and the shortest distance over which the target can be brought into sharp focus increases from 8 cm at sixteen years to 50 cm at fifty years and 100 cm at one hundred years.

There are two types of light-sensitive cells; cones, which mediate perception of detail and colour, and rods, which are sensitive only to patterns of light and dark and which are effective for detecting information under conditions of poor illumination but not for perception of detail. The rods and cones are distributed differently across the retina with the cones predominant at the centre, around the fovea, and the rods predominant at the periphery. It follows from this that when the eye fixes on a target such as printed text, there are limitations on the area that can be perceived in detail. The periphery of the eye may pick up movement and gross aspects of shape, but for further information the eyes and the head must also be moved. The visual field is defined as that part of the environment that is taken in by the eyes when the eyes and head are still. It is usually described in terms of the viewing angles that are subtended at the eye, with zero degrees defined as the line of sight and the centre of the visual field.

It is possible to calculate for a given viewing distance and viewing angle what is the optimal size for visual displays and for their constituent components such as alphanumerical symbols. Character height is a function of viewing angle. To be legible at all, a letter must subtend an angle of five minutes of visual arc, and the British Standard for labels on instruments is an angle of fourteen minutes. As a rule of thumb the range for appropriate character sizes is from sixteen to twenty-five minutes of visual arc, and this translates into the following height–distance relationships. Baber and Wankling (1992) recommend a character height of 3.5 to 7 mm for a dashboard display at the typical distance of from 80 to 100 cm for the car driver. Grandjean (1986) suggests an optimal character height of 3 mm for a distance of 50 cm and 4.3 mm for a distance of 70 cm between the operator and a computer screen (a visual display unit

or VDU). The legibility of an alphanumerical symbol display depends on more than its height. It will also depend upon its other characteristics such as its proportions, its width, thickness of line, spacing between lines, letters and words and so on. Ergonomics manuals provide normative data on these parameters of typeface (e.g., Pheasant, 1987, pp. 79–86).

More generally, reading is a complex skill that takes years to acquire and the psychological processes underlying reading have proved difficult to understand. One of the problems (for the researcher, that is) is the speed at which reading takes place. The fluent reader has an average speed of around 290 words per minute; the mean number of characters per word in this chapter is just over six, giving a rate of twenty-nine characters per second. Continuing debates concern the relative importance of the word and the individual letter as units in reading and the role of letter–sound correspondence. It would theoretically be possible to learn to read by learning to identify all the individual words. Although this would be very demanding it would be a comparable achievement to that of those who have learnt a representational or logographic system like Chinese, where the symbols are independent of the spoken form of the language and stand for individual words or concepts and where the reader goes directly from the graphic symbol to its meaning. English is a phonemic and alphabetic system where words are built by using over and over again a small set of letters, each letter standing in rough correspondence to a sound in the spoken form of the language. In such a system readers can link the visual symbol to its meaning, constructing words and larger units of meaning letter by letter using something like silent or covert speech.

If this is how reading proceeds it will be aided most by typefaces that enhance the identification of the individual characters. In printed text serif faces contribute to faster reading. The formation of characters on the cathode ray tubes of VDUs through dot matrix methods presents its own problems, and variation in the dimensions of letters and choice of font influences the ease of discrimination of characters like Y and V, or Z and 2. The choice of character is a complex matter influenced by the nature of the task and by constraints on display; for example, the effectiveness of a font style is dependent upon the size of the dot matrix.

Adherents to the view that reading is based on units larger than

individual letters stress the role of word shape and typographic features, as reading will be helped by any clues that discriminate among words. Some evidence of the importance of word shape also comes from the study of eye movements. It will be recalled that only a few letters are available in any single fixation of the eye, so fluent reading requires a sequence of eye movements. Developments in the technology of recording eye movements have led to increasing understanding of their role in reading. It is known that the eyes do not follow the line of print in a smooth flowing movement, but move in a jumpy irregular but accurate leap from one position to the next. This movement is called a saccade. The eyes first fix on a location several characters in from the beginning of the first line and remain there for about a quarter of a second (250 milliseconds or msec). They then sweep in a saccadic movement about ten or twelve letter spaces to the right (a visual angle of one to four degrees) and rest for another 250 msec. Most saccades are from left to right across the page, but several are regressions to earlier parts of the text. The duration of a fixation, the length of a saccade and the number of regressive movements are affected by characteristics of the material being read, such as its unfamiliarity or difficulty. Although only limited detail can be detected in the periphery of the eye it can be shown that peripheral information is helpful in the identification of words.

What role do typographic features play? The question whether the shape of words helps or hinders reading remains controversial. Some psychologists take the view that changes in the shape of words brought about for example by alternating upper and lower case in words (as in AlTeRnAtInG uPpEr AnD lOwEr CaSe) have very little effect upon reading and that readers extract some 'deep' representation of letters that is not affected by variations in their physical appearance. They point to evidence that most variations in typefaces or in letter form have in fact little effect upon reading speed (Rayner & Pollatsek, 1989). It is also claimed that the information that proves useful in peripheral perception is related to the identification of individual letters rather than to shape clues.

Others argue against this position. Words can still be identified when only parts of the letters, especially the top half, are available. Transformations of the text such as inverting or reversing it make reading more difficult, but this effect is minimised when the

relationships between the letters and the shapes of spaces between letters are maintained. Filling the spaces between words also affects ease of reading. Finally it is argued that printing in upper case letters only slows reading, compared to a mixture of upper and lower case letters, presumably because it provides less information about word shape. Speed of reading is of course only one criterion. Printing in upper case can help the identification of letters, particularly when space is limited and the letters are small. One problem with the interpretation of these studies is that when you change one attribute of characters such as their case you inevitably change another, such as their size. Rudnicky and Kolers (1984) attempted to allow for this by presenting readers with typefaces that varied size and case of letters in a systematic way. They found that both kinds of changes, but especially changes in size, affected a number of measures of reading performance, and their data provide strong support for the belief that the physical characteristics of typeface do play an important role in reading.

Reading is not merely a matter of letter or word identification. A person reads in order to attain particular objectives and will, in pursuit of these, adopt different styles, perhaps moving quickly through the text to get its gist or to highlight the principal points or else concentrating on individual phrases or sentences to grasp the details of an argument or presentation. A VDU is different in important respects from the printed page, presenting both opportunities and difficulties for the reader. Only a small number of lines is usually visible on the screen, and the reader may be obliged to move the text, a line or a screen at a time. Sometimes a document will move at speed past the reader's eyes. These aspects of presentation, together with problems of character stability, luminance and contrast, may make the VDU more difficult for the reader than the printed page. On the other hand 'cut and paste' facilities and the ability to search for words and parts of words may provide an opportunity to read in a different way, to adopt strategies that allow a degree of control over the presentation of text.

Legibility also depends on the degree of contrast in luminance between the symbol and its background, and on the degree of resolution of the symbol. For a VDU resolution will be a function of the size and spacing of the dot matrix that is used to generate characters and the style of font used. It will depend on surrounding

conditions of illumination and also on reflection and glare. For example, the surface of a VDU is reflective and a source of light behind the operator will reflect off the screen making it difficult for the eyes to focus and causing discomfort and delays in processing the information. This is one feature of the design of workstations and VDUs that has given rise to concern over their effects upon the health of operators, particularly those in offices, mainly women, who spend perhaps more than six hours each day in routine tasks like word processing and data entry and retrieval. Some concerns relate to the visual strain induced by such characteristics of screens as flicker; others relate to the problems such as Repetitive Strain Injury that are linked to spending long periods of time in a fixed posture or in repetitive actions.

There are many differences between text on the page and text on the screen. The screen image is produced on a cathode ray tube. The cathode is a gun that fires a beam of electrons at the phosphor-coated surface of the screen, sweeping across the screen line by line from top left to bottom right. The phosphor glows for only a fraction of a section and needs to be refreshed in order to maintain continuous luminance. This process can give rise to problems with the stability of the image, to the perception of flicker or shimmer. Computer users do complain of the discomfort that they experience with reflections and flicker on VDUs but it takes careful research of the kind reviewed by Grandjean (1987) to establish which characteristics of machines produce these responses and to provide a basis for standards for the health and safety of operators. Current British regulations (HSE, 1992) for an acceptable standard for VDUs require employers to analyse their equipment with a view to assessing and reducing risks, and to ensure that workstations meet minimal requirements including screens that are adjustable for brightness and contrast, that tilt and are free from glare. The application of such regulations and recommendations needs to be sensitive to individual differences among operators. For example, older users are more prone to be affected by glare (Haigh, 1993), as they need an increased level of illumination to see outlines clearly, and this light in turn may be more likely to be scattered within the eye because the lens is more opaque. These changes can affect people's performance when they are in their twenties but become more troublesome in their forties.

Research has shown that many VDUs in common use are inadequately designed from the point of view of reflections, the refreshment rate of the image and the resolution and stability of characters. A further concern is with the effects of electromagnetic radiation emitted by VDUs upon the health of women operators and in particular the possibility of increased rates of reproductive problems such as increased rates of miscarriage, premature birth or birth defects. Studies have not identified any greater risks among operators in comparison with control groups. However simple causal relationships between a single environmental factor like prolonged exposure to a VDU and psychological outcomes such as stress or possible effects upon subsequent life events such as pregnancies are notoriously difficult to study. It can be difficult to study a sample that is large enough to rule out chance fluctuations in the incidence of reproductive problems. There are also many confounding factors such as the amount of time spent at the keyboard, the nature of the task; for example, whether it is boring and repetitive; and the surrounding conditions, such as the design of the workstation and the office space (Bramwell & Davidson, 1989).

There are also concerns over the musculoskeletal disorders that can be experienced by computer operators. Apart from movements of the eyes and of course of the fingers, typing is a static activity. Aches in the back, neck and shoulders may be a consequence of spending long hours in a fixed posture at the workstation. A static posture, particularly one which maintains the body in an unnatural position, produces muscle fatigue, stress on joints and impedes circulation. These may lead to persistent problems in joints and tendons such as arthritis, tendinitis or disc problems. Recent attention has focused on conditions identified as Repetitive Strain Injury (RSI) or Static Posture Overuse Disorder and Stress (SPODS). As these names suggest, there are problems associated with repetitive actions like typing and sitting still in a fixed posture for long periods of time. The European Community and the British Health and Safety Executive have now published regulations in an attempt to reduce the risks of these disorders, requiring employers to ensure that workers have adequate breaks, that they receive appropriate information and health and safety training.

There are essentially two kinds of solutions. The first focuses on having frequent breaks in the persistent or repetitive activity. It has

a b c

23 Examples of physical exercises aimed to combat the problems
caused by working at VDUs but which could be shown to (*a*)
have the potential to exacerbate existing health conditions, (*b*)
replicate the stresses of VDU work, or (*c*) pose potential safety
hazards

been shown that short, frequent breaks are more effective than longer
infrequent ones. Physical exercises have also been recommended
to prevent musculoskeletal discomfort, by aiding relaxation and
strengthening stretched and weakened muscles. Lee *et al.* (1992)
have reviewed a number of published exercise programmes to ex-
amine their usefulness in countering the effects of constrained posture
without exacerbating problems, their acceptability in terms of their
conspicuousness, simplicity and time required, and the safety of
implementing them in workplaces. These programmes are designed
for the exercise of the neck, shoulders, elbow and lower arm, lower
back and hip, and knee and lower leg. Many existing programmes
fall short of the criteria adopted by Lee, and care should be taken
in following any particular programme.

The second solution is to apply ergonomic principles to ensure
that the posture adopted by the operator is correct. The rapid action
of the fingers is supported by a static forearm and by the neck,
shoulders and trunk. This is an inherent source of strain and these
strains can be worsened when wrist and hand are kept in a constrained
posture. The posture adopted reflects both the preferences of the
user and the design of the workstation. Operators vary in their
physical characteristics such as body size and length of reach and

these have to be taken into account. Investigations have shown that levels of musculoskeletal discomfort are associated with factors such as correct sitting posture and appropriate working height, distance between seat and desk, and relative height of seat and desk, and by provision of adequate leg-room. These can be aided by providing the operator with a height-adjustable desk, an adjustable seat together with backrest and footrest, and of course necessary information about these parameters. Grandjean (1987) proposes a number of recommended ranges for these parameters:

Keyboard height (floor to home row)	70–85 cm.
Screen centre above floor	90–115 cm.
Screen inclination to horizontal	88–105 cm.
Keyboard (home row) to table edge	10–26 cm.
Screen distance to table edge	50–75 cm.

The solution to problems associated with information technology in the workplace requires a combination of approaches. Operators must be provided with well-designed workstations and with adequate training in their appropriate use. Work schedules must take into account the stresses of persistent repetitive activities. Ergonomic research has played an important role in understanding the causes of these stresses, but it should be recognised that such research is not restricted to measurement of physical characteristics of machines and their users. How people behave is crucial, as the most effective designs or safety plans can be ignored or modified. Studies of actual behaviour in the workplace, the evaluation of systems of induction and training, and the careful analysis of accidents and cases of stress and illness are all essential. There are also sources of stress in the workplace that are indirectly correlated with the use of computer technology – the widespread use of workstations may reduce casual social interaction, produce feelings of isolation and boredom and reduce autonomy.

Communicating with the computer

The operator not only receives information from the VDU but also inputs information to the computer and despite the development of alternative methods such as the 'mouse' the keyboard remains the principal means for providing input. The QWERTY arrangement of keys (so called because of the order of the first letters on the top

row of letters, from left to right) has of course been inherited from the manual typewriter. This is not surprising in that much of the development of information technology has been in the office and has built upon and extended traditional secretarial and office skills. Because of our familiarity with the traditional keyboard and our observation of the high typing speeds that can be attained by accomplished typists it can easily be assumed that this particular arrangements of keys was originally designed with the aim of maximising performance. This seems not to have been the case. The basic layout of the keyboard including the ordering of letters and the diagonal arrangement of keys, was designed by Sholes, patented in 1878 and produced by the Remington company. There had been earlier designs including a circular layout of keys, and a linear arrangement rather like a piano keyboard, and before Sholes's design came to dominate the manufacture of typewriters the consensus was that an alphabetical ordering of letters would prove the most appropriate.

There remains uncertainty about the origins of the QWERTY design. One view is that it was chosen not, as one might think, to increase the speed of typing but to decrease it. Rapid typing could result in a jamming of the machine because of the collision of the typebars, and this problem could be reduced if letters that were frequently typed in quick succession could be located at different places on the keyboard. However, this solution was not implemented in an entirely systematic way. Noyes (1983) reports that statistical analysis of the frequency of use of English letters reveals that the QWERTY arrangement is less successful in separating frequently used keys than a random arrangement of the keys would be. Many pairs of letters that are often typed in succession, such as E and R, are still adjacent on the keyboard. The QWERTY keyboard seems also to retain characteristics of alphabetical ordering, for example, the sequence DFGHJKL is the order in the middle (or 'home') row, and the original design also located M to the right of L. Norman (1988, p. 229) is suspicious that the letters that spell 'typewriter' should all be on the top row. From its introduction the QWERTY design has been heavily criticised. It has been argued that it is too demanding of the left hand and of the little (and weakest) fingers and that it requires too many movements between rows. It is claimed that the easiest movements are two-handed ones within reach of the home row, but the QWERTY board minimises such movements and indeed

makes too little use of the home row in comparison with the other rows. It is also argued that musculoskeletal problems can arise from the constrained position of the hands and wrists (Zipp *et al.*, 1983).

Many alternative designs have been proposed over the years, particularly as the constraints upon layout have been changed by the transition from mechanical to electronic keyboards. These alternatives have often been based upon research into the frequency of occurrence of individual letters and letter sequences. One much studied design has been the Dvorak Simplified Keyboard which was produced by Dvorak and his associates in the 1930s to overcome perceived limitations in the Sholes design. More work was to be allocated to the right hand and to the stronger fingers and more use to be made of the home row. Rather than separating frequent pairs of letters these were to be located beside each other. Layouts based on alphabetical principles have also been proposed, and have often been manufactured, for example in personal organisers. One's first impression might be that the alphabetical layout would be particularly easy to learn, because of our familiarity with this ordering, but research has shown that this is not in fact the case. Norman (1988) suggests that one reason for this is that some arbitrary breaks in the order are necessary because of the need to arrange keys in rows. A considerable amount of research has been carried out into the influence of these different arrangements upon typing performance, but the results of such studies are inevitably affected by the long experience with the QWERTY keyboard that skilled typists have. Basically, the Sholes design has proved good enough, and, whatever its origins, it has good features, in distributing keystrokes between the two hands in such a way as to afford very rapid typing speeds. Even where research indicates that an alternative arrangement may produce faster learning or more efficient typing this would need to be superior to a remarkable degree in order to compensate for the enormous investment that has taken place to sustain the dominant design.

Sholes Keyboard

```
1  2  3  4  5  6  7  8  9  0  -  =
Q  W  E  R  T  Y  U  I  O  P  [  ]
A  S  D  F  G  H  J  K  L  ;  '
Z  X  C  V  B  N  M  ,  .  /
```

24 Split keyboard designed by Grandjean and his team in association with Standard Telephone and Radio of Zurich in 1984. An opening angle of 25 degrees and a lateral slope of 10 degrees produced more comfortable typing by reducing sidewards twisting of the hands and inward rotation of forearms and wrists

Dvorak Simplified Keyboard

```
1  2  3  4  5  6  7  8  9  0
?  ,  .  P  Y  F  G  C  R  L  /
A  O  E  U  I  D  H  T  N  S  -
'  Q  J  K  X  B  M  W  V  Z
```

Some designers have attempted to improve the ergonomic properties of keyboards to reduce musculoskeletal problems. They have recommended a flat keyboard that allows the operator to rest forearms and wrists on the desk. Nakaseko, Grandjean and their group (1985) have produced a design where the keyboard is split into two so that the two hands can be kept in a less constrained position. After experimenting with various parameters of the design and analysing typists' responses to these variations in terms of measures of posture and their comments and reports of aches and medical symptoms, a split keyboard was designed, with an angle of twenty-five degrees between the two halves, a lateral inclination of 10 degrees and a large support for wrists and forearms (see Figure 24). This design was very much preferred to the standard keyboard. Eilam (1989) describes more radical alternatives including functional keyboards where a small number of keys are custom-made to elicit

particular responses from the computer (an extension of the function keys on computer keyboards that can be customised for, say, a word-processing application) and chord keyboards where simultaneous operation of a number of keys produces one character or sign and where differences among characters are produced by depressing different patterns of keys. A five-key board can generate thirty-one different characters and so one hand is sufficient to 'type' input. These alternatives are useful for specialised uses or users, but the dominance of the QWERTY design for general purposes will be very difficult to overturn.

The example of keyboards is interesting from the point of view of the influence of the function of design upon its appearance. In this case contemporary designs that implement new technologies are constrained by solutions to mechanical problems that reflect the more primitive technology of the previous century. Keyboards are satisfactory from a functional perspective but they are not optimal. The changes that have taken place in the design of typewriters in the past century have largely been changes in styling that owe more to formal and meaning characteristics than to functional considerations. Forty (1986) suggests that it was the marketing of portable typewriters as an item for domestic use in the 1920s that first led to the enclosure of the machine in a light-coloured casing in order to overcome consumers' resistance to its industrial connotations. These changes were subsequently introduced to the workplace in an effort to develop an image of the typist that was less like that of a technician or factory worker. In the same period there was increasing attention to office furniture and the design of its layout, presumably reflecting the growth of the service sector and office work, and the need to recruit and retain skilled clerical staff. The design of equipment that was stylish and less like a machine was obviously helped by the development of electric typewriters.

The complexity of human behaviour ensures that the development of an extensive database on perceptual and anthropometric characteristics is not in itself sufficient to account for the human side of human–machine interaction. For example, while it is possible (and certainly useful) to set out recommendations and standards for easy and quick identification of text, whether on the page or on the screen, the effective design of messages has to allow for the different reasons that people have for reading; they may scan text or read it for

detailed understanding, they may be searching for a specific item of information or trying to get the gist of a passage. They develop strategies for reading, and different strategies make different demands upon the printed word. Design for these various demands will be more soundly based if we had a grasp of the principles underlying skilled reading. In general, research is the more practical the more it can draw upon sound theory.

Theories in experimental psychology explore some basic notions, as we have seen. The first is that behaviour can usefully be thought of as a skill, as a sequence of actions guided by some controlling principle. Threading a needle or catching a ball are skills and so too are reading and following a conversation. The exercise of skill depends crucially on *feedback*. Smith and Smith (see Salvendy, 1987) distinguish three forms of feedback; reactive, instrumental and operational, deriving respectively from information about the control of movements, from information about the actions of the machine or tool, and from their effects upon the environment. They provide this helpful example: 'in handwriting, the writer gets reactive feedback from his own movements, instrumental feedback from movements of the pen or pencil, and operational feedback from the written words'. Experimental studies have shown that disruption of any of these three forms reduces the quality of the performance of a skill. The second notion is that control is guided by some mental model of the activity; a person has a plan or set of expectations about how a system works. Many of these models work effectively below the level of conscious awareness; at other times we have to examine our own models more explicitly – how can I return to the main command menu? how can I get back to the office from here? how much can we afford to pay for a CD system?

These notions of skill and mental models are simple but can be very powerful in generating guidelines for effective design. The concept of a model warrants closer examination, as the term is used in different ways (Booth, 1989). The model may refer to the designer's conceptualisation of the potential user and anticipation of how the object is to be used. It can also refer to the assumptions about the user that are incorporated into the machine; the design of features in a word-processing program or spreadsheet are based upon a model of the user and, once incorporated, predispose the user to behave in particular ways. Norman (1988) writes of the conceptual model, a

comprehensive understanding of how a system works, the kind of understanding that a designer or engineer might have. He contrasts this with a mental model, a user's understanding of how a system or machine works. Most user models are hazy and incomplete, and are constructed through interaction with the machine. Most people have little detailed knowledge of how their video recorder or CD player works, and they rely heavily on the instructions for controls provided by the manufacturer and on their experience of the consequences of their past actions. Finally Norman introduces the concept of the system image, the physical realisation of the designer's conceptual model, and the machine as it appears to the user. User models may be at variance with the conceptual model, and this may be because the system image provides a poor guide to the conceptual model. As a general design principle, Norman recommends that designers should ensure that the system image is coherent and allows the user model to approximate the important properties of the conceptual model.

There are alternative approaches to designing interfaces between systems and users that aim to bridge the gulfs between the physical nature of the system and the psychological goals of the user. Shneiderman (1983) introduced the concept of the Direct Manipulation Interface, promoting the idea that the user should be able to feel that he or she is acting directly in pursuit of his or her goals. Rasmussen and Vicente (1989) propose Ecological Interface Design, the principal goal of which is to make things visible, to develop a consistent mapping between the invisible properties of the system and the information provided by the interface so that the user can readily identify the current state of the device, know what actions are possible and see the consequences of actions.

We can see many of the issues raised by these approaches in the case of computer interfaces. One of the problems with many command languages was that the onus on bridging the gulfs of execution and evaluation was laid heavily on the user. Often the user was faced with only a prompt, and the input had to meet precise rules of syntax in order to elicit a response that would further the user's goals. A failure to provide an acceptable input could elicit a response like 'Bad Command' that provided the user with no insight into the source of the error. The structure of the system is often invisible. For example, directories, subdirectories and files are typically organised

according to a hierarchical structure, but nothing on the screen indicates this. An attempt to move across from one level to another without moving to the top of the hierarchical tree might elicit a response like 'File not found'.

The Graphic User Interface (GUI) was devised by Xerox and implemented in the 8010 Star Information System in 1981, but it only became commercially successful when it was adopted by Apple for its Macintosh personal computer in 1984. This interface is more visible. Users do not have to remember the commands as they are not faced with a screen that is blank apart from the cursor. The screen contains pull-down menus, where choices are made by moving and clicking the mouse. The structure of directories and subdirectories is depicted graphically, and it is not necessary to type a sequence of commands to move through the different levels. Information is displayed on overlapping rectangles or 'windows', and the user can easily move from one window to another. The system gives the user the sense of working directly on the screen, as actions with the mouse produce corresponding movements on the screen, and it is thus an example of a direct manipulation interface. The hierarchical structure of the windows and the visible reaction of files when their icons are pointed at are both good examples of mapping. Feedback is provided in that dialogue boxes provide information about the machine's responses to the user's actions, avoiding the blank screen and flashing cursor.

The system also makes effective use of metaphor, as it gives the impression of a desktop with the files set out upon it. Material that is to be deleted is placed in the waste-basket. Metaphors are useful in design in that they help the users to form a model of the system by allowing them to draw upon their existing knowledge. Thus knowledge of desktops, folders, files and waste-bins helps the user to infer the features of the interface. Metaphors can also be confusing; a computer interface is not literally a desktop, and the user has to be aware of the boundaries of the relationship. It can be confusing for example to learn that one way of ejecting a floppy disk from the Macintosh is to place it in the waste-basket. The novice might fear that this action would delete the contents of the disk. The successful application of these principles may be one reason why the Macintosh has been highly successful and has forced software designers for other kinds of computers to introduce rival systems such as Windows.

Manufactured pleasures

Summary

Because of the enormous range of the discipline of ergonomics we have restricted our discussion to examples from typography and the design of workstations and keyboards. Nevertheless, several more general points can be made. First, it is possible to examine the functions of design in a systematic way. This approach draws upon theories of human performance and upon data generated by experimental methods. It has produced much information that is valuable, particularly in terms of the consequences of design for the health and safety of users. Minimum standards can be established that draw upon users' psychological and physical characteristics. The approach is not restricted, as is often believed, to recommendations for the physical characteristics of objects, but takes into account the psychological characteristics of users and the relationship between user and object. A number of guidelines for successful design have been proposed.

Yet it is difficult to avoid the conclusion that this kind of information is not the overriding factor in choosing or responding to the design of everyday objects. A small, but perhaps telling example is provided by Aldersey-Williams (1992) in his examination of an 'everyday icon', the compact disc case:

> the compact disc case epitomises the industrial designer's art . . . a quiet victory for industrial design. Admittedly the compact design case is not especially easy to open. But perhaps this is part of the point. One music magazine likened it to the knack of opening oysters. The beautiful appearance and iconic nature of the jewel box may even be part of the explanation for our willingness to pay the excessive prices charged for compact discs.

This may be contrasted with Norman's (1988) exasperation with 'the psychopathology of everyday things', and reinforces his belief that designers tend to put aesthetic considerations first. There have been many changes in the design of typewriters and keyboards but these have largely been a matter of styling. There are rival designs, aimed at increasing the efficiency of operation and reducing the risks of musculoskeletal and other disorders but these largely play third place to concerns with harmony and proportion and with the connotations and associations of objects.

5 Form, meaning, function

Don't despise things. Every thing has a soul that speaks to our soul, and may move it toward love. To understand that is the real materialism. (Robertson Davies, *What's Bred in the Bone*)

In the final chapter I move towards an integration of my three themes. I illustrate through the examination of colour, with a short excursion into the field of typography, how our responses to objects and places can only be understood by considering the interaction of form, function and meaning. 1 then consider some of the questions in the psychology of design that still prove difficult to answer and outline a novel approach that I hope may begin to deal with some of these questions. This draws upon the concept of empathy, a concept that has figured in many accounts of responses to works of art, but which has yet to be fully developed.

Colour

Perhaps colour more than any other aspect of design illustrates the contributions of meaning, function and form to design, and its study can show how both biological and cultural explanations have much to offer. There has been considerable technological progress since the assertion, attributed to Henry Ford, that customers could have any colour they wanted as long as it was black. Developments in dyes and discoveries and improvements in plastics and other human-made materials have meant that the choice of colour is now a design decision that is freed of many of the constraints of the past. For example, when tights were first marketed as an article of women's clothing in the 1960s only six shades of 'flesh' were available, but by the end of the 1980s Christian Dior was advertising a range of tights available in 101 colours, and there had by then been developed a manufacturing capacity for many different designs of patterned tights.

Manufactured pleasures

The freedom from constraints in the use of colour that has been permitted by technological developments also has its drawbacks. For example, the tendency to build using colours that were particular to a region because of the availability of local stones and the expense of importing materials could contribute to a sense of community and provide an integrative force in design (Porter, 1992).

Describing colour

What determines responses to colours? There are factors that are related to the perceptual qualities of colours and other factors that have more to do with people's preferences and the meanings that particular colours have for them. The perception of colour has intrigued scientists for centuries, and many advances in our understanding of colour phenomena have been made in conjunction with the design of objects. Observations that sunlight could be separated into the colour spectrum were made by Sir Isaac Newton in 1663 in the course of grinding lenses and working on the construction of telescopes. Newton's research led to recognition that the perception of colour is dependent on the eye's sensitivity to light of different frequencies of electromagnetic waves, and that the existence of so many colours in everyday life is produced by surfaces that contain dye or pigment that act differently for different colours through processes of absorption and reflection. The human eye can discriminate a very large number of colours (a person with normal colour vision can distinguish among 10,000 hues), and one goal of research has been to bring order to the description and classification of colours.

One of the problems with this is that it is difficult to match colour names with perceptual experience, in that there seems to be at most 4,000 words in English to name the 10,000 colours, and most people have a much smaller vocabulary. There is evidence of cross-cultural differences in colour naming, for example, the Iakuti tribe has a single word for both green and blue, and the Eskimo has different words for the whiteness of snow. Of course the speaker of a language can combine words to describe colours, and as a rule (for English) the longer the description of a colour the more hesitant people will be in making discriminations and the more disagreement there will be among people in naming the colour. Berlin and Kay (1969) proposed that there is strong evidence of cross-cultural consistency in colour naming if respondents are asked to choose from among

Munsell colour chips the ones which provide the best examples of particular colour terms in their language. They also claim that there is a regular order in the use of colour words in different languages. If there are two colour words in a language these will tend to be black and white. If there are three the third will be red; the fourth and fifth will be green and yellow, the sixth blue and the seventh brown. This order correlates with indices of the frequency of use of colour words in everyday English and in poetry (McManus, 1983). Studies of language in different societies suggest a considerable degree of agreement in colour perception. Nevertheless, ordinary language is obviously inadequate to describe colour with the precision that is required for communication about paints, dyes and fabrics in an industrial context. We shall see that systems such as the Munsell atlas have been proposed to specify colour but nothing has been developed that is equivalent to musical notation for specifying patterns of sound.

Several schemes have been proposed for the classification of colours. One of the oldest is the colour circle, which arranges the colours around a circle, in such a way that hues on diametrically opposed sides are complementary (if they are mixed in equal proportions they will produce grey). Blue and yellow are opposed, and if these are located at twelve o'clock and six o'clock on the circle, green would be at three o'clock and reddish purple at nine o'clock. The second scheme proposes three basic dimensions, hue, brightness, and saturation, that relate perceptual experience in an approximate way to the physical properties of light waves. Hue refers to what we have so far been calling colour, red, green, yellow, etc., and corresponds to the wavelength of light. Brightness is a function of the energy of the light source and corresponds to the amplitude or height of the wave, although it is also related to hue, in that some hues appear brighter than others even when all have equal amplitudes. This has implications for the choice of hue in designing objects that have to be highly visible under conditions of poor illumination. Accident statistics can present a more complex picture, in that colour meanings and preferences may be as important as visibility in the incidence of road accidents (Department of Transport 1991). Black cars are most likely to be involved in accidents involving death or injury, followed by white, with brown and yellow the safest. Newer white cars are more at risk than older (pre-1985) cars, and this may

25 The three dimensions of the appearance of colour can be represented
as a solid figure. This figure provides three different models
for appearance. Lightness is represented on the vertical axis, hues are
arranged around the rim, and chroma or saturation is represented by
the distance of the colour away from the vertical

be because white has become a popular colour for high-performance
cars.

Saturation refers to the apparent purity of the colour, and is
associated with the complexity of the light wave, in that a light wave
that is composed of only a few different wavelengths will appear
most saturated and least diluted. It can readily be demonstrated by
gradually diluting a water-colour pigment until all traces of colour
have disappeared. Saturation is not independent of brightness as
marked changes in amplitude will reduce the purity of the hue. These
three dimensions can be visualised as a colour solid in the form of
a double cone. (see Figure 25) Brightness can be represented on the
vertical axis, ranging from white through grey to black. If a section
were taken through the middle of the cone, then the hues would be
arranged on the colour circle that would be revealed. Saturation is
represented by the distance along the radius of this circle from least

146

saturated at the centre to most saturated at the edge. The shape of the double cone contains information about the relationships between dimensions. For example, as brightness increases towards the top or white axis or decreases towards the bottom, black axis the amount of saturation that is possible becomes progressively less and less.

These dimensions provide the basis for Munsell's attempt to provide an atlas of colour in which the appearance of each of 1,200 chips of different colour could be described in terms of its hue, value (brightness) and chroma (saturation). Each colour could be identified by a unique number that indicated its location on scales based upon the three dimensions. The circle of hues is divided into five principal hues – blue, green, yellow, red and purple – and five intermediate hues – blue-green, green-yellow, yellow-red, red-purple, and purple-blue. These ten points divide the circle into ten segments and these can be subdivided into another ten, yielding 100 hues in total. This system provides a very useful means for communicating about colour that can be used, for example, by paint manufacturers. It has the weakness that the system requires that colours be viewed against a neutral grey background under daylight conditions of illumination. Furthermore there are important perceptible qualities of colour that are not captured by these three dimensions, for example, the apparent luminosity of a colour – the red brake light of a car 'glows' and appears different to a painted red glass. The Munsell system is restricted to colours that can be reproduced on material. Other systems are available such as the Natural Colour System developed by Dulux, the British paint manufacturer.

The Commission Internationale de L'Eclairage (CIE) developed a system in 1931 that can be applied to signal lights as well as to materials. Their approach draws upon the phenomenon of additive colour mixture. This refers to a process of mixture that takes place in the eye, as when the observer looks at a screen on to which different coloured lights are simultaneously projected so close together that they stimulate closely adjacent parts of the retina and the eye is unable to resolve them. It was long known that any colour can be matched by some combination of three primary colours and this suggests a system whereby any colour could be described in terms of its values on three defined primary colours. The CIE system specifies the three primaries and it has proved possible to identify colours in terms of their co-ordinates on only two of the

three primaries. Thus colours can be depicted on a two-dimensional chromaticity diagram. The system also provides information that relates the target colour to the three dimensions of hue, saturation and brightness.

One of the most important treatises on colour was produced in the middle of the nineteenth century by Chevreul who was in charge of the dye and colour department at Gobelins, the French state-controlled works responsible for tapestries, drapery and carpets. Chevreul observed that the apparent colour of a dyed sample was affected by the colours of adjacent samples and his further experimentation lead him to formulate the Law of Simultaneous Contrast of Colours. For example a patch of grey may be viewed against a light or a dark background, and the same patch of grey will appear much lighter against the dark background. A grey patch against a coloured background will take on a hue complementary to the background, so that it will look yellowish on a blue background and bluish on a yellow one. The apparent hue of a patch will be enhanced if placed on a background of a complementary colour; a blue will appear more blue in a yellow context. Chevreul's research was of obvious significance for the manufacture of tapestries. In certain circumstances it proved necessary to use wools of different colours in a design even though the intention was to produce the appearance of one colour and conversely the impression of different colours might be given by careful choice of context for wool of only one colour. His studies of interactions between colours and of colour mixtures also influenced the theories and techniques of Impressionist artists and post-Impressionist techniques including Seurat's Pointillism.

These seminal studies, and later research by, among others, Edwin Land (the inventor of Polaroid and of the Polaroid camera) have offered insight into the complex processes that govern colour perception. It is evident that the perception of a colour is influenced by its brightness and saturation, by the nature of the coloured surface, and by surrounding colours. Surrounding colours produce not only contrast effects but also assimilation effects, where the colour of an image may blend with or spread into the background colour. Walraven (1985) provides a valuable summary of how these factors affect the perception of colour on a visual display (VDU). Images that are small or that are displayed for a very short period of time

tend to produce poor colour discrimination, especially those involving distinguishing red from blue and green from yellow, an effect analogous to colour-blindness. Changes in the brightness of a display will induce changes in perceived hue. Murch (1984) draws upon this research to set out principles for the use of colour in VDUs. Perception is also influenced by the viewer's knowledge about objects, as is evident from the phenomenon of colour constancy. This is where the perception of the hue of an object remains the same despite changing conditions of illumination. This can be observed by taking colour slides of a scene at different times during the day. The slides will show a surprising degree of change in colour from one to another. There is controversy over the degree to which prior knowledge of the 'true' colour of objects is necessary for this phenomenon, as it is also revealed when this knowledge is unavailable, as, for example, when the appearance of the colour of paper discs is studied. Nevertheless, the phenomenon demonstrates that the perception of colour cannot be predicted solely on the basis of calculations of wavelengths of light.

These observations about colour have obvious implications for their use in design, as Chevreul had discovered. The appearance of colour, whether of wiring or of the lines on maps and diagrams may be affected by conditions of illumination in ways that are difficult to predict and will depend upon the context in which they are used. Colour coding is extensively used in information design and care has to be taken to ensure that different hues are not confused. How different do two colours have to be in order to be rapidly distinguished? Providing answers to this kind of question, identifying the critical colour difference, is one of the objectives of ergonomics. It turns out that this difference depends upon the particular colours being compared, the difference in luminance between the coded stimuli, and by the size of the display field and of the characters. When small characters are used in a large display, the critical difference has to be quite large (Nagy & Sanchez, 1992). Colours in a design may be chosen because of aesthetic factors or because they convey particular meanings, but it is clear that there are important functional considerations, and that these are not necessarily simple, but require investigation. It seems that the identification and discrimination of colour is affected by contextual factors and by the interaction of these factors, and the choice of colour is also affected

by the objectives of the design and the kind of response that is required of the user.

Colour preferences

Do people have innate colour preferences and is there agreement in their preferences? A number of studies have suggested an affirmative answer to both these questions, and have shown that people tend to prefer hues of shorter wavelength. McManus *et al.* (1981) confirm an overall preference for blue and a dislike for red and yellow (although a minority of people like red or yellow best) and it was found that brightness and saturation as well as hue influenced preference judgements. However, the questions posed in these studies are somewhat abstract in that colour is not linked in any way to the environment. Blue may be the most preferred hue but in many circumstances, for example in food colouring, people would be averse to blue, and in other circumstances, for example, the preferred colour of cars, blue would be less popular than other hues, such as red. One reason for this is that colours have meanings that influence preferences in particular contexts. Black is a popular colour for certain items of clothing – 'the little black dress' – but a black shirt may have unacceptable political connotations for people over a certain age. Perhaps people have a mental image of the ideal colour for different kinds of foods and advertisers can make use of these images by arranging the lighting in colour photographs or in supermarket displays to enhance the desirability of the products. Items whose colours deviated from the ideal would be judged unappealing even if the same colour was liked in the abstract or in another context. There is considerable empirical support for the influence of context upon the meanings of colours, for example in research by Sivik (1975) that showed that people's preferences were different depending on whether they were judging colour samples, photographs of simulated buildings or actual buildings.

The meanings of colours

To what extent is there consensus about the meanings of colours? Here I summarise typical findings for some individual hues. Red tends to be perceived as adventurous, sociable, powerful, protective and exciting. Yellow is cheerful, jovial, exciting, affectionate and impulsive. Green is calm and restful. Blue is affectionate, cautious,

pleasant, soothing, calm and restful. In general the longer wavelengths tend to be more energetic and extroverted, the shorter wavelengths calmer and more introverted. A further dimension is the perceived temperature of hues, with red, orange and yellow usually perceived as warm, and blue, green and violet as cold. This has been investigated in many ways, by asking people directly for their associations between colour and temperature or by interviewing them after they had been working in rooms saturated with different colours. Colours also produce different impressions of distance: blue and green seem further away and rooms in these colours appear larger; red, orange and brown seem closer and rooms smaller. These psychological qualities of colours have implications for interior designers who may wish to make offices pleasant and comfortable places in which to work (Grandjean, 1986; Sundstrom, 1986).

Hue is not the only determinant of these meanings, and emotional responses are also affected by the brightness and saturation of colours. Hogg *et al.* (1979) identified five factors underlying ratings of Munsell colours on a large set of semantic differential scales. The largest factor, dynamism – based upon scales measuring the qualities 'exciting', 'dynamic', 'hard' and 'vibrant' – was correlated with saturation but not with hue or brightness. The second largest, spatial quality ('open', 'free', 'spacious') was correlated with brightness but not with hue or saturation. The often reported relationship between warmth and hue was evident but its effect was modified by saturation, in that less saturated hues tended to be perceived as cooler. Judgements of the pleasantness of colour were not correlated with any of the three colour dimensions. Discussion of the emotional impact of colour has emphasised the influence of hue and these findings suggest that the effects of saturation and intensity have been underrated.

Taken together this body of research confirms the common-sense observation that people differ in their preferences, but nevertheless there is evidence of impressive consistency in judgements, and this has encouraged a belief among many psychologists that responses to colour are innate rather than learnt through experience. Humphrey (1976) argued that colour directly affects the parts of the nervous system responsible for emotional arousal so that, for example, placing a person in a situation where he or she is surrounded by a field of red light produces increases in heart rate, brain activity and skin

responses. He proposes that different kinds of evidence for humans and animals all converge upon an evolutionary explanation of the significance of colours. Red is a colour signal in nature that owes its prevalence to its visibility, because of its high contrast with natural surroundings, and because of its accessibility since, for one thing, it is the colour of blood that can appear on the surface of the body as in the monkey's red bottom or the human blush. It is often, but not invariably, a danger signal, and Humphrey suggests that it is always an important signal, one to which the animal needs to be alert. Its precise implications for behaviour will depend on the context, but the animal will be more prepared to take appropriate action if its nervous system is aroused for action.

Yet the evidence for these influences upon colour can be ambiguous, and we cannot discount the possibility that responses may have been acquired through a process of learning rather than because of any innate character. Adults' judgements concerning the relationship between colour and temperature do not seem to be shared by children. Morgan *et al.* (1975) asked children and adults to hold a container that could contain water heated to different temperatures and to choose one slide from a set of colour slides to match the temperature. Six-year-old children did not make the association and those who were twelve showed less agreement than did adults. Kwallek and Lewis (1990) report a series of studies where participants performed clerical tasks in offices painted red or green. They did find the expected tendency for workers to report feeling more tense and anxious in the red office, but this is not always the case and the effects upon task performance are unpredictable. The consistency that is observed may be influenced to an unknown extent by the expectations that people have acquired about the effects of colour.

Consistency in responses is only one source of evidence about innate determinants of behaviour. Supporters of this position point to similarities in responses among people of different societies and across different species. Counter-arguments tend to focus upon cultural variation in colour meanings since it is always difficult to be sure about the significance of similarities and differences among species. In practice the degree of cultural variation that is found renders it difficult to draw any firm conclusions. Certainly there is substantial evidence of cultural differences but, as Kreitler and Kreitler (1972) suggest, there usually seem to be some common

themes underlying the superficial differences in meanings. Thus the often quoted example that contemporary Western society's associations between black and death and mourning are not shared by Chinese who associate white with funerals, yet we, like the Chinese, associate white with purity and righteousness (as in our traditional white apparel for women being married for the first time); the apparent difference may reflect philosophical and religious differences in attitudes to mourning and the meaning of death rather than any significant underlying difference in the meaning of the colour. In classic Indian philosophy white stands for repose and understanding; in Western studies reviewed by Sundstrom (1986), white meant shy, sociable, tender and soothing.

There is certainly evidence of variation, but few meanings that are altogether surprising. In societies other than our own white may not be appropriate for weddings, but ceremonies may draw upon other symbolic meanings; for example, there is a common association between the bride and a queen, and this might in turn influence colour choice. In parallel fashion red can be on the political right, as in the robes and uniforms of royalty, or on the left as in the red flag and much communist imagery, but both surely draw upon the colour's widespread association with power and energy. In classical Indian thought red is identified with ambition, heroism and the striving for power. These commonalities in colour reference may be suggested by common experience. Red may everywhere be associated with blood and fire, and many ancient rites connected with religion and power involve these elements. Black may owe its associations to the blackness of night before modern means of illumination. The colours of seasons of the year, the white of winter and green of spring, the blue of sky and water, may all provide rich sources of meaning that may be common to many parts of the world. Cultural variation may also be related to environmental differences in an understandable way. An example provided by Kreitler and Kreitler concerns an Indian association of red with aggressive ambition and materialism and notes that the word for red is the same as that for the dust which is so salient during the long dry season: 'just as the red-brownish dust whirling in the air dims the clarity of the sky and of vision, and soils all exposed objects, the strivings for power and pleasure were regarded as obscuring the view one may attain of oneself, as soiling the character, and as dimming comprehension'.

26 'Maluma' and 'taketa'. There is considerable consensus among people as to the assignment of these names to these two figures – 'maluma' is rounded and 'taketa' angular. This demonstration can be traced to the Gestalt psychologist Wolfgang Kohler, in 1938

Widely agreed meanings of colours have obvious advantages for communication, and there have been attempts to standardise meanings. The US Department of Defense (cited by Helander, in Salvendy, 1987) specified that red should be used to indicate that a system is inoperative, flashing red should signal an emergency, yellow should be a sign that caution is needed, and green should denote a correctly functioning system. Many of these colour meanings have a wide currency; we have already noted the significance of red in an evolutionary context, and yellow, in combination with black, is also found throughout nature as a sign of danger, often indicating a source of poison.

Multi-modal perception

Further sources of colour meanings are the expressive or phy-siognomic qualities of perception. It has been argued that colours, like lines or shape, have immediate aesthetic qualities that are in-herent in the stimulus and do not need to have been acquired by associations. Physiognomy is an old idea in art theory, but it has been little studied by psychologists other than by the Gestalt group. Some recent studies in this field have used two non-representational drawings, one of which is more jagged in appearance, with straight lines and many acute angles, and the other rounder, with curves and wavy lines. One is called the 'maluma' and one the 'taketa' (the reader may wish to guess which name is associated with which; see Figure 26). Lindauer (1984) reports an experiment where these two

figures, along with several others, were presented coloured red, green, yellow or blue. Participants were asked to choose the Munsell chip that best approximated the colour of the figure from a range that included the four hues, each varying across ranges of brightness and saturation. There were significant differences in responses even though there was little chance of these judgements being influenced by prior associations. Taketa (the angular figure) tended to be matched with the brightest and most saturated colours and maluma was matched with the darkest and least saturated colours.

One of the most intriguing phenomena in the field of sensory association is that of synaesthesia, or multi-modal perception, as it is called by many contemporary psychologists. This concept suggests that qualities may be common to or transferred from one sensory domain to another; a colour may be loud, a sound bright, or an odour sharp. Each of these may be heavy or light. Multi-modal perception may be idiosyncratic or take an extreme form where people report experiencing one sensory modality in terms of the qualities of a different modality. One of the most striking examples from the literature is that of a man simply known as 'S', whose exceptional feats of memory led to a thorough investigation of his powers by the Russian psychologist Luria (1968). S's memorising relied strongly on powerful imagery, and he provided many examples of synaesthetic imagery where a sound would elicit a visual sensation together with sensations of taste and feeling. There is now considerable evidence that multi-modal perception is not restricted to exceptional individuals but is a widespread phenomenon, and there is agreement among people as to the relationships among the senses (Marks, 1975, 1984). Auditory pitch is correlated with visual brightness in that high-frequency sounds are perceived as bright and low-frequency sounds as dark.

Marks suggests that these sensory correspondences are fundamental to perception and are not pathological or restricted to only a few people. Closer analysis of the perceptual qualities of sounds suggests that they can be discriminated not only by pitch and loudness but also in terms of their brightness (or density) and volume. The perceived brightness of a sound increases as a function of both its pitch and loudness. Volume is also related to pitch and loudness, having its maximum at high pitch, low loudness and its minimum at high pitch and high loudness. The theory of inter-modal correspondence

predicts that judgements of the visual brightness and size of objects will be associated with pitch and loudness in an equivalent manner. Colours are associated with musical notes and also with vowel sounds (*a* arouses red and blue, *e* and *i* arouse yellow and white, *o* red and black, *u* brown, blue or black; *i* and *e* are the brightest vowels and *o* and *u* the darkest). These relationships can be understood in terms of correspondences between qualities of brightness and compactness of vowel sounds and the brightness and red–green dimensions of colour. High-pitched vowels yield bright colours; compact vowels yield red and diffuse vowels green colours.

The large corpus of evidence marshalled by Marks implies that colours have meanings that are intrinsic to perception and so are universal and not acquired by experience through learnt associations. He documents the extensive use of this phenomenon in poetry, music and painting (see Marks, 1984). Synaesthesia may underlie other aspects of colour perception such as the association between temperature and hue. Our discussion of colour has emphasised consensus in the meanings it elicits. I do not intend to minimise the role that learning can play or the cultural variation that exists. The point I wish to emphasise is that the aesthetic appeal of colour, the messages it conveys and the functions that it serves may all be influenced and constrained by meanings that are subtle yet amenable to investigation by scientific methods. I now provide a further case, this time looking at corporate identity as expressed in typographic design.

Preferences for typefaces reflect all three considerations of form, function and meaning. Much of the discussion of typographic design is concerned with its aesthetic qualities, and many artists like Eric Gill and David Jones have worked in this field. The history of the development of different typefaces is a subject in its own right. Function is not only a matter of the legibility of a typeface but also of the uses to which it is to be put. One common use has been in promoting corporate identity, where an organisation aims to present a unified face to the public and to its employees. A unified style also has the advantage in that its familiarity through repeated exposure reduces the user's uncertainty as to what to expect – less attention needs to be devoted to coming to terms with the form of the message and more can be directed instead to its content. An example is the system of British road signs. Typeface and size and the colour of

letters and background are standardised across the country. Motorways, for which a particular set of regulations governing driver behaviour apply, have signs with white symbols on a blue background. Primary roads have white letters and numbers on a green background. Local directions are indicated by black lettering on a white background.

One of the best-known examples of corporate identity is the work of Frank Pick for London Transport, which, following its formation through the merger of a number of different companies, became responsible for a unified transport system in London. Barman (1979) provides a useful account of Pick's early work on the underground railway when Pick was in charge of publicity, an account that underlines the interrelationships among form, function and meaning. The introduction of a unified scheme for posters, station signs and so on has to be seen in the context of the lack of control over such messages that characterised the time, and the consequent proliferation of styles in signs and posters. Pick realised the advantages of standardisation, order and simplicity in the design and location of signs and considerable experimentation went into achieving this. A typeface was developed by Edward Johnston in 1916 to be used for all lettering throughout the system. Pick was evidently concerned with the meanings that the chosen typeface should convey. He asked Johnston 'for an alphabet that would be clear and open, with a straightforward manliness of appearance that would prevent the management's communication being mistaken for a trader's advertisement by passengers in a hurry'. He told Johnston that the letters should have 'the bold simplicity of the authentic lettering of the finest periods' and yet 'belong unmistakeably to the twentieth century'.

Although Pick is regarded as one of the pioneers of corporate identity, Barman suggests that this was not the function uppermost in his thinking: 'Its function at the time when it was created was quite simply to tell a traveller with an Underground train with the greatest possible efficiency that he had reached his destination.' (p. 46) Legibility, a concern with formal qualities and with the connotative meanings of the design all characterise the work of Pick and Johnston. A design that achieves a balance of these attributes is likely to be successful, as the London Transport designs have been regarded for many years. However, these attributes are not necessarily complementary, and critics can argue that balance has not

HEIMSKRINGLA
BY
SNORRI STURLUSON

THE
SAGA
OF
HARALD
HARDRULER

27 The typeface Norway Alphabet Normal

been achieved. For example, Trevett (1992, p. 41) criticises London Transport for its traditional emphasis upon 'function and engineering convenience over aesthetics and passenger comfort'.

Particular typefaces have widely shared meanings in that we can readily agree on whether a typeface is modern or traditional or has 'manliness of appearance' and this consensus will be taken into account when making design decisions. Jones (1991) describes how a new typeface, Norway Alphabet Normal (see Figure 27), has been developed to promote that country's identity. The 'coarse', 'primitive' and 'ugly' typography is intended to reflect Norway's rugged lifestyle and 'survival on the jagged edge of north-west Eurasia'. It is easy to believe that these qualities of the typeface are identified because the meanings of typography have been acquired through exposure to its different uses and contexts. Perhaps there are more subtle meanings that owe less to familiarity with particular styles. The success that a typeface has in, say, providing corporate identity may be due not so much to its formal characteristics but to some shared, if unconscious, meaning, shared between the design and the image of the company or product that is identified. There is support

for this position in research by Walker *et al.* (1988) who have examined the question, from the perspective of multi-modal perception, of what makes one typeface more appropriate for one message than for another.

In their study Walker and his associates had their participants rate a selection of fourteen typefaces on a set of semantic differential bipolar adjective scales, including soft–hard and weak–strong. In a separate stage of the experiment a different group of participants rated a set of thirteen occupations such as those of baker or blacksmith, using the same set of adjectives. Among the hypotheses tested by the researchers were (i) whether there was some agreement that typefaces and occupations could each be characterised by particular qualities, and (ii) whether shared qualities between typeface and occupation would lead to that typeface being judged more appropriate for that occupation. The evidence broadly supported both hypotheses, suggesting that if a society of bakers or blacksmiths were seeking to promote their identity then they should use a typeface that matches their image.

Form, meaning and function

So far, we have considered two broad perspectives on psychology, the biological and the social; and three factors that influence responses to design; form, meaning, and function. These factors are not orthogonal to these perspectives. Explanations of formal qualities, of proportion and harmony, tend to be framed in terms of properties innate to the human nervous system. Relationships between these properties of objects and responses are held to be universal, though subject to modification by cultural features. Accounts of function also tend towards the universal and the innate. Thus human spatial behaviour is frequently asserted to obey principles of territoriality and the defence of personal space. Human perceptual and physiological characteristics place constraints upon skilled behaviour and set limits upon design features like legibility and discriminability. Accounts of meanings on the other hand tend to stress variability and the effects of historical and cultural contexts. This is not to say that meanings might not have some universal elements. There is for example a consensus from research into people's responses to objects using the semantic differential technique,

studies of the arousal potential of objects and investigations of inter-sensory phenomena, that at most two or three dimensions can characterise meaning across a wide range of domains of experience. Nevertheless, the thrust of explanations in terms of the meanings of objects has been on cultural factors like early socialisation experiences, in the case of transitional objects and fetishes, or the development of the self-concept and of personal identity. Those who emphasise the role of meanings suggest indeed that there are no universal determinants of responses or else that these are minor in comparison with cultural influences.

A major problem with all of these competing paradigms is that many of the qualities of the objects themselves have become lost. These debates are abstract in that the theories could equally well be applied to a whole range of human endeavours. They pay little attention to the material reality of objects, as was admitted by Freud who concentrated on unravelling the meanings of works of art and regarded himself as unqualified to discuss their formal or technical attributes. Similarly discussion of transitional objects has had little to say about the material or tactile qualities of these objects despite the fact that it is these very qualities that comfort the child. The challenge for any psychological theory is to attend to this material reality and, at the same time, to accommodate the insights that have been offered by theories that stress formal and functional properties of objects and their meanings. I hope that I have managed to show in the previous chapters and in my discussion of colour that a focus on each of these does tell us something worthwhile about objects and places. The way ahead is surely to integrate these different approaches and to consider that any object has the potential to provide information about all of them. Paul Greenhalgh and I have attempted this integration by arguing that the most fruitful place to locate psychological responses to objects is in the relationship that forms between object and person (Crozier & Greenhalgh, 1992a, 1992b). That is to say, explanations in terms of the objective properties of objects or in terms of the meanings and mental models of those perceiving and using objects are necessarily incomplete. Our account emphasises the concept of personification of objects and of a process we call the 'simultaneity of reception of impulses from an object'. Our position can be set out as follows: the aesthetic response can be conceptualised in terms of an empathy between object

and spectator that may arise from personification of the object, where the person is regarded as imbuing the object with human consciousness.

The empathy principle

My primary concern is with what has been termed the 'aesthetic' response to objects, to ask what happens when a person contemplates and is moved by an inanimate object. What happens is a complex event in that there is a meeting between two complex entities. The object provides sensations of scale, weight, colour, density and mass. It can also convey information about the process by which it has been manufactured, about how it has been used. The user may have information about the history and significance of that object or of that class of objects, its psychological or economic values. The user does not respond to this range of information as a 'detached observer'; the object is in a real sense measured against the body as well as in terms of more cognitive responses. The psychologist's task is to explain how this wealth of information can become integrated into an aesthetic response, and one useful approach to this is to focus on the *relationship* between person and object.

This is useful for several reasons. First, as I have suggested, explanations run into difficulties when they focus only on the object or user. For example, decorative objects or buildings or gardens may be specially constructed to engage the spectator. The designer 'tests' these in the process of design and construction against his or her own reactions, and in a sense has a relationship with the emerging object. Yet the object can fail to elicit the intended response and may leave the spectator unmoved. It is also well known, as discussed in my earlier chapter, that objects that in the past have elicited a positive response may no longer be able to do so, though clearly the material properties of the object have not altered. A particularly telling example is the alteration in response that can be produced by changes in information that is available about an object. We looked at this issue in the case of the imagery produced by Madonna that adopts many of the modes of representation that are associated with pornographic imagery. One argument here is that the meaning of these modes may be changed because they have been intentionally taken over and manipulated by a woman. There are parallels with this example, as I have argued elsewhere (Crozier & Greenhalgh,

1992b). In a case cited in the *Observer* (1 September 1991) a novel that was received with critical acclaim was subsequently withdrawn from publication when it became known that it had not been written by an Asian woman, as originally believed, but by a white male. An explanation of this revision of opinion consequent upon the change in attribution was that, in the light of this new information about the author's identity, this was now a *different book*. Other examples are the changes in psychological and economic value that flow from the re-attribution of a work of art or the discovery that an art object is a forgery. Explanations of responses in terms of formal properties regard these changes in opinion as aberrant, signs that aesthetic judgements are easily swayed, but this is surely unsatisfactory; the object cannot be isolated from its context and the knowledge that the user brings to interaction with it.

Problems also emerge when the above examples are used to support the position that responses are to be understood in terms of the meanings that a person assigns to objects. This approach loses all sight of the perceptual and tactile qualities of objects; thus, anything at all might become a transitional object. Anything could become a fetish object provided it met the conditions of the circumstances in which it was first seen by the child. This overlooks the child's or the fetishist's engagement with the object of desire, and ignores the sensations of touch and smell or the rhythmic movements of objects. In reality, transitional objects are not interchangeable and, as parents will know, it is very difficult to substitute another comforter, even one apparently of the same kind, for the favourite that has been lost or left behind. More generally, this reliance upon meaning suggests an interchangeability of objects, and taken to the extreme, entails the loss of the distinctive features that have made the object the subject of psychological enquiry.

History suggests that if the scientist wishes to get a grasp of some complex phenomenon he or she can make fruitful use of metaphor and analogy. For example, I have illustrated in my chapters on form and the functions of objects the uses to which the computer metaphor has been put in understanding behaviour. An emphasis upon the relationship between person and object suggests that human relationships may be a useful source of insight. There are qualities of relationships, like warmth or embarrassment, that cannot be understood by focusing on only one individual, and many emotions

such as anger or guilt that are experienced by an individual are comprehensible if the broader social perspective is adopted. The suggestion that objects may be *like* human beings in the sense that they embody personal qualities was first made by Moffett (1975). I take this further to propose that the user 'transforms' an object into a human being in order to explore its properties. Objects, like people, are rich sources of information. Under appropriate circumstances this richness interacts with the user in such a way that it affords a relationship of a kind that normally occurs only among people. This process Greenhalgh and I define as personification.

Human beings seem to have a strong tendency to personify their environment. All kinds of human characteristics are attributed to inanimate objects and people have discourse with objects as though they were alive. This is most conspicuous in early childhood, particularly in that stage of development that psychologists characterise as the period of 'symbolic play'. Piaget characterised the young child at this stage of development as animistic, prone to attribute consciousness to all kinds of objects. Toys are given names and the child plays and talks with them as though they were alive. Similar processes can be observed when adults hit their thumb with a hammer or talk to something that they can't find, and when objects won't 'do as they are told'. Nicknames are assigned to favourite objects and items of clothing, gender is assigned to objects and so on. We feel emotions towards objects and have discourse with them as though they were alive.

Decorative and designed objects, including works of art, are specifically intended to engage the intellect and the emotions and the personification process here becomes particularly intense and multi-layered. We regard the viewer as personifying an object in order to explore its properties, and an object will succeed or fail to engage the viewer by the degree to which it appears to simulate human discourse. When it does succeed the object seems to have a consciousness of its own, to be alive. That is to say, the complexity of information conveyed enables a kind of relationship that normally occurs only among human beings, and in order to absorb this complexity the viewer has to deal with the object as though the information came from a conscious being.

The aesthetic response is not triggered by the sheer amount of information that an object may present or by complexity *per se*. Such

an explanation only restates the formal thesis, substituting unspecified 'personal' properties for line and shape, balance or good gestalts. There must be an *orchestration* of information, where the wealth of information is apprehended simultaneously by the viewer as a single plural experience. This is a gestalt in the sense that it is an organisation of information that is not simply the sum of the parts, but we go further than that to emphasise the relationship that is formed between object and viewer, a relationship where, in a sense, the object and viewer identify with each other. The person brings his or her psychological complexity to the range of formal, symbolic and functional information that is potentially available in the objcct. Complexity is neither in the object nor in the person, but in their relationship. The object has the potential to identify with the viewer because it has been endowed with human qualities. We think of this relationship as an empathy between object and person.

The concept of empathy has a long history in discussions of aesthetics. The word is a translation of the German *Einfühlung,* ('feeling into') drawing upon the Greek *en* (in) and *pathos* (feeling). It has the sense of projecting oneself into the position of another, of experiencing another's feelings as one's own. In aesthetics the theory of empathy was an attempt to explain the expressive properties of objects by assuming that spectators projected human emotions on to inanimate objects. This theory was criticised by the Gestalt psychologists who asserted that expressive qualities can be directly experienced without this projection stage, and these criticisms proved to be fatal in that empathy became a neglected topic in aesthetics, a concept only of historical interest. It did, however, prove to have useful applications in social psychology, in theories of interpersonal relationships, and also in psychotherapy, where the capacity for empathy is regarded as an essential attribute of the successful therapist. In recent years a number of writers, particularly those working within a psychoanalytical framework, have reinstated the concept of empathy in discussions of aesthetics, now focusing on the spectator's capacity to place himself or herself in the position of the artist. I welcome the revival of this concept but think of it as characterising the quality of a relationship, a dynamic process that takes place between object and viewer. My conceptualisation shares something with Dewey's notion of *fusion*: 'the other factor that is required in order that a work may be expressive . . . is meanings and

values extracted from prior experiences and funded in such a way that they fuse with the qualities directly presented in the work of art'.

At present this approach is at an early stage in its development. Yet it allows us to discern the shortcomings of earlier approaches. I believe that previous research has failed to take into account the tactile nature of our response to the world of objects and has not given sufficient weight to the complexity of emotional responses. My approach suggests that the next stages in investigation are the analysis of the range of people's responses to design and a classification of the kinds of relationships that can be identified. It implies that the appropriate methodology is to draw upon one's own introspections and to listen to the accounts that others provide of their experiences with objects and places. At some stage the experimental methods that have featured so heavily in my summary of research will also have a place, in allowing investigators to test the implications of some of these ideas. How useful this approach will turn out to be will depend very much upon its capacity to generate further questions. We have examined many theories in this book, some that have been unproductive and some that have had a vitality that has survived years of study. One can never be sure which theories will prove to be fruitful, but my best guess is that the most promising approaches will look at the relationship between user and object and will attend to the tactile, to the feel and the imagined feel of objects as well as to their visual appearance. There are many signs that psychology is giving increasing recognition to the importance of conceptualising a person's transaction with the environment in terms of relationship. For example, Gibson's theory of direct perception has attempted to resolve the difficulties faced by approaches to perception that are framed in terms of a perceiver making sense of the information that is available in the retinal image. He argues that there is information available in the environment that is both necessary and sufficient for perception. Thus there is no need to postulate schemas, unconscious inferences or other cognitive processes mediating between the environment and the perceiver. He emphasises those characteristics of the optical array that remain invariant across change and that are 'picked up' directly by the perceiver. But Gibson's observer is immersed in the world, not detached from it. The environment invites or demands responses from a person who is attuned to it.

Conclusions

Are we any closer to providing a comprehensive account of psychological responses to the designed world? Clearly much energy and ingenuity has gone into the attempt to provide such an account. I have surveyed theories that have offered broad generalisations and also approaches that have taken a close look at the factors that influence performance of quite specialised tasks. I am conscious that I have only touched upon areas – psychoanalysis, social psychology, the study of the meanings of material objects, ergonomics – that have evolved into major fields of human enquiry in this century. I have attempted to bring order to this diversity by suggesting that responses can be discussed in terms of formal characteristics, the meanings of objects, and the extent to which objects fulfil their functions. Explanations of each of these discerptible elements have tended to emphasise either inherent human responses, often linked to evolutionary notions of adaptation to the environment, or the influence of culture and the social environment. I hope that I have been able to show, in discussion of uses of the environment or of responses to colour, that thinking about design in this way can be illuminating. My approach may give the impression that I have given an unnecessarily complicated account of responses to places and objects that seem to common sense immediate and simple. Yet closer examination surely suggests that these are complex issues that do not lend themselves to straightforward answers. They are also surely important issues. Design adds colour and interest to our life, but it is also revealing of the culture that we have inherited and continually re-create. Its study illuminates many of the stresses in our social conditions and our interaction with the environment. Design makes many connections with psychology, and I hope that a closer mutual understanding between psychologists and designers will benefit both professions, and help to create a world that enhances all our lives.

References

Aaker, D. A. & Day, G. S. (1990) *Marketing Research*, 4th ed., New York, Wiley.

Abelson, R. P. (1986) 'Beliefs are like possessions', *Journal for the Theory of Social Behaviour*, 16, 223–50.

Aldersey-Williams, H. (1992) 'The compact disc case', *Design*, October, p. 40.

Alland, A. (1983) *Playing with Form: Children Draw in Six Cultures*, New York, Columbia University Press.

Altman, I. & Gauvain, M. (1981) 'A cross-cultural and dialectic analysis of homes', in L. Liben, A. Patterson & N. Newcombe (eds.), *Spatial Representation and Behavior Across the Life Span: Theory and Application*, New York, Academic Press.

Appadurai, A. (ed.) (1986) *The Social Life of Things: Commodities in Cultural Perspective*, Cambridge, Cambridge University Press.

Applegate, C. (1992) 'The question of Heimat in the Weimar Republic', *New Formations*, 14, 64–74.

Appleton, J. (1975) *The Experience of Landscape*, London, John Wiley.

Appleton, J. (1988) 'Prospects and refuges revisited', in J. L. Nasar (ed.) *Environmental Aesthetics*, Cambridge, Cambridge University Press, pp. 27–44.

Ardrey, R. (1966) *The Territorial Imperative*, New York, Atheneum.

Arnheim, R. (1955) 'A review of proportion', *Journal of Aesthetics and Art Criticism*, 14, 44–57.

Arnheim, R. (1974) *Art and Visual Perception*, Berkeley, University of California Press.

Arnheim, R. (1982) *The Power of the Center*, Berkeley, University of California Press.

Baber, C. & Wankling, J. (1992) 'An experimental comparison of text and symbols for in-car reconfigurable displays', *Applied Ergonomics*, 23, 255–62.

Barman, C. (1979) *The Man Who Built London Transport*, Newton Abbot, David & Charles.

Barthes, R. (1973) *Mythologies*, London, Paladin.

Beardsley, M. C. & Arnheim, R. (1981) 'An exchange of views on Gestalt psychology and aesthetic explanation', *Leonardo*, 14, 220–3.

References

Belk, R. W. (1991) 'The ineluctable mysteries of possessions', *Journal of Social Behavior and Personality*, 6, 17–55.

Benjafield, J. (1984) 'On the relation between the Pollyanna and golden section hypotheses', *British Journal of Social Psychology*, 23, 83–4.

Benjafield, J. (1992) *Cognition*, Englewood Cliffs, New Jersey, Prentice-Hall.

Bennett, K. B. & Flach, J. M. (1992) 'Graphical displays: implications for divided attention, focused attention, and problem solving', *Human Factors*, 34, 513–33.

Benton, T. (1990) 'The myth of function', in P. Greenhalgh (ed.), *Modernism in Design*, London, Reaktion Books.

Berger, J. (1972) *Ways of Seeing*, Harmondsworth, Penguin.

Berlin, B. & Kay, P. (1969) *Basic Color Terms: Their Universality and Evolution*, Berkeley, University of California Press.

Berlyne, D. E. (1971) *Aesthetics and Psychobiology*, New York, Appleton-Century-Crofts.

Berlyne, D. E. (ed.) (1974) *Studies in the New Experimental Aesthetics*, Washington, DC, Hemisphere.

Bih, Herng-Dar (1992) 'The meaning of objects in environmental transitions: experiences of Chinese students in the United States', *Journal of Environmental Psychology*, 12, 135–47.

Booth, P. A. (1989) *An Introduction to Human–Computer Interaction*, Hove, East Sussex, Erlbaum.

Boselie, F. (1992) 'The Golden Section has no special aesthetic attractivity!', *Empirical Studies of the Arts*, 10, 1–18.

Bouleau, C. (1963) *The Painter's Secret Geometry, A Study of Composition in Art*, New York, Harcourt, Brace and World.

Bowlby, J. (1988) *A Secure Base*, London, Routledge.

Bramwell, R. S. & Davidson, M. J. (1989) 'Visual Display Units (VDUs) and reproductive health – the unresolved controversy', *The Psychologist: Bulletin of the British Psychological Society*, 8, 345–6.

Bronstein, A. A. (1992) 'The fetish, transitional objects, and illusion', *Psychoanalytic Review*, 79, 239–60.

Brown, B., & Altman, I. (1983) 'Territoriality, defensible space and residential burglary: an environmental analysis', *Journal of Environmental Psychology*, 3, 203–20.

Bruce, V. (1989) 'Human factors in the design of coins. 1989 C. S. Myers Lecture', *The Psychologist: Bulletin of the British Psychological Society*, 12, 524–7.

Carswell, C. M. & Wickens, C. D. (1987) 'Information integration and the object display', *Ergonomics*, 30, 511–27.

Castelfranchi, C. & Poggi, I. (1990) 'Blushing as a discourse. Was Darwin wrong?', in W. R. Crozier (ed.), *Shyness and Embarrassment: Perspectives from Social Psychology*, Cambridge, Cambridge University Press.

Chatwin, B. (1988) *The Songlines*, London, Picador.

Coleman, A. (1985) *Utopia on Trial: Vision and Reality in Planned Housing*. London, Hilary Shipman.

Colman, A. M., Sluckin, W., & Hargreaves, D. J. (1981) 'Preferences for Christian names as a function of their experienced familiarity', *British Journal of Social Psychology*, 20, 3–5.

Crozier, W. R. & Greenhalgh, P. (1992a) 'Beyond formalism and relativism: the empathy principle', *Leonardo*, 25, 83–7.

Crozier, W. R. & Greenhalgh, P. (1992b) 'The empathy principle: towards a model for the psychology of art', *Journal for the Theory of Social Behaviour*, 22, 63–79.

Cruikshank, D. (1989) 'Model Vision', *Architects Journal*, 28 June, 24–9.

Csikszentmihalyi, M. & Rochberg-Halton, E. (1981) *The Meaning of Things: Domestic Symbols and the Self*, Cambridge, Cambridge University Press.

Davies, R. (1983) *The Rebel Angels*, Harmondsworth, Penguin.

Davies, R. (1987) *What's Bred in the Bone*, Harmondsworth, Penguin.

Day, H. I. (1981) *Advances in Intrinsic Motivation and Aesthetics*, New York, Plenum.

De Beauvoir, S. (1949/1987) *The Second Sex*, Harmondsworth, Penguin.

Department of Transport (1991) *Road Accidents Great Britain*, London, HMSO.

Dewey, J. (1934/1958) *Art as Experience*, New York, Capricorn Books.

Dittmar, H. (1992) *The Social Psychology of Material Possessions*, Hemel Hempstead, Harvester-Wheatsheaf.

Eckblad, G. (1980) 'The curvex: simple order structure revealed in ratings of complexity, interestingness, and pleasantness', *Scandinavian Journal of Psychology*, 21, 1–16.

Edney, J. J. (1974) 'Human territoriality', *Psychological Bulletin*, 81, 959–75.

Eilam, Z. (1989) 'Human engineering the one-handed keyboard', *Applied Ergonomics*, 20, 225–9.

Ellis, P. (1982) 'The phenomenology of defensible space', in P. Stringer (ed.) *Confronting Social Issues*, Vol. 2, London, Academic Press.

Erikson, E. (1968) *Identity: Youth and Crisis*, London, Faber.

Forty, A. (1986) *Objects of Desire. Design and Society 1750–1980*, London, Thames and Hudson.

Freud, S. (1928/1961) 'Fetishism', in J. Strachey (ed.), *The Standard Edition of the Complete Psychological Works of Sigmund Freud*. XXI, 152–7. London, The Hogarth Press.

Gauvain, M., Altman, I., & Fahim, H. (1984) 'Homes and social change: A case study of the impact of resettlement', in K. J. Gergen & M. M. Gergen (eds.), *Historical Social Psychology*, Hillsdale, NJ, Erlbaum.

Gaver, W. W. & Mandler, G. (1987) 'Play it again, Sam: on liking music', *Cognition and Emotion*, 1, 259–82.

References

Gibson, J. J. (1979) *The Ecological Approach to Visual Perception*, Boston, Houghton-Mifflin.

Goffman, E. (1971) *The Presentation of Self in Everyday Life*, Harmondsworth, Penguin.

Goffman, E. (1979) *Gender Advertisements*, London, Macmillan.

Gordon, I. (1981) 'Left and right in art', in D. O'Hare (ed.) *Psychology and the Arts*, Sussex, Harvester, pp. 211–41.

Grandjean, E. (1986) *Fitting the Task to the Man*, London, Taylor & Francis.

Grandjean, E. (1987) *Ergonomics in Computerized Offices*, London, Taylor & Francis.

Graumann, C. F. (1974) 'Psychology and the world of things', *Journal of Phenomenological Psychology*, 4, 389–404.

Greenhalgh, P. (1990) *Modernism in Design*, London, Reaktion Books.

Gulerce, A. (1991) 'Transitional objects: a reconsideration of the phenomenon', *Journal of Social Behavior and Personality*, 6, 187–208.

Haigh, R. (1993) 'The ageing process: a challenge for design', *Applied Ergonomics*, 24, 9–14.

Hardy, T. (1878/1974) *The Return of the Native*, London, Macmillan.

Harré, R. (1979) *Social Being*, Oxford, Blackwell.

Health and Safety Executive (1992) *Display Screen Equipment Work. The Health and Safety (Display Screen Equipment) Regulations 1992. Guidance on Regulations*, London, HMSO.

Heyduk, R. G. (1975) 'Rated preference for musical compositions as it relates to complexity and exposure frequency', *Perception and Psychophysics*, 17, 84–91.

Hogg, J., Goodman, T., Porter, T., Mikellides, B. & Preddy, D. E. (1979) 'Dimensions and determinants of colour samples and a simulated interior space by architects and non-architects', *British Journal of Psychology*, 70, 231–42.

Humphrey, N. K. (1976) 'The colour currency of nature', in T. Porter and B. Mikellides (eds.), *Colour in Architecture*, London, Studio Vista.

Huntley, H. E. (1970) *The Divine Proportion*, New York, Dover Publications.

Jacobs, J. (1961) *The Death and Life of Great American Cities*, New York, Random House.

Johnson-Laird, P. N. (1988) *The Computer and the Mind*, London, Fontana.

Jones, M. (1991) 'National characters', *Design*, June, 28–30.

Jung, C. G. (1960) *Psychology and Religion*, New Haven, Yale University Press.

Kanizsa, G. (1979) *Organization in Vision*, New York, Praeger.

Kaplan, R. (1985) 'The analysis of perception via preference: a strategy for studying how the environment is experienced', *Landscape Planning*, 12, 1161–76.

Kaplan, S. (1987) 'Aesthetics, affect and cognition. Environmental prefer-

ence from an evolutionary perspective', *Environment and Behavior*, 19, 3–32.

Kasmar, J. V. (1970) 'The development of a usable lexicon of environmental descriptors', *Environment and Behavior*, 2, 153–69.

Kellogg, R. (1970) *Analyzing Children's Art*, Palo Alto, National Press Books.

Kinross, R. (1988) 'Herbert Read's *Art and Industry*: a history', *Journal of Design History*, 1, 35–50.

Kreitler, H. & Kreitler, S. (1972) *Psychology and the Arts*, Durham, NC, Duke University Press.

Kreitler, H. & Kreitler, S. (1990) 'Psychosemantic foundations of creativity', in K. J. Gilhooly, M. T. G. Keane, R. H. Logie & G. Erdos (eds.), *Lines of Thinking: Reflections on the Psychology of Thought*, London, Wiley.

Krupat, E. (1985) *People in Cities*. Cambridge, Cambridge University Press.

Kwallek, N. & Lewis, C. M. (1990) 'Effects of environmental colour on males and females: a red or white or green office', *Applied Ergonomics*, 21, 275–8.

Lawrence, R. J. (1982) 'A psychological-spatial approach for architectural design and research', *Journal of Environmental Psychology*, 2, 37–51.

Lee, K., Swanson, N., Sauter, S., Wickstrom, R., Waikar, A. & Mangum, N. (1992) 'A review of physical exercises recommended for VDT operators', *Applied Ergonomics*, 23, 387–408.

Lindauer, M. S. (1984) 'Physiognomy and art: approaches from above, below and sideways', *Visual Arts Research*, 10, 52–65.

Locher, P., Smets, G. & Overbeeke, K. (1992) 'The contribution of stimulus attributes, viewer expertise and task requirements on visual and haptic perception of balance', *Paper presented at the 12th International Congress of the International Association for Empirical Aesthetics, Hochschule der Künste Berlin*.

Luria, A. R. (1968) *The Mind of a Mnemonist*, New York, Basic Books.

Mandler, G. (1975) *Mind and Emotion*, New York, Wiley.

Marks, L. E. (1975) 'On colored-hearing synesthesia: cross-modal translations of sensory dimensions', *Psychological Bulletin*, 82, 303–31.

Marks, L. E. (1984) 'Synesthesia and the arts', in W. R. Crozier & A. J. Chapman (eds.), *Cognitive Processes in the Perception of Art*, Amsterdam, North-Holland.

Martindale, C., Moore, K. & Borkum, J. (1990) 'Aesthetic preference: anomalous findings for Berlyne's psychobiological theory', *American Journal of Psychology*, 103, 53–80.

Martindale, C. & Uemura, A. (1983) 'Stylistic change in European music', *Leonardo*, 16, 225–8.

Mawby, R. I. (1977) 'Defensible Space: a theoretical and empirical appraisal', *Urban Studies*, 14, 168–79.

References

McClintock, A. (1993) 'The return of female fetishism and the fiction of the phallus,' *New Formations*, 19, 1–21.

McKechnie, G. (1977) 'Simulation techniques in environmental psychology', in D. Stokols (ed.), *Perspectives on Environment and Behavior*, New York, Plenum, pp. 169–89.

McManus, I. C. (1980) 'The aesthetics of simple figures', *British Journal of Psychology*, 71, 505–24.

McManus, I. C. (1981) 'The aesthetics of colour', *Perception*, 10, 651–66.

McManus, I. C. (1983) 'Basic colour terms in literature', *Language and Speech*, 26, 247–52.

Miller, J. (ed.) (1983) *States of Mind: Conversations with Psychological Investigators*, London, British Broadcasting Corporation.

Mitchell, J. (1975) *Psychoanalysis and Feminism*, Harmondsworth, Penguin.

Moffett, L. A. (1975) 'Art objects as people: a new paradigm for the psychology of art', *Journal for the Theory of Social Behaviour*, 5, 215–23.

Morgan, G. A., Goodson, F. E. & Jones, T. (1975) 'Age differences in the associations between felt temperatures and color choices', *American Journal of Psychology*, 88, 125–30.

Murch, G. M. (1984) 'Physiological principles for the effective use of color', *IEEE Color Graphics and Illustration*, 4, 49–54.

Nagy, A. L. & Sanchez, R. R. (1992) 'Chromaticity and luminance as coding dimensions in visual search', *Human Factors*, 34, 601–14.

Nakaseko, N., Grandjean, E., Hunting, W. & Gierer, R. (1985) 'Studies on ergonomically designed alphanumeric keyboards', *Human Factors*, 27, 175–87.

Nasar, J. L., Julian, D., Buchman, S., Humphreys, D. & Mrohaly, M. (1983) 'The emotional quality of scenes and observation points: a look at prospect and refuge', *Landscape Planning*, 10, 355–61.

Neisser, U. (1976) *Cognition and Reality*, New York, Freeman.

Newman, O. (1972) *Defensible Space: Crime Prevention Through Urban Design*, New York, Macmillan.

Norman, D. A. (1986) 'Cognitive engineering', in D. A. Norman & S. W. Draper (eds.), *User Centred System Design: New Perspectives on Human–Computer Interaction*, Cambridge, MA, MIT Press.

Norman, D. A. (1988) *The Psychology of Everyday Things*, New York, Basic Books.

Noyes, J. (1983) ' The QWERTY keyboard: a review', *International Journal of Man–Machine Studies*, 18, 265–81.

Osgood, C. E., May, W. H. & Miron, M. S. (1975) *Cross-Cultural Universals of Affective Meaning*, Urbana, University of Illinois Press.

Passoja, D. E. & Lakhtakia, A. (1992) 'Carpets and rugs: an exercise in numbers, *Leonardo*, 25, 69–71.

Pheasant, S. (1987) *Ergonomics: Standards and Guidelines for Designers*, Milton Keynes, British Standards Institute.

References

Porter, T. (1992) 'Natural selection. Interview with Carl Gardner', *Design*, November, 50–1.

Prentice, D. A. (1987) 'Psychological correspondence of possessions, attitudes, and values', *Journal of Personality and Social Psychology*, 53, 993–1003.

Proshansky, H. M., Fabian, A. K. & Kaminoff, R. (1983) 'Place-identity: physical world socialisation of the self', *Journal of Environmental Psychology*, 3, 57–83.

Purcell, A. T. (1984) 'The aesthetic experience and mundane reality', In W. R. Crozier & A. J. Chapman (eds.), *Cognitive Processes in the Perception of Art*, Amsterdam, North-Holland.

Purcell, A. T. (1986) 'Environmental perception and affect: a schema discrepancy model', *Environment and Behavior*, 18, 3–30.

Rasmussen, J. & Vicente, K. J. (1989) 'Coping with human errors through system design: implications for ecological interface design', *International Journal of Man–Machine Studies*, 31, 517–34.

Rayner, K. & Pollatsek, A. (1989) *The Psychology of Reading*, Englewood Cliffs, NJ, Prentice-Hall.

Robinson, J. (1990) *Wayward Women: A Guide to Women Travellers*, Oxford, Oxford University Press.

Rosch, E. H. (1975) 'Cognitive representations of semantic categories', *Journal of Experimental Psychology: General*, 104, 192–233.

Rudmin, F. W. (ed.) (1991) 'To have possessions: A handbook on ownership and property [Special Issue]', *Journal of Social Behavior and Personality*, 6, No. 6.

Rudnicky, A. I. & Kolers, P. A. (1984) 'Size and case of type as stimuli in reading', *Journal of Experimental Psychology: Human Perception and Performance*, 10, 231–249.

Salvendy, G. (ed.) (1987) *Handbook of Human Factors*, New York, Wiley.

Sennett, R. (1976) *The Fall of Public Man*, Cambridge, Cambridge University Press.

Shneiderman, B. (1983) 'Direct manipulation: a step beyond programming languages', *IEEE Computer*, 16, 57–69.

Sivik, L. (1975) 'Studies of color meaning', *Man–Environment Systems*, 5, 155–60.

Sixsmith, J. (1986) 'The meaning of home: an exploratory study of environmental experience', *Journal of Environmental Psychology*, 6, 281–98.

Sluckin, W., Hargreaves, D. J. & Colman, A. M. (1983) 'Novelty and human aesthetic preferences', In J. Archer and L. Birke (eds.), *Animal and Human Exploration*, London, Van Nostrand.

Smith, C. & Lloyd, B. B. (1978) 'Maternal behavior and perceived sex of infant: revisited', *Child Development*, 49, 1263–5.

Stone, L. A. & Collins, L. G. (1965) 'The golden section revisited: a perimetric explanation', *American Journal of Psychology*, 78, 503–6.

References

Sundstrom, E. (1986) *Work Places: The Psychology of the Physical Environment in Offices and Factories*, Cambridge, Cambridge University Press.

Sword, R. (1974) *Utility Furniture and Fashion 1941–1951. Geffrye Museum Exhibition Catalogue*, London, Inner London Education Authority.

Tabin, J. K. (1992) 'Transitional objects as objectifiers of the self in toddlers and adolescents', *Bulletin of the Menninger Clinic*, 56, 209–20.

Teigen, K. H. (1987) 'Intrinsic interest and the novelty–familiarity interaction', *Scandinavian Journal of Psychology*, 28, 199–210.

Trevett, N. (1992) 'Action stations', *Design*, February, 41–3.

Tuohy, A. P. & Stradling, S. G. (1987) 'Maximum salience vs. golden section proportions in judgemental asymmetry', *British Journal of Psychology*, 78, 457–64.

Von Bertalanffy, L. (1967) *Robots, Men and Minds: Psychology in the Modern World*, New York, George Braziller.

Walker, E. L. (1973) 'Psychological complexity and preference: a hedgehog theory of behavior', in D. E. Berlyne & K. B. Madsen (eds.), *Pleasure, Reward, Preference*, New York, Academic Press.

Walker, P., Smith, S. & Livingston, A. (1988) 'Predicting the appropriateness of a typeface on the basis of its multi-modal features', *Information Design Journal*, 5, 29–42.

Walraven, J. (1985) 'The colours are not on the display: a survey of non-veridical perceptions that may turn up on a colour display', *Displays*, 6, 35–42.

Whitfield, T. & Slater, P. (1979) 'The effects of categorization and prototypicality on aesthetic choice in a furniture selection task', *British Journal of Psychology*, 70, 65–75.

Wickham, C. J. (1991) 'Representation and mediation in Edgar Reitz's *Heimat*', *The German Quarterly*, 64, 35–45.

Williamson, J. (1978) *Decoding Advertisements*, London, Marion Boyars.

Wilson, B. & Wilson, M. (1984) 'Children's drawings in Egypt: cultural style acquisition as graphic development', *Visual Arts Research*, 10, 13–26.

Wilson, E. (1991) *The Sphinx in the City*, London, Virago.

Wilson, S. (1980) 'Vandalism and "defensible space" on London housing estates', in R. V. G. Clarke & P. Mayhew (eds.) *Designing Out Crime*, London, HMSO.

Winnicott, D. W. (1953) 'Transitional objects and transitional phenomena', *International Journal of Psychoanalysis*, 34, 89–97.

Wittgenstein, L. (1953) *Philosophical Investigations*, Oxford, Blackwell.

Worth, R. (1992) 'A material whirl, review of C. Switchenberg (ed.) The Madonna Connection: Representational Politics, Subcultural Identities and Cultural Theory', the *Guardian*, 17 November.

Zajonc, R. B. (1968) 'Attitudinal effects of mere exposure', *Journal of Personality and Social Psychology Monograph*, 9 (2, Part 2, 1–28).

Zajonc, R. B. (1980) 'Feeling and thinking. Preferences need no inferences', *American Psychologist*, 35, 151–75.

Zee, A. (1986) *Fearful Symmetry: The Search for Beauty in Modern Physics*, New York, Macmillan.

Zipp, P., Haider, E., Halpern, N. & Rohmert, W. (1983) 'Keyboard design through physiological strain measurements', *Applied Ergonomics*, 14, 117–22.

Zusne, L. (1970) *Visual Perception of Form*, New York, Academic Press.

Index

Index

object display, 122–4
visual display unit (VDU), 128, 130–4
see also keyboard design

women, depiction, 94–6, 107, 109–12

Zajonc, R. B., 67, 71, 83–4